ALONG THE
BORDER OF HEAVEN

The lonely sail in the distance
Vanished at last beyond the blue sky.
And I could see only the river
Flowing along the border of heaven.

—Li Po

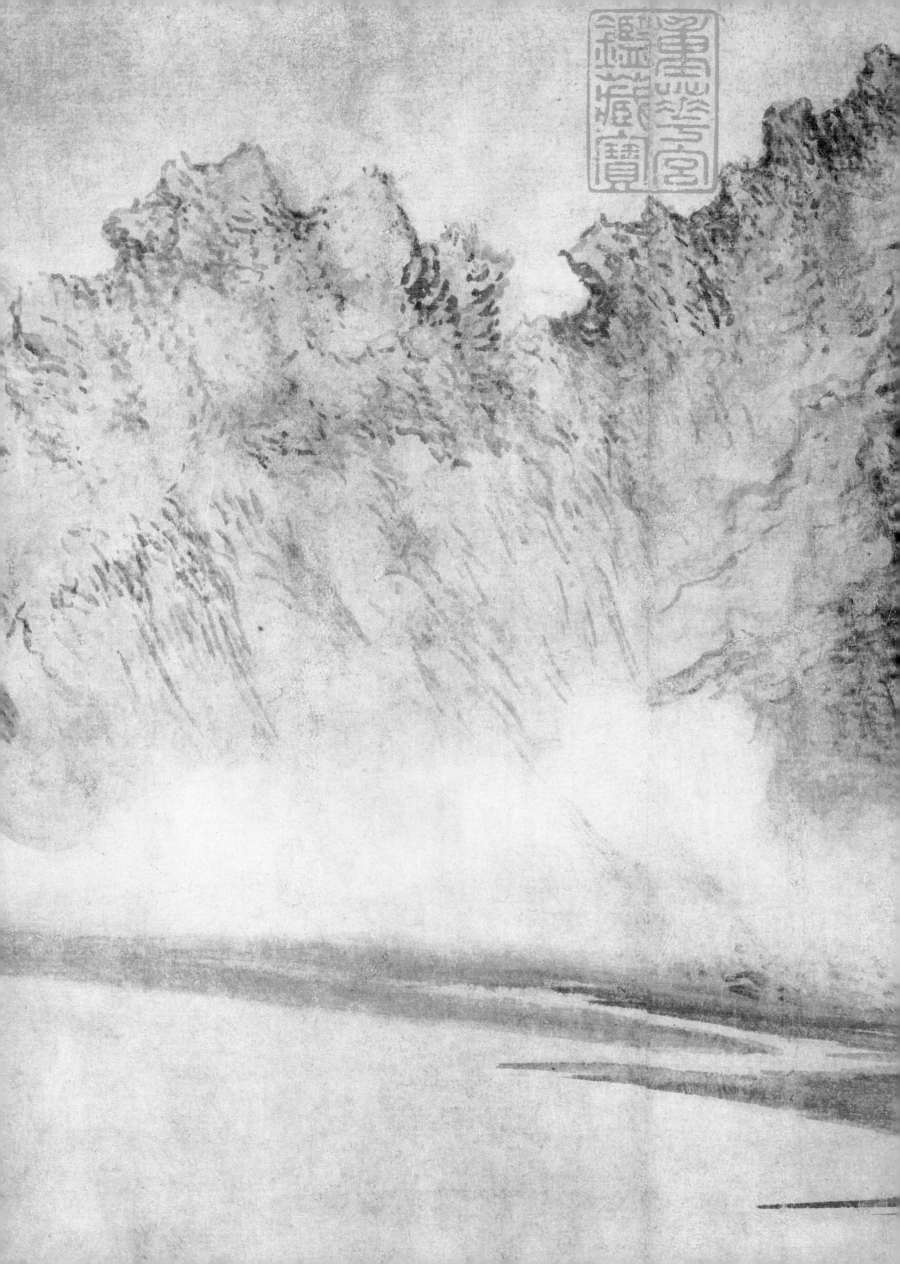

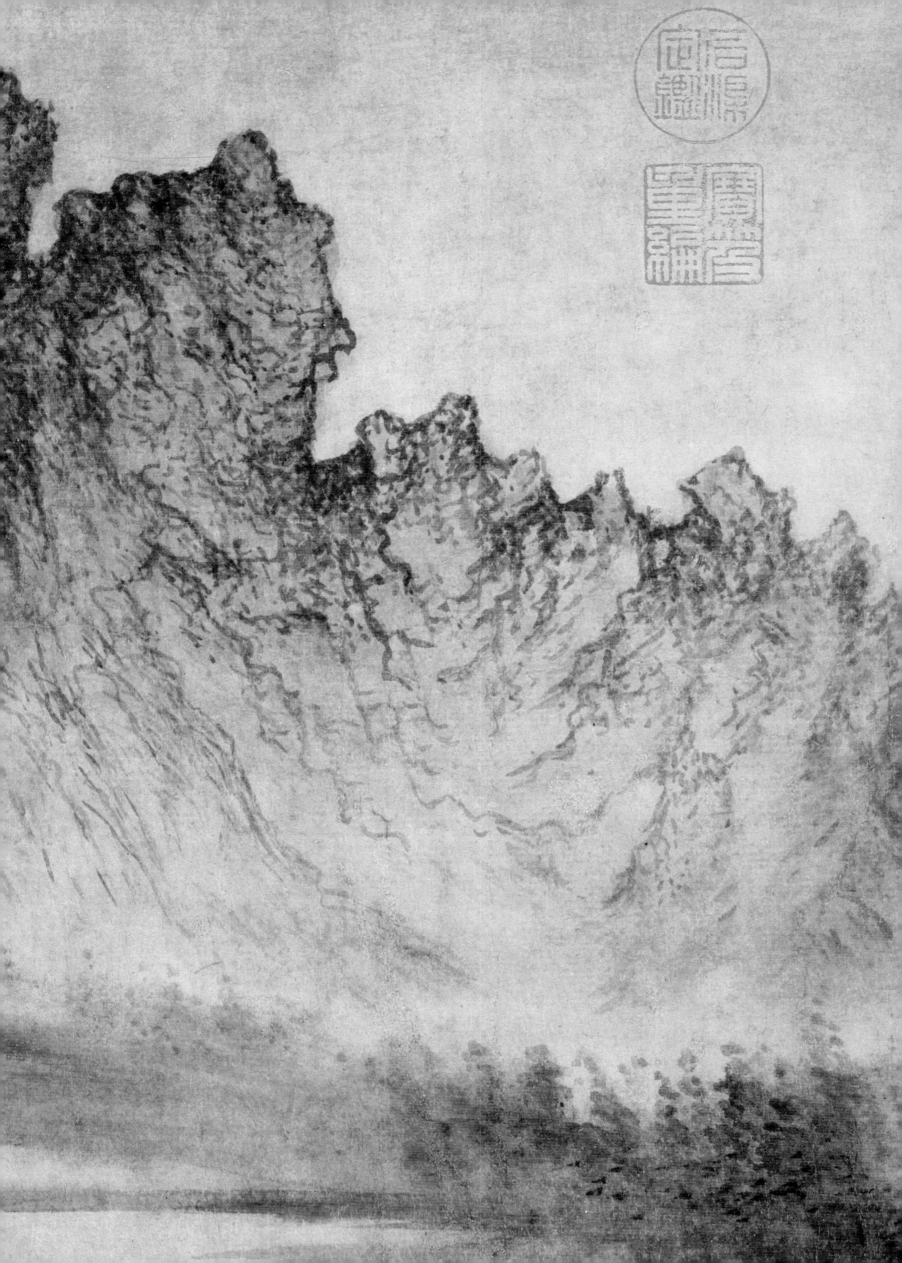

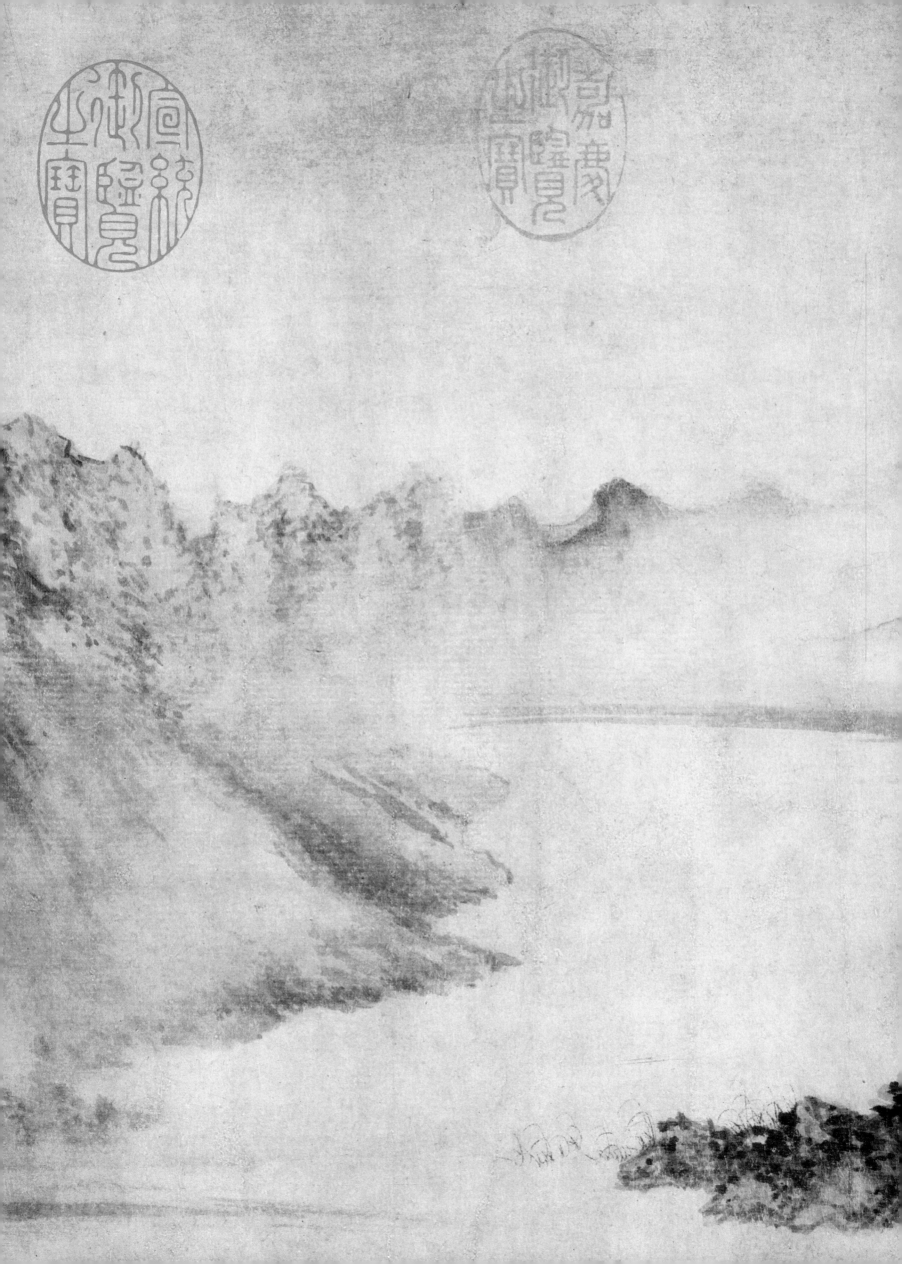

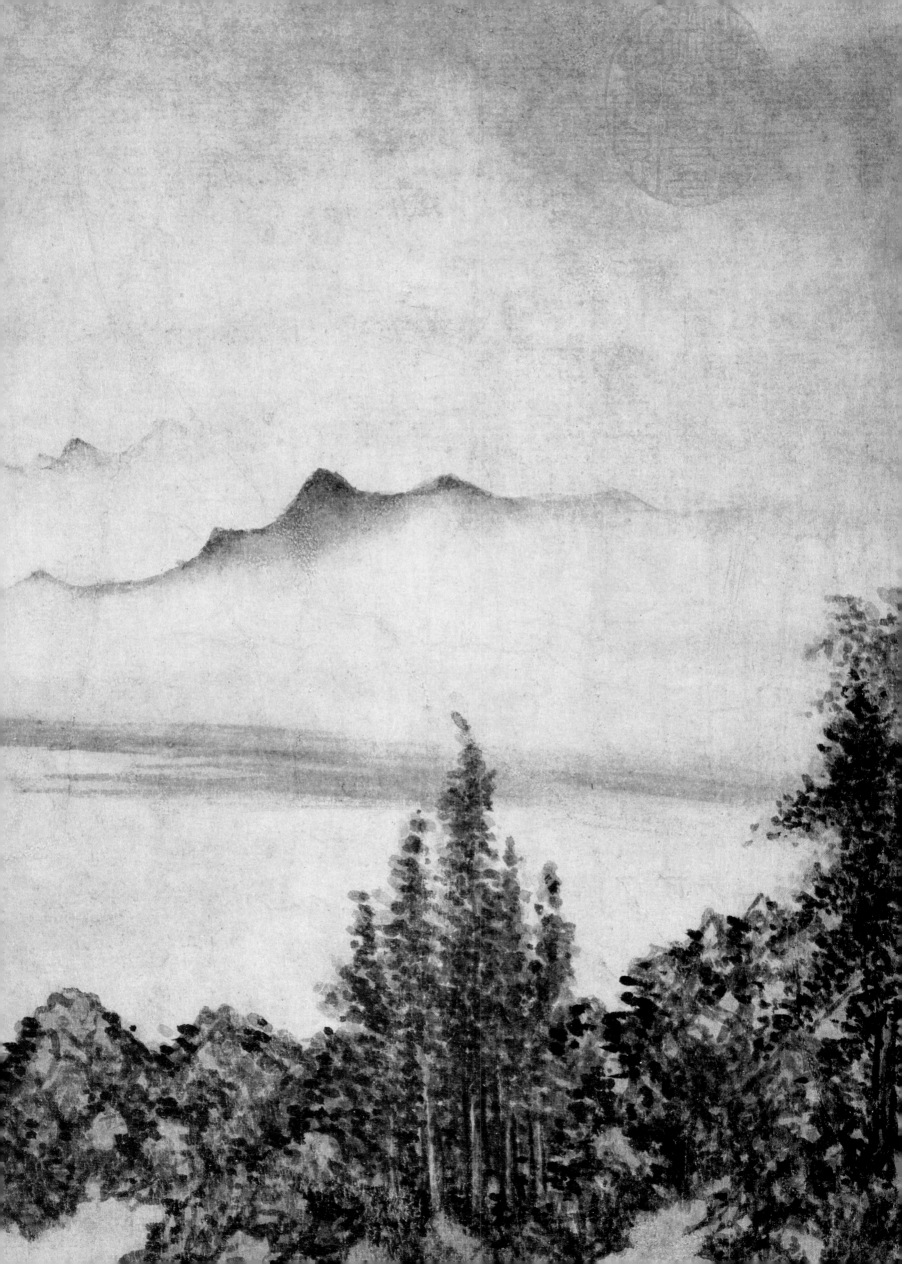

ALONG THE

BORDER OF HEAVEN

SUNG AND YÜAN PAINTINGS
from the
C. C. Wang Family Collection

Richard M. Barnhart

The Metropolitan Museum of Art
New York

Copyright © 1983 by The Metropolitan Museum of Art, New York

Published by
The Metropolitan Museum of Art, New York
Bradford D. Kelleher, Publisher
John P. O'Neill, Editor in Chief
Joan S. Ohrstrom, Editor
Gerald Pryor, Designer
Photography of paintings from the Metropolitan's collection and
the C. C. Wang Family Collection by Walter J. F Yee, The Photograph
Studio, The Metropolitan Museum of Art

Library of Congress Cataloging in Publication Data

Barnhart, Richard M.
 Along the border of heaven.

 Includes index.
 1. Painting, Chinese—Sung-Yüan dynasties, 960-1368—
Catalogs. 2. Wang, Chi-ch'ien—Art collections—
Catalogs. 3. Painting—Private collections—Catalogs.
I. Wang, Chi-ch'ien. II. Title.
ND1043.4.B37 1983 759.951'074 83-5485
ISBN 0-87099-291-0

Typeset by U. S. Lithograph Inc., New York
Printed by Gardner/Fulmer Lithograph, Buena Park, California
Bound by Robert Burlen & Son, Inc., Hingham, Massachusetts

On the slipcase: *The Riverbank* (detail), attributed to Tung Yüan (fig. 1)
Frontispiece: *Cloud Mountains* (detail), by Fang Ts'ung-i (fig. 81)

Contents

List of Illustrations

Fig. 18
Duke Wen of Chin Recovering His State
Scene 3: "Departure from Ch'u"
Detail

Fig. 19
Duke Wen of Chin Recovering His State
Scene 3: "Departure from Ch'u"
Detail

Fig. 20
Duke Wen of Chin Recovering His State
Scene 4: "Received by the Ladies of Ch'in"

Fig. 21
Duke Wen of Chin Recovering His State
Scene 5: "Tzu-fan Presenting a Jade Disk"

Fig. 22
Eighteen Songs of a Nomad Flute
Unknown artist, 14th century
Copy after anonymous Southern Sung academy
 painter, ca. 1140
Scene 3: "Desert Night"
Section of a handscroll; ink, color, and gold on silk
 (28.5 × 1,211.9 cm.)
Overall: H. 11 ³⁄₁₆ × L. 477 in.
The Metropolitan Museum of Art
Gift of The Dillon Fund, 1973
 (1973.120.3)

Fig. 23
Eighteen Songs of a Nomad Flute
Scene 13: "The Farewell"

Fig. 24
Eighteen Songs of a Nomad Flute
Unknown artist, 12th century
Scene 13: "The Farewell"
Album leaf; color on silk
H. 9¾ × W. 26⁷⁄₁₆ in.
 (24.8 × 67.2 cm.)
Museum of Fine Arts, Boston
Ross Collection, Gift of Denman Waldo Ross
 (28.64)

Fig. 25
Odes of the State of Pin
Ma Ho-chih, active ca. 1130–70
Scene 1: "The Seventh Month"
Section of a handscroll; ink and color on silk
Overall: H. 10⅞ × L. 265 ¹⁵⁄₁₆ in.
 (27.6 × 650 cm.)
The Metropolitan Museum of Art
Purchase, Gift of J. Pierpont Morgan, by exchange,
 1973 (1973.121.3)

Fig. 26
Odes of the State of Pin
Scene 1: "The Seventh Month"
Detail

Fig. 27
Odes of the State of Pin
Scene 2: "The Kite-Owl"

Fig. 28
Odes of the State of Pin
Scene 4: "Broken Axes"
Detail

Fig. 29
Cottages in a Misty Grove, dated 1117
Li An-chung, active ca. 1100–40
Album leaf; ink and color on silk
H. 9½ × W. 10⅓ in. (24.2 × 26.3 cm.)
The Cleveland Museum of Art
Gift of Mr. and Mrs. Severance A. Millikin (63.588)

Fig. 30
Hermitage by a Pine-Covered Bluff
Unknown artist, mid-12th century
Album leaf; ink and color on silk
H. 8¼ × W. 9 in. (21 × 22.9 cm.)
The Metropolitan Museum of Art
Gift of Mr. and Mrs. Jeremiah Milbank and Gift
 of Mary Phelps Smith, in memory of Howard
 Caswell Smith, by exchange, 1973 (1973.121.12)

Fig. 31
Watching Deer by a Pine-Shaded Stream
Ma Yüan, active ca. 1190–1225
Album leaf; ink and color on silk
H. 9¾ × W. 10¼ in. (24.8 × 26 cm.)
Mr. and Mrs. A. Dean Perry collection, Cleveland
Intended gift to The Cleveland Museum of Art

Fig. 32
Scholar by a Waterfall
Ma Yüan, active ca. 1190–1225
Album leaf; ink and color on silk
H. 9¾ × W. 10½ in. (24.8 × 26.7 cm.)
The Metropolitan Museum of Art
Gift of The Dillon Fund, 1973 (1973.120.9)

Fig. 33
Enjoying Plum Blossoms
Ma Yüan, active ca. 1190–1225
Fan; ink and color on silk
H. 9⅞ × W. 10⅝ in. (25.1 × 27 cm.)
C. C. Wang family collection, New York

Fig. 34
Plum Blossoms by Moonlight
Ma Yüan, active ca. 1190–1225
Fan; ink and color on silk
H. 9⅞ × W. 10½ in. (25.1 × 26.7 cm.)
John M. Crawford, Jr., collection, New York

Fig. 35
Scholar and Crane
Ma Yüan, active ca. 1190–1225
Fan; ink on silk
H. 9¾ × W. 10⅜ in. (24.8 × 26.4 cm.)
C. C. Wang family collection, New York

Fig. 36
Scholar by a Pine Stream
Ma Yüan, active ca. 1190–1225
Fan; ink on silk
H. 9¹¹⁄₁₆ × W. 10⁵⁄₁₆ in. (23 × 26.2 cm.)
C. C. Wang family collection, New York

Fig. 37
Windswept Shore
After Hsia Kuei, active ca. 1190–1225
Album leaf; ink on silk
H. 8¼ × W. 9 in. (21 × 22.9 cm.)
The Metropolitan Museum of Art
Purchase, Bequest of Theodore M. Davis, by
 exchange, 1973 (1973.121.11)

Fig. 38
Chickadee, Plum Blossoms, and Bamboo
Unknown artist
Fan; color on silk
H. 9⅞ × W. 10³⁄₁₆ in. (25.1 × 25.9 cm.)
C. C. Wang family collection, New York

Fig. 39
Orchids
Ma Lin, active ca. 1250
Album leaf; ink and color on silk
H. 10¹⁵⁄₁₆ × W. 8¹³⁄₁₆ in. (26.2 × 22.4 cm.)
The Metropolitan Museum of Art
Gift of The Dillon Fund, 1973 (1973.120.10)

Fig. 40
Birds in a Tree Above a Cataract
Li Ti, 12th century
Album leaf; color on silk
H. 9¾ × W. 10¼ in. (24.8 × 26 cm.)
Mr. and Mrs. A. Dean Perry collection, Cleveland
Intended gift to The Cleveland Museum of Art
 (64.155)

Fig. 41
The Nine Songs of Ch'ü Yüan, last leaf dated 1305
Attributed to Chao Meng-fu, 1254–1322
"The Lord of the Yellow River"
Detail
Leaf from an album of eleven paintings; ink on paper
Each leaf: H. 10⅜ × W. 6¼ in. (26.4 × 15.9 cm.)
The Metropolitan Museum of Art
Fletcher Fund, 1973 (1973.121.15)

Fig. 42
The Nine Songs of Ch'ü Yüan
Attributed to Chang Tun-li, 13th century
"The Princess and the Lady of the Hsiang River"
Section of a handscroll; color on silk
Overall: H. 9¾ × L. 236¼ in. (24.7 × 608.5 cm.)
Museum of Fine Arts, Boston
Archibald Cary Coolidge Fund (34.1460)

Fig. 43
The Nine Songs of Ch'ü Yüan
Attributed to Chao Meng-fu
"The Lady of the Hsiang River"
Detail
(see fig. 41)

Fig. 44
The Nine Songs of Ch'ü Yüan, dated 1360
Chang Wu, active ca. 1336–64
"The Lady of the Hsiang River and Female
 Attendant"
Section of a handscroll; ink on paper
Overall: H. 11¾ × L. 408 in. (29.8 × 1,036 cm.)
The Cleveland Museum of Art
Purchase from the J. H. Wade Fund (59.138)

Fig. 45
Liu Ch'en and Yüan Chao Entering the T'ien-t'ai Mountains
Chao Ts'ang-yün, 14th century
"Entering the Mountains and Crossing the Stream"
Section of a handscroll; ink on paper
Overall: H. 8⁷⁄₁₆ × L. 222¼ in. (21.4 × 564.4 cm.)
C. C. Wang family collection, New York

Fig. 46
Liu Ch'en and Yüan Chao Entering the T'ien-t'ai Mountains
"Feasting"

Fig. 47
Wang Hsi-chih Watching Geese
Ch'ien Hsüan, ca. 1235–after 1300
Handscroll; ink, color, and gold on paper
H. 9⅛ × L. 36½ in. (23.2 × 92.7 cm.)
The Metropolitan Museum of Art
Gift of The Dillon Fund, 1973 (1973.120.6)

Fig. 48
Narcissus
Chao Meng-chien, 1199–1264
Detail
Handscroll; ink on paper
Overall: H. 9½ × L. 36½ in. (24.1 × 92.7 cm.)
The Metropolitan Museum of Art
Gift of The Dillon Fund, 1973 (1973.120.4)

Fig. 49
The Mind Landscape of Hsieh Yu-yü
Detail (see fig. 50)

Fig. 50
The Mind Landscape of Hsieh Yu-yü
Chao Meng-fu, 1254–1322
Handscroll; ink and color on silk
H. 10¹³⁄₁₆ × L. 45¹³⁄₁₆ in. (27.4 × 116.3 cm.)
The Art Museum, Princeton University
The Ellen B. Elliott Collection (L.216.69)

Fig. 51
The Land of Immortals
Ch'en Ju-yen, active ca. 1340–70
Handscroll; ink and color on silk
H. 13 × L. 40½ in. (33 × 102.9 cm.)
Mr. and Mrs. A. Dean Perry collection, Cleveland
Intended gift to The Cleveland Museum of Art

Fig. 52
The Land of Immortals
Detail

Fig. 53
Twin Pines, Level Distance
Chao Meng-fu, 1254–1322
Handscroll; ink on paper
H. 10 × L. 42¼ in. (25.4 × 127.3 cm.)
The Metropolitan Museum of Art
Gift of The Dillon Fund, 1973 (1973.120.5)

Fig. 54
Twin Pines, Level Distance
Detail

Fig. 55
Crows in Old Trees
Lo Chih-ch'üan, died before 1330
Hanging scroll; ink and color on silk
H. 59⅜ × W. 31½ in. (150.8 × 80 cm.)
The Metropolitan Museum of Art
Purchase, Gift of J. Pierpont Morgan, by exchange,
 1973 (1973.121.6)

Fig. 56
Returning Fishermen, dated 1342
T'ang Ti, ca. 1296–1367
Hanging scroll; ink and color on silk
H. 52¾ × W. 33¹⁵⁄₁₆ in. (134 × 86.4 cm.)
The Metropolitan Museum of Art
Bequest of Joseph H. Durkee, by exchange,
 1973 (1973.121.5)

Fig. 57
Crows in Old Trees
Detail (see fig. 55)

Fig. 58
Leafless Tree, Bamboo, and Rock, dated 1321
Chao Meng-fu, 1254–1322
Hanging scroll; ink on silk
H. 62¾ × W. 33¾ in. (159.4 × 85.7 cm.)
C. C. Wang family collection, New York

Fig. 59
Lofty Virtue Reaching the Sky, dated 1338
Wu Chen, 1280–1354
Hanging scroll; ink on silk
H. 65⅜ × W. 38⅝ in. (166 × 98.1 cm.)
C. C. Wang family collection, New York

Fig. 60
Bamboo, Rock, and Tall Tree
Ni Tsan, 1301–74
Hanging scroll; ink on paper
H. 26½ × W. 14½ in. (67.3 × 36.8 cm.)
The Cleveland Museum of Art
Purchase, Leonard C. Hanna, Jr., Bequest
 (78.65)

Fig. 61
Bamboo, Rock, and Tall Tree
Detail

Fig. 62
Bamboo After Wen T'ung, dated 1343
K'o Chiu-ssu, 1290–1343
Hanging scroll; ink on silk
H. 42¾ × W. 18¼ in.
 (108.6 × 46.3 cm.)
C. C. Wang family collection, New York

Fig. 63
Bamboo and Rocks, dated 1318
Li K'an, 1245–1320
Pair of hanging scrolls; ink and color on silk
Each panel: H. 74¾ × W. 21¾ in.
 (189.9 × 55.2 cm.)
The Metropolitan Museum of Art
Gift of The Dillon Fund, 1973
 (1973.120.7)

Fig. 64
Bamboo and Rocks
Detail

Fig. 65
Fragrant Snow at Broken Bridge
Wang Mien, 1287–1366
Hanging scroll; ink on silk
H. 91⅜ × W. 19⅝ in. (232.1 × 49.8 cm.)
The Metropolitan Museum of Art
Purchase, Gift of J. Pierpont Morgan, by exchange,
 1973 (1973.121.9)

Fig. 66
Streams and Mountains, dated 1372
Hsü Pen, 1335–78
Hanging scroll; ink on paper
H. 26¾ × W. 10¼ in. (67.9 × 26 cm.)
Mr. and Mrs. A. Dean Perry collection, Cleveland
Intended gift to The Cleveland Museum of Art

Fig. 67
Farewell by a Stream on a Clear Day
Chao Yüan, active ca. 1350–75
Hanging scroll; ink on paper
H. 37¼ × W. 13¾ in.
 (94.6 × 34.9 cm.)
The Metropolitan Museum of Art
Purchase, Gift of J. Pierpont Morgan, by exchange,
 1973 (1973.121.8)

Fig. 68
Spring Dawn at the Cinnabar Terrace
Lu Kuang, active ca. 1360
Hanging scroll; ink on paper
H. 24⅛ × W. 10¼ in. (61.3 × 26 cm.)
The Metropolitan Museum of Art
Edward Elliott Family Collection, Purchase,
 The Dillon Fund Gift, 1982 (1982.2.2)

Fig. 69
The Su-an Retreat
Wang Meng, ca. 1301–ca. 1385
Hanging scroll; ink and color on silk
H. 53¾ × W. 17½ in. (136.5 × 44.4 cm.)
C. C. Wang family collection, New York

Fig. 70
The Su-an Retreat
Detail

Fig. 71
Dwelling in the Ch'ing-pien Mountains, dated 1366
Wang Meng, ca. 1301–ca. 1385
Hanging scroll; ink on paper
H. 55½ × W. 16⅝ in.
 (141 × 42.2 cm.)
Shanghai Museum

Fig. 72
The Riverbank
Detail (see fig. 1)

Fig. 73
Two Trees on the South Bank, dated 1353
Ni Tsan, 1301–74
Hanging scroll; ink on paper
H. 22⅙ × W. 10⅝ in.
 (56 × 27 cm.)
The Art Museum, Princeton University
Anonymous Gift (75.35)

Fig. 74
The Garden of Green Waters
Ni Tsan, 1301–74
Hanging scroll; ink on paper
H. 35¾ × W. 13⅝ in. (90.8 × 34.6 cm.)
C. C. Wang family collection, New York

Fig. 75
River Pavilion and Distant Mountains, dated 1368
Ni Tsan, 1301–74
Hanging scroll; ink on paper
H. 32¼ × W. 13⅛ in. (81.9 × 33.3 cm.)
C. C. Wang family collection, New York

Fig. 76
River Pavilion and Distant Mountains
Detail

Fig. 77
Woods and Valleys of Mount Yü, dated 1372
Ni Tsan, 1301–74
Hanging scroll; ink on paper
H. 37⅛ × W. 14⅛ in. (94.3 × 35.9 cm.)
The Metropolitan Museum of Art
Gift of The Dillon Fund, 1973 (1973.120.8)

Fig. 78
Pine Pavilion, Mountain Scenery, dated 1372
Ni Tsan, 1301–74
Hanging scroll; ink on paper
H. 40 × W. 17¼ in. (101.6 × 43.8 cm.)
C. C. Wang family collection, New York

Fig. 79
The Romantic Spirit of the Eastern Chin, dated 1360
Fang Ts'ung-i, ca. 1301–after 1378
Handscroll; ink and color on paper
H. 10 × L. 52½ in. (25.4 × 133.3 cm.)
C. C. Wang family collection, New York

Fig. 80
The Romantic Spirit of the Eastern Chin
Detail

Fig. 81
Cloud Mountains, ca. 1365
Fang Ts'ung-i, ca. 1301–after 1378
Handscroll; ink and color on paper
H. 10⅝ × L. 56⅞ in. (27 × 144.5 cm.)
The Metropolitan Museum of Art
Purchase, Gift of J. Pierpont Morgan, by exchange,
 1973 (1973.121.4)

Foreword

Confucius once said, "Being fond of something is better than knowing it, but taking delight in something is better than being fond of it." I have brought together many paintings from the T'ang period through the Ming and Ch'ing dynasties. I take delight in paintings. Since my childhood, they have been my abiding passion. For more than half a century, I have practiced painting, studied the works of old masters day and night, and collected paintings, not parting with them even in times of personal adversity. I enjoy my life simply by unrolling the scrolls or opening the albums of great masters.

I was lucky enough to be born into a family whose collection was handed down from generation to generation. Since my earliest days, I have been surrounded by poetry, books, calligraphy, and paintings. When I was fourteen years old, my widowed mother let me have Ku Lin-shih as my first painting teacher. Master Ku was the grandson of the renowned collector Ku Wen-pin, whose studio name, Kuo-yün-lou—"Studio of Passing Clouds"—suggests that his delight in owning and viewing great paintings is similar to the pleasure he experienced while watching beautiful drifting clouds. Master Ku's collection offered me my first opportunity to see important works by the illustrious painters Shen Chou, Wen Cheng-ming, Tung Ch'i-ch'ang, and the Four Wangs.

At first, my eyes saw only the beauty of landscape painting in the orthodox tradition. Gradually, as my own development as a painter progressed, my appreciation of the ancient masters increased, and I wished to learn more. At the age of nineteen, while continuing my studies at the Comparative Law School at Soochow University in Shanghai and teaching painting at the Shanghai Academy of Art, I became a pupil of Wu Hu-fan, known both for his scholarship and for the collection he had inherited from his grandfather Wu Ta-ch'eng. By comparing qualities of brushstroke technique, Master Wu Hu-fan traced the art of Tung Ch'i-ch'ang back to the great hermit painters of the Yüan dynasty. Impressed by their high achievement, I searched for paintings by these ancient masters. Opposite Mr. Wu's residence on Sung-shan Road was a shop called Chi-ku-chai, where I discovered many of their works, and, with my earnings as a teacher, I started to purchase whatever I could. I would discuss the paintings and attempt to authenticate them with two of my colleagues—Mr. Hsü Pang-ta, also a student of Master Wu's, and Mr. Chang Ts'ung-yü (Chang Heng), whose collection was known by his studio name, Yün-hui-chai. Mr. Chang was especially interested in the works of the Yüan masters. At the time, the prices of these works were quite reasonable, for others believed only what they were told, and did not trust what they could see. I obtained outstanding paintings by such artists as Ni Tsan and Wang Meng. Through Master Wu, I was able to make frequent visits to the collection of P'ang Yüan-chi, China's most celebrated collector. This rewarding experience allowed me to journey in spirit to the studios of the great Tung Yüan and Chü-jan.

While in Shanghai, I often heard comments from Mr. Liu Hai-su about the unique accomplishments of five innovative Western artists—Cézanne, Gauguin, Matisse, Picasso, and Van Gogh. As described by Mr. Liu, a "rebel" painter himself, the works sounded shocking to me. I was intrigued and decided to travel in the hope of seeing the original paintings by these great masters and expanding my knowledge of art. I spent some months in Japan in 1947, viewing both private and public collections, and then came to the

United States, where I spent a year visiting various museums and studying their treasures. I returned to Shanghai with vastly changed concepts about painting. I was able to understand more fully the ideas and works of the individualist artists outside the orthodox tradition, particularly the paintings of Shih K'o, Liang K'ai, Chu Ta, and Tao-chi. In 1948 I left mainland China to live in Hong Kong. During this period, many collections were being dispersed and I had the opportunity to view outstanding works and to purchase some of them. At this point, I based my selections on my own judgment.

Along with my study, training, and travel, two events significantly influenced my development both as an artist and as a connoisseur. In 1935, when the imperial collections of the National Palace Museum were moved from Peking to Shanghai, I was privileged to assist in cataloguing these great works of art, and in 1936 I worked with Victoria Contag, a young German scholar, compiling the seals of Ming and Ch'ing painters and collectors for scholarly reference to support authentication. Of course, an examination of seals is essential to the validation of a painting, but alone it is not sufficient. If authentication is based simply on the seals of an artist or a collector or on the quality or age of the silk or paper or on the inscriptions and colophons of later admirers, the attribution cannot be secure. One cannot be certain if a work is genuine or merely a clever imitation by a skillful forger. One must scrutinize the work itself and attempt to understand the artist's characteristic composition and brushstroke technique. It is the brushstroke that is the key to the artist's identity. Finally, it is the painting itself that is the painter's identity.

To talk about the brushstroke technique of an artist is to risk sounding inscrutable, but it is a necessary risk. It is difficult to explain the difference between an utterly casual stroke faultlessly executed, a mark of perfect control, and a stroke made in imitation of a master's hand which, after intense scrutiny, reveals itself as flashy or crude. The ability to differentiate between the two comes from years of careful observation and thoughtful study, or, more important, from years of practicing painting.

An artist's individual brushstroke technique may be compared to the voice of a singer. The voice itself, a gift bestowed by nature, requires training, but its timbre, range, and tonal color are uniquely its own. When we look at the great works of the Northern Sung masters, with their majestic compositions, delicate nuances of color and ink, and distinctive brushstroke techniques, we are reminded of the glories of grand opera, with its impassioned music, its dramatic libretto, and the magnificent performances of the principal singers. The Yüan masters placed a greater emphasis upon brushwork and simplified the other elements of painting. Yüan painting can be compared to Japanese Noh drama, which stresses singing and simplicity of movement.

Although Ming dynasty masters attempted to revive the operatic settings and performances of the Northern Sung, the splendor of the Sung was beyond their reach. Tung Ch'i-ch'ang and other artists praised the superb technique of such painters as Tung Yüan and Chü-jan, but these literati painters were often more innovative in their compositions. In emphasizing brushstroke technique, however, Tung Ch'i-ch'ang opened the way for the later, individualist painters, who can be appreciated as operatic singers performing in solo recital.

The pleasure afforded me by the paintings I have collected goes beyond personal gratification. In China, the imperial collections and those of noted collectors are not readily accessible to the general public. Unless one is a close friend of a private collector, the doors to his holdings remain securely locked. I am pleased to think that among the paintings I selected long ago for my own delight, some of those now on view in various museums may offer the same enjoyment to the public. It is for this reason that many of the works discussed in this volume by Professor Richard M. Barnhart are in museum collections. As Dr. Paul Singer once said, "We collectors are simply temporary caretakers."

In certain instances, I find myself in disagreement with Professor Barnhart's attributions. He graciously offered me the opportunity to make short comments of my own, which follow at the end of the text (see Appendix 2).

Many individuals have made significant contributions to the creation of this catalogue, and all of them deserve my gratitude. My friend Richard Barnhart, Professor of the History of Art, Yale University, merits a special note of thanks. His sensitive appreciation of the paintings discussed in this book is all a collector could wish for. For their unstinting enthusiasm and assistance, I am grateful to Douglas Dillon, Chairman of the Board, the Metropolitan Museum of Art, and to Wen Fong, the Museum's Special Consultant for Far Eastern Affairs. I should like to make particular mention of Alfreda Murck of the Museum's Department of Far Eastern Art, who performed countless tasks in the preparation of this catalogue and gave tirelessly of her time and expertise.

<div align="right">

C. C. Wang

</div>

寶武堂藏畫序

　　夫子曰：﹁知之者不如好之者，好之者不如樂之者。﹂寶武堂庋藏唐、五代以來絹楮丹青，余蓋樂諸繢事者也夫。

　　余生無他好，自幼弄筆，骎老彌勤。與大師手澤摩娑朝夕，雖患難未嘗輟離。益智頤神，使余欣然而樂，怡焉以安，但得之舒卷展册間爾。

　　季遷蒐求名迹，不同於好事聚積敵富也。往者：皇臺石渠珍秘無論矣。巨室朱門之豪藏，輕易不眎人。民戶或有世傳，又慮攖懷璧皋禍，相率閟弗宣揚。是以不接貴游，非親故交，輒莫繇瞻仰法書寶繢也。

　　余幸生於簪纓之第，承先人遺澤，耳目濡染，則詩文書畫而已。年十四，願爲畫人。寡母許以長洲顧鶴逸（麟士）師爲啓蒙。師之祖子山（文彬）公，撰﹁過雲樓書畫記﹂喩所娛樂，直烟雲過岑樓前耳。鶴逸先生尊沈、文、董、四王、吳、惲法軌。余初於正統派畫外，不他顧也。

　　雖然，余漸感不足於所見，因習畫當廣拓知聞，遍識鉅迹也。十九歲，讀律滬濱東吳法學院，因得游吳夫子湖颿（萬）之門，夫子襲祖悫齋（大澂）公寶藏，聲名遐播，論華亭溯研元季隱逸。小子拳拳服膺，悟其藝躋乎道矣。吳寄嵩山路，對宇有集古齋鬻古畫。余時授畫課，有所入，輒投諸集古齋。與同門徐邦達辨畫眞僞，辯論上下，究察豪厘。韞輝齋主人張葱玉（珩），亦稱莫逆，是共余購求元賢劇制者。他人信耳不信目，元畫價不過昂，余廼收雲林，山樵諸合作。侍湖颿先生，於是得出入龐氏萊臣（元濟）之虛齋，遍攬究竟，目光如炬，而神游董源巨然几案間矣。

　　余留婁江日，劉海粟倡藝術革命以叛徒自命，盛稱歐西塞尙‧哥庚‧梵谷聲藝烜赫，復侈譚當代馬帝司與畢加索爲剏作巨擘；聞者以爲異論，余則立意浮海廓我見解焉。公元一九四七年，余游日本，訪博物院，瀏覽公私所藏中外名畫，繼至美利堅合衆國，亦遍觀博物院館陳展寶繢，如是者一年。返滬後，觀念遂變：稍稍於傑焉自樹之畫人剏作，加以研賞，石恪、梁楷、朱耷、道濟之筆墨意匠，漸獲我心，視野如岸斷江闊，浩瀚當前，揚帆竸遠！偶語同道，論中國鑒藏家與日本、歐、美蒐藏家好、惡、取、舍所以然之故，徐、張諸子，輒首肯焉。

　　一九四八年移居香港。時故家舊藏，多出世所守易斗升，則多得未曾見之佳品鉅制也。先是，故宮博物院古文物南遷，余曾審查顧問助編選品送英倫中華藝展圖目。又得與德國人孔達女史合撰明清畫家印鑑（附宋、元、明、淸收藏家印鑑）供鑒賞家參攷。此亦影響余研討檢藏之兩事也。

　　憑印鑑以別畫之眞僞，備參攷之一端而已。吾儕當據畫，究攷畫家筆墨造詣與經營位置及傅彩之特徵，以論得失。惟辨筆墨，能別精微。究竟，畫固人之徵也。若徒察畫人印迹，收藏家圖記，絹楮質地色澤，乃至於後人題跋載記，終難碻證當前畫件爲眞迹，抑似是實非之妙手摹品也。

　　論畫人某家筆墨精微，似踏深履薄，未可憑測，然必探索以識之。上乘妙詣，韻致天成之筆，別於刻結粗濫之迹，誠難辯喩於不知者之前。積歲揣探，多看名畫，明辨審問，久必知悉。若自執筆，習學臨摹，尤多助益。

畫家筆墨，譬如歌者之聲音。聲喉固天賦也，名歌者亦勤習練，以竟其成就。然個別之音色，發聲之度量，是辨識之特徵也。觀夫北宋大家畫，若坐享名歌劇之纍演，音樂、劇本故事、歌詞，俱第一流，更得名歌者以天賦歌喉演唱，嘆觀聽之極矣。北宋名畫之造境，經營、傅彩、上乘也，名家勾勒皴染之筆墨韵致，則各各不同，獨有所成。觀元賢畫，譬若觀日本“能”劇，重在唱做上象徵之表演，不拘泥形象上之逼真。所謂超乎象外，得之環中。

　　明季畫家，欲更復北宋堂廡，而才學俱不勝任矣。董其昌盛贊董源、巨然及元諸賢筆精墨妙，而未嘗重視於結構經營侖奐之美。雖然，標舉筆墨爲繢事要義，董氏爲嗣后闢新天地，特立獨行畫人，各有千秋。

　　余自香港而日本而歐美，買畫惟自主張。擇尤而收，知機緣之不再，時變賣所有以買畫，或以舊所蓄畫與人交易，賓主各足所求。

　　友人辛爾博士嘗曰：「我輩鑒藏家，輒文物之暫時守護者耳」此顧氏過眼雲霞意也，物聚固無不復散者。是以近年來，博物院主管，好古敏求而商購敝藏，余意亦樂於供諸衆，以見余昔所以自娛者。若干目原蹟，已屬歐、美各博物院館矣。

　　班宗華教授茲編列錄寶武堂所藏，淵博精湛。余至佩服，間有不盡同意處，承許略申己見，附驥篇末，備讀者垂察，幸甚幸甚。

　　本編幸得狄倫董事長及東方部特聘顧問方聞教授之鼓勵與策助，始克付刊。院內執事同仁，對所收敝舊藏，愛惜護持，依時陳展，公諸同好，謹並誌謝之忱。

<div align="right">震澤王季遷識</div>

Preface

From the tenth century to the end of the Manchu Ch'ing dynasty early in this century, the dominant concern of the Chinese painter has been the natural world of landscape, trees and rocks, birds and animals, flowers, and bamboo—"the myriad phenomena occasioned by consciousness," in the words of the eleventh-century art historian Kuo Jo-hsü. The older figure and narrative traditions remained vital for a time, during the period of the Sung (960–1279) and Yüan (1279–1368) dynasties, then rapidly declined, becoming the concern only of journeymen artisans and court chroniclers.

It is this watershed of Chinese art from the tenth through the fourteenth centuries, when the new art of landscape painting and bird and flower painting was born and the ancient traditions had their final flowering, that provides the historical context for this book. No attempt has been made, however, to provide a full historical background for the works discussed. A selection of some of the finest Sung and Yüan paintings from the collection of Wang Chi-ch'ien provides the only focus. These works have been grouped by subject matter and period, described and analyzed, and allowed to form their own network of relationships. Inevitably, there are imbalances and gaps. It is remarkable, nonetheless, that so complete a survey of Sung and Yüan painting can be written based on the collection of one connoisseur-collector. Few great museums outside of China could offer so rich and complete a selection. With the exceptions of figures 4, 9, 12, 24, 34, 42, and 71, all the paintings reproduced in this book are or have been in the C. C. Wang family collection.

Like those of his most distinguished predecessors in China, whose great collections his alone recalls, Mr. Wang's collection of Chinese painting has had an organic life. While much of it remains in his hands, many of the paintings are now housed in the museums of New York, Cleveland, and Princeton. One of the purposes of this book is to lend the collection a sense of historical permanence. Mr. Wang will publish a more thorough catalogue in Chinese one day, and it will provide a necessary counterpart to this volume, which does not dwell at length on questions of documentation.

I first saw parts of the Wang collection as a graduate student at Princeton University in the mid-1960s and have been studying it ever since. The opportunity, extending over many years, to learn from one of the most eminent collectors of our time and to study his extraordinary collection I count among the most valuable experiences of my life. It seems increasingly unlikely that such a collection, and such a collector, will ever be seen again. To Wang Chi-ch'ien, my gratitude for allowing me to write this book.

There are others whose help I would like to acknowledge. Joan S. Ohrstrom, my editor, has done what seemed to me the impossible by fashioning the manuscript into a book. Whatever clarity and order it possesses owes to her, and to the Editorial Department of the Metropolitan Museum of Art. I am indebted also to Rosanne Wasserman, who did the initial reading of the manuscript. Alfreda Murck, Assistant Curator–Administrator of the Department of Far Eastern Art at the Metropolitan, offered many helpful suggestions and has played a major role in editorial preparation. Wen Fong, as always, has been a constant support, a stimulating guide, and a provocative critic. Again and again I have drawn upon his scholarship and that of Professor James Cahill of the University of California, Berkeley. To these friends and colleagues, I express my thanks.

R. M. B.

ALONG THE BORDER OF HEAVEN

1

The Idea of Eternity

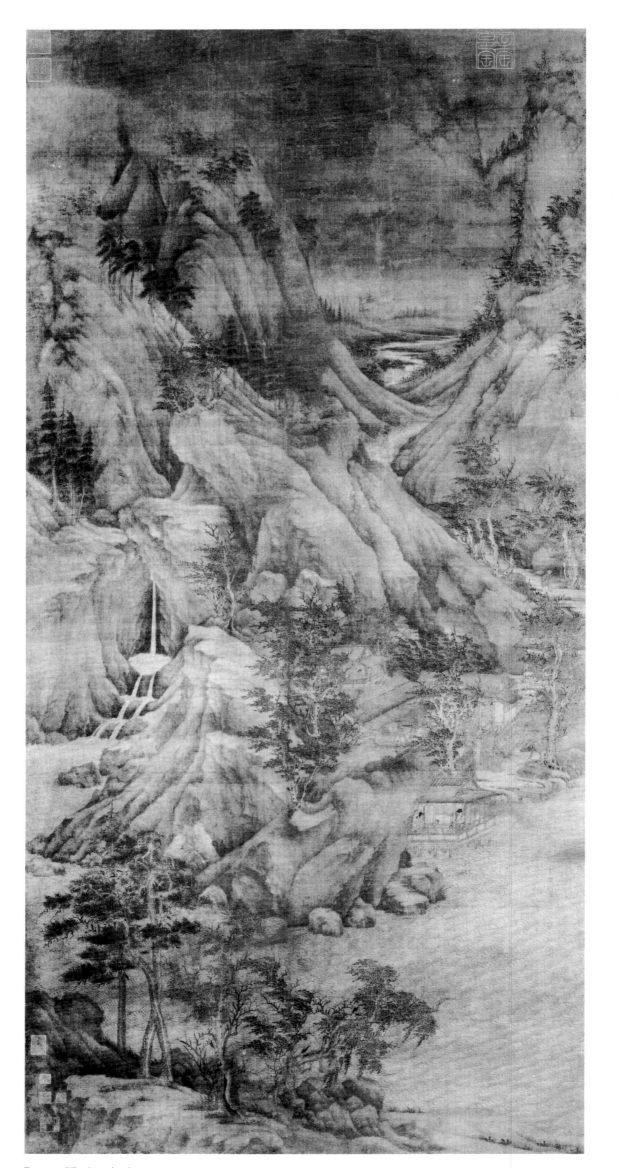

Fig. 1. *The Riverbank*
Attributed to Tung Yüan, died 962
Hanging scroll; ink and slight color on silk
C. C. Wang family collection, New York

Landscape Paintings of the Five Dynasties (907–60)
and
Northern Sung (960–1127) Periods

Quite properly the artistic entity described as Sung landscape painting stands high among the major artistic achievements of the world. Perhaps in no other time or place has man's response to his environment been so attractively or sensitively recorded in visual form; certainly never before or since the Sung period did Chinese painters so nearly achieve a perfect balance between objective reality and subjective response. The images Sung landscape masters fashioned are timeless: nothing in them is so concretely descriptive as to hinder their universality. Underlying the art is a history of man's speculation on his place in the universe, his relationship to all things, and the nature of creation and existence—a history rich, diverse, and profound which was subsumed within the structure of the art of landscape painting itself. To single out a particular attitude or historical circumstance especially significant to the understanding of Sung landscape is necessarily to oversimplify; yet one state of mind seems indispensable to an awareness of the deepest meanings of the art. It is a consciousness ubiquitous in Chinese poetry, philosophy, and art, and never more succinctly stated than by the poet Tu Fu (712–70), who wrote as T'ang China was being torn apart by the An Lu-shan rebellion: "The nation is destroyed; the mountains and rivers remain." The mountains and rivers had always been there, they were there still, they would always remain. Li Po (701–62) wrote a poem of farewell to Meng Hao-jan stating in another way this contrast between ephemeral human life and eternal nature:

> My friend bade farewell at the Yellow Crane House,
> And went down eastward to Willow Valley
> Amid the flowers and mists of March.
> The lonely sail in the distance
> Vanished at last beyond the blue sky.
> And I could see only the river
> Flowing along the border of heaven.

As the sail of the traveler disappears into the horizon, there remains only the water—a pond that briefly rippled and then was still.

After Meng Hao-jan died, the poet Wang Wei (699?–761?), who was also a painter, remembered him:

> I can never see my old friend again—
> The river Han still streams to the east
> I might question some old man of his place—
> River and hills—empty is Tsaichou.

The hills and rivers, changeless settings for brief lives, were conceived then as embodiments of ultimate intelligence and virtue. In the words of the classic Confucian text *Chung yung*, or "Doctrine of the Mean," "Nature is vast, deep, high, intelligent, infinite and eternal."

One could, of course, paint landscape simply because it was beautiful, and no doubt some artists did. Often enough, however, the painters themselves make clear a deeper intent. Wang Wei was reputedly among the first great painters of landscape, and his poetic imagination cannot be separated from his painter's mind. The idea of nature is the idea of eternity, order, and structure; the embodiment of virtue and morality; and a constant reminder of the Tao of existence.

The Riverbank

"Landscapes are big things," wrote the master Sung landscapist Kuo Hsi (ca. 1020–90) about 1075, referring both to the actual landscape and to paintings of it. He preferred to paint on great walls or on groups of large hanging scrolls, and a number of surviving landscapes of the tenth and early eleventh centuries confirm his testimony that the early landscape masters often conceived their visions of the natural world on a vast scale. *The Riverbank* (fig. 1), measuring over seven feet high, is the tallest of all extant early Chinese landscape paintings, surpassing in that respect even the powerful *Travelers by Streams and Mountains* (ca. 1000; National Palace Museum, Taipei) by Fan K'uan (active ca. 990–1030), and rivaling it in grandeur of conception. Like the few other paintings plausibly attributed to the period of the tenth to early eleventh centuries—the formative years in the history of landscape painting in China—the scroll is darkened with age and the silk badly damaged. Recent remounting and repair have restored some of *The Riverbank*'s original presence, but the painting is today the battered wreck of a majestic artistic vision.

The scroll is formed of two long pieces of silk now joined down the center, as are most paintings of comparable date. Originally the two panels may have been differently mounted, perhaps as a two-panel screen or even as part of a set of four or more panels. In any case, there is reason to believe that in the fourteenth century the two panels were separated.

In the lower-left corner is a partially effaced signature: "Painted by Assistant Administrator of the Rear Park, Servant Tung Yüan" (see Appendix 1). Tung Yüan, later regarded as the patriarch of the southern school of landscape painting and one of the three greatest landscape masters of the Sung period, died obscurely in 962. Knowledge of his life was barely preserved in written records, and his art attracted little interest outside the provincial Southern T'ang kingdom of Nanking, which was not absorbed into the new Sung dynasty until thirteen years later, in 975. Toward the end of the eleventh century, as more and more southerners contributed to the cultural life of the country and interest in the distinctive southern heritage grew, a few scholars of the arts began to resurrect Tung Yüan's art and name, precipitating the painter's gradual rise to eminence. By this time, however, most of his work had been lost, and in the succeeding centuries a confusing and diverse corpus of works has been associated with his name. While there is no way to confirm or to deny the authenticity of the signature, *The Riverbank* gives every indication of being a tenth-century painting, and its importance to the history of Chinese landscape painting can scarcely be overstated (see Appendix 2).

Dominating the composition is a massive mountain formation that rises from right to left until the far peaks vanish into the distant sky. Where they are lost to sight, a shimmering, pale rivulet is seen wending its way down; it plunges into the mountain at the left and emerges below in the sharp lines of a waterfall, which splashes into the river flowing through the foreground (fig. 2). This interaction of mountains and water is the very essence of *shanshui* ("mountains and water"), the Chinese concept of landscape. In Chinese art, mountains do not exist without water: "The wise find pleasure in the waters, the virtuous find pleasure in mountains," wrote Confucius, a little enigmatically but certainly suggesting something fundamental to his concept of ideal existence. There is a wholeness in the cycle of

Fig. 2. *The Riverbank*
Detail

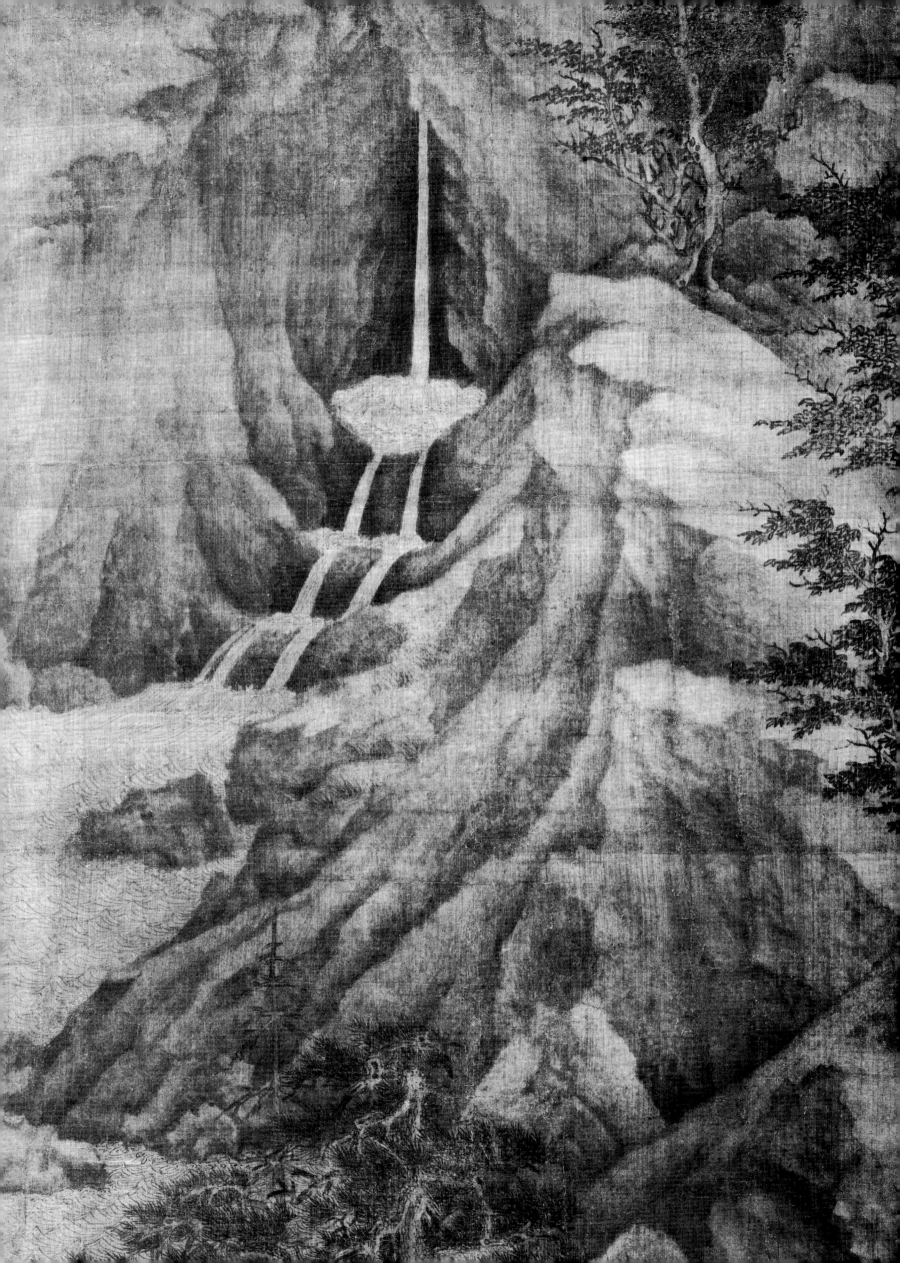

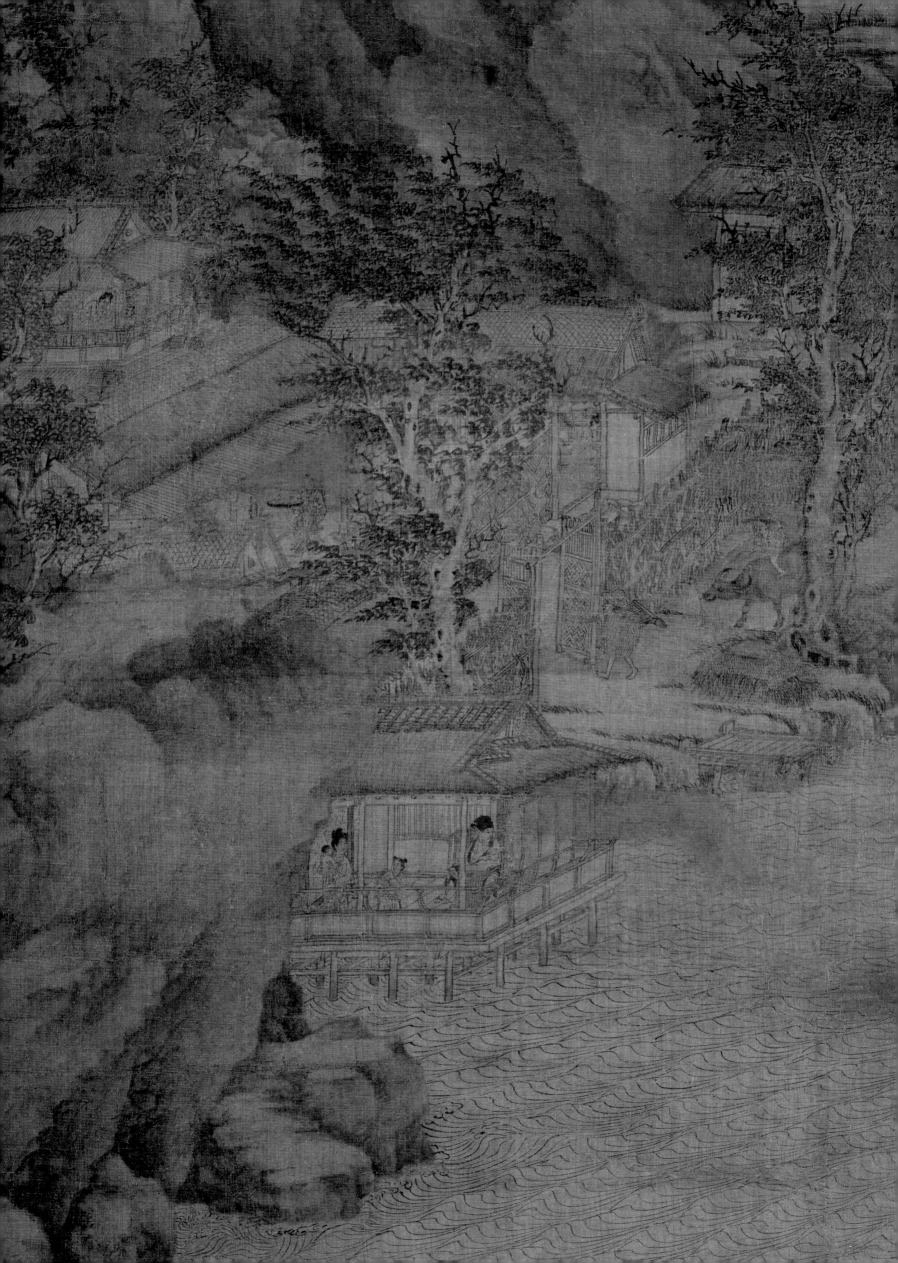

creation, life, and growth reflected in the eternal struggle of mountains and water: the mountains rise into the sky, water falls from the sky, washing over the mountain, moving it, rebuilding it. On one level of interpretation this incessant symbiotic relationship is the subject of *The Riverbank*, as it is of most Northern Sung landscape paintings. Translated into a formal mode, the water is openness—moving space that joins the sky to establish the only counterbalance to the solid mass of rock and mountain. As one studies *The Riverbank* and observes the movements within its structure, one becomes aware of continuous interaction, of interpenetration, and finally of the inextricable union of earth and water, the two primal elements. Growing from their union are the trees, grasses, flowers, and shrubs of the landscape; tall pines in the high distant mountains; gnarled, windswept deciduous species joining the pines in the foreground; dark bamboo in the sheltered valleys. With the trees our scale narrows, our focus on the dimension of life sharpens as we draw away from the cosmic vastness of mountains and water toward the relative vulnerability of trees, which are born, grow, flourish, decay, and die, as do all the living things of earth. We are thus brought to the final elements of the landscape, its human inhabitants.

There are thirteen figures in the painting, although it requires some searching to find them all. Ten of them are associated with the extensive villa set into the mountains along the riverbank in the center foreground (fig. 3). Two young boys, one astride a water buffalo, approach the side gate. Inside, at the right, a woman works in a kitchen, while another woman carries a tray across the courtyard. Above them, in a second-story room set back among the trees, is a third woman with a child. The main occupants of the household appear to be the group assembled in the pavilion-type wing extending out on wooden piles over the water. A scholar, leaning casually on the balustrade, looks out across the river; behind him stand a young boy and a woman holding a baby. Three travelers can also be seen walking along the pathway through the mountains.

The architectural design of the villa is an adaptation of the classical two-court structure; the public front gate is at the far end—just at the foot of the mountain path winding down from the hills—and inside it are the outer courtyard and kitchen-utility wing. Nearer to us is the private family court and the barely visible rooftop of a wing parallel to the kitchen. Adapting the basic design to its specific setting between the base of the mountains and the edge of the river are a two-story hideaway set back and up into the mountains and a verandalike construction extending out over the water—all in all, the perfect mountain retreat for a scholar, his family, and his servants.

Paintings of "lofty scholars" in remote settings were popular in Nanking in the tenth century, although they were associated less with Tung Yüan than with his compatriot Wei Hsien (active ca. 965). A painting by Wei in the Peking Palace Museum, depicting the Han dynasty scholar Liang Po-luan and his wife, the poet Meng Kuang, in an idealized setting, provides an interesting parallel to *The Riverbank* in both composition and subject matter. Stylistically, however, the painting most intimately related to *The Riverbank* is Chao Kan's handscroll *Along the River During Winter's First Snow* (fig. 4), one of the few other authentic mid-tenth-century paintings attributable to a Nanking master.

Chao Kan (active ca. 970) was a student in the painting academy of the Southern T'ang kingdom of which Tung Yüan was the leading landscape master; one would therefore not be surprised to find a close correspondence in the works of the two men. Even so, allowing for the obvious physical differences between the paintings—small handscroll in color versus large hanging scroll in ink—one can only be struck by the intimacy of their stylistic relationship. There are no contour lines in the rock, earth, or mountain forms of either painting, for example—a striking coincidence that marks the difference between northern and southern landscape styles in the tenth and early eleventh centuries. All surviving northern landscapes of the time employ sharp, strong brush contours in rock and mountain representation. In both of these southern paintings only a soft ink wash is used, without direct line, creating a

Fig. 3. *The Riverbank*
Detail

Fig. 4. *Along the River During Winter's First Snow*
Chao Kan, active ca. 970
Detail
Handscroll; color on silk
National Palace Museum, Taipei, Taiwan, Republic of China

subtly tonal and evocative effect overall, especially appropriate to the suggestion of smooth, rounded earthen surfaces of the kind common to south-central China. Other similarities between the two works are seen in the techniques used to portray trees, bamboo, and shrubs, and in the undulating netlike pattern of waves. On the evidence of style, there can be no question of the relationship between Chao Kan and the painter of *The Riverbank*.

Over a decade ago I noted a similar affinity between Chao Kan's handscroll and another landscape attributed to Tung Yüan, the great *Wintry Groves and Layered Banks* (Kurokawa Institute for Studies of Ancient Cultures, Hyogo, Japan). Curiously, the latter is the most advanced and powerfully painted of all Tung Yüan attributions, quite different in its bold, broken brushwork and blunt power from the measured, delicate, and precise *Riverbank*. The most plausible solution to this riddle was suggested in 1968 by Professor Max Loehr of Harvard University. If both *The Riverbank* and *Wintry Groves* are the creations of Tung Yüan, then the former must be an early work, perhaps dating from the 930s, and the latter a product of two or three decades later, near the end of the artist's life. When only fragments of an artistic lifetime remain, this conclusion seems to be the most reasonable one we can draw. Chao Kan, faithful student and follower, presumably continued to paint in a style close to his master's earlier manner, as disciples frequently do, while also reflecting certain elements from Tung's more advanced stage.

One additional painting may be introduced into this context, because it is attributed to the most important follower of Tung Yüan, the Buddhist priest Chü-jan (active ca. 960–80). *Buddhist Retreat by Stream and Mountains* (fig. 5), in the Cleveland Museum of Art, bears a notation indicating that it is the fifth of a set of six matched hanging scroll panels; it should therefore be regarded as compositionally fragmentary. In a way, it corresponds to the left half of *The Riverbank* as a section in a continuous sequence. Chü-jan, we know, was especially fond of large-scale landscape compositions; the Northern Sung imperial collection contained six sets of six-fold panels and four sets of four-fold panels by him.

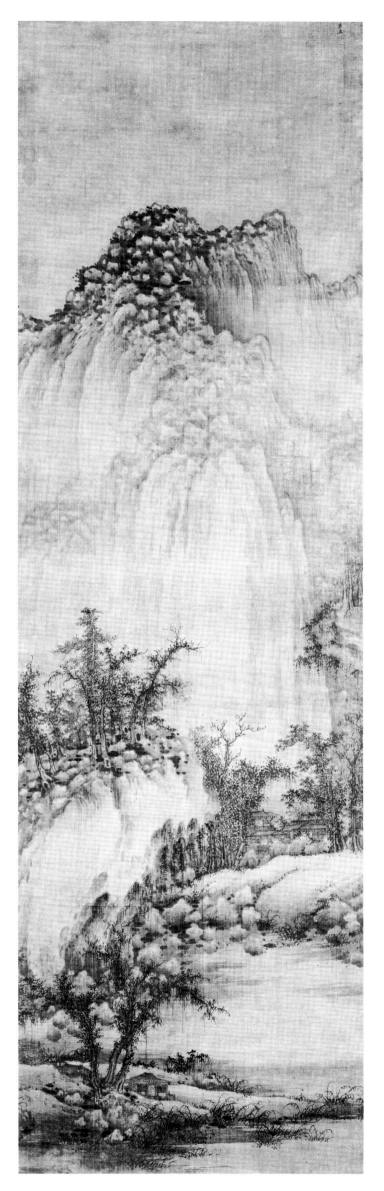

Fig. 5. *Buddhist Retreat by Stream and Mountains*
Attributed to Chü-jan, active ca. 960–80
Hanging scroll; ink on silk
The Cleveland Museum of Art

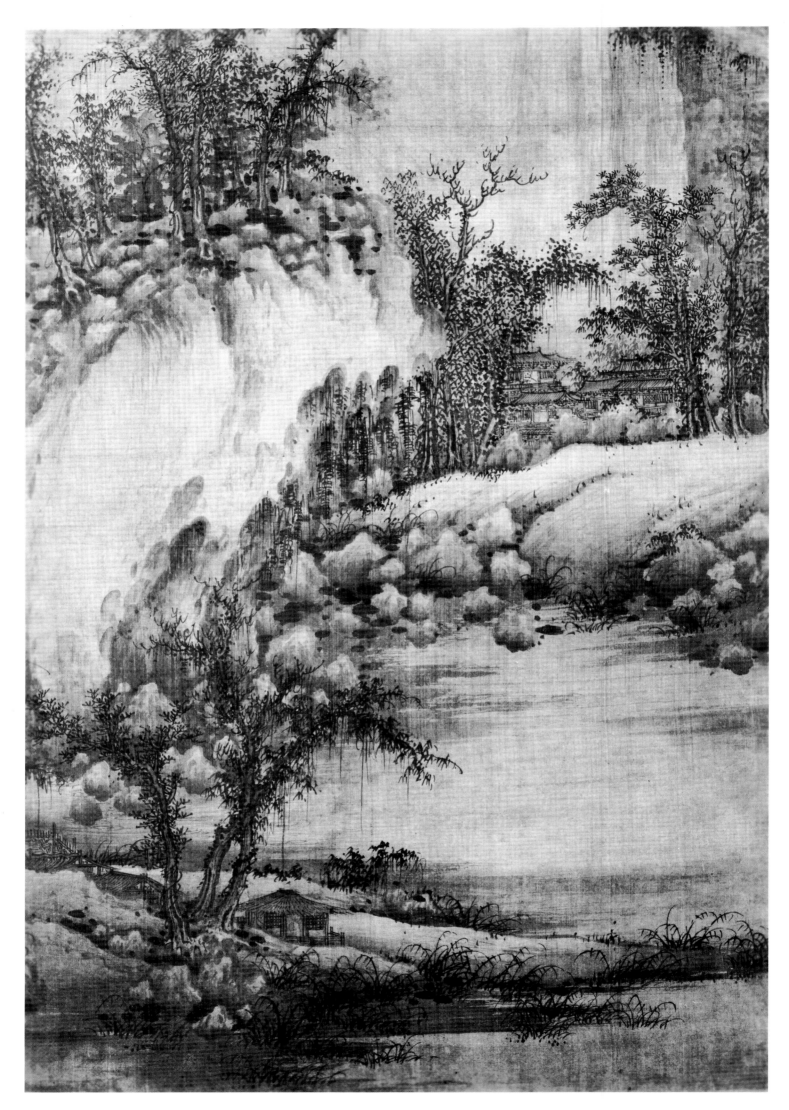

Fig. 6. *Buddhist Retreat by Stream and Mountains*
Detail

The Cleveland painting is probably the sole surviving remnant of one of those sets of six. Coincidentally, all three of the finest and most important attributions to Chü-jan—the Cleveland scroll and two works now in the National Palace Museum, Taipei, *Serried Cliffs and Forests* and *Hsiao I's Theft of the Lan-t'ing Manuscript*—give evidence of being single remnants of larger sets, since each is a narrow, individual strip of silk. Recalling that each half of *The Riverbank* measures 21⅝ inches (55 cm.) in width, it is interesting to observe that the three Chü-jan scrolls measure 21⅞, 23½, and 22⅝ inches (55.4, 59.6, 57.5 cm.), respectively. Presumably 23 inches was roughly the common width of silk rolls used in tenth-century Nanking, as it was through the Sung period in general. The two Taipei scrolls also happen to be exactly the same height, 56¾ inches (144.1 cm.), while the Cleveland composition is 73 inches (185.4 cm.) high, indicating that the original six-fold Cleveland set would have measured over 11 feet wide by 6 feet high, a monumental size that we can no longer see directly in early Sung landscape painting.

The brushwork and ink in *Buddhist Retreat* are far more vigorously employed than in *The Riverbank*, with even a hint of real virtuosity in the liquid energy of tree trunks and foliage and in the dark dots applied so forcefully here and there (fig. 6). In its relationship to other, earlier works by Chü-jan and Tung Yüan, this technique, the most advanced associated with Chü-jan, appears to correspond chronologically to that of Tung Yüan's *Wintry Groves*. *Buddhist Retreat* was probably painted late in Chü-jan's lifetime, sometime after his move to the north in 975. In all of these works, however, there are a basic simplicity and cleanness of conception and a fine-scaled and meticulous sense of tonal harmony that unifies form and space into an easy, convincing relationship. We become aware of the logical movement of the eye from foreground through middle distance to the far mountains and of the spacious openings that draw us through and in. Even the densest, most richly detailed Sung landscapes possess this lucidity and harmoniousness of space.

An important peripheral aspect of Sung landscape painting that remains to be adequately explored is documentation, particularly through the collectors' and connoisseurs' seals found on the painting surface. There has been an unfortunate tendency, especially on the part of Western art historians, to disregard these factors in favor of purely stylistic judgments. Style, it is true, indicates that *The Riverbank* and *Buddhist Retreat* are tenth- or eleventh-century paintings, but the seals on both pictures support that conclusion and the information they provide about ownership and transmission can be supported by textual sources.

In the lower-left and lower-right corners of *The Riverbank* are six early seals ranging in date from the mid-thirteenth century to the late fourteenth. The sequence begins with individual seals of two late Sung collectors, the notorious prime minister Chia Ssu-tao (died 1275) and the distinguished collector Chao Yü-ch'in, or Chao Lan-p'o (mid-thirteenth century), a member of the Sung imperial family. It continues with three seals of the Yüan painter-connoisseur K'o Chiu-ssu (1290–1343) and ends with the half-seal of the Ming government collection of the period about 1374–84. Recorded in the list of paintings in Chao Yü-ch'in's collection, compiled by the late thirteenth-century scholar Chou Mi, is "*The Riverbank*, by Tung Yüan," and in the collected works of Chao's relative, the painter Chao Meng-fu (1254–1322), is a poem called "For Tung Yüan's *Riverbank*." No clear record of the painting after it entered the Ming government collection has yet been found, and when it was acquired in this century by Chang Ta-ch'ien (born 1899), it no longer had a title. Chang studied the seals and old records, decided that the painting must be *The Riverbank* attributed to Tung Yüan in the texts referred to, and restored its name. There is every reason to accept his attribution, although it remains a hypothesis.

Buddhist Retreat by Stream and Mountains bears the same Ming government half-seal as *The Riverbank*, as well as the seals of four of the greatest collectors of later centuries—Liang Ch'ing-piao (1620–91), Keng Chao-chung (1640–86), An Ch'i (ca. 1683–after 1744), and the Ch'ien-lung emperor (reigned 1736–95)—and is recorded in detail in An Ch'i's catalogue

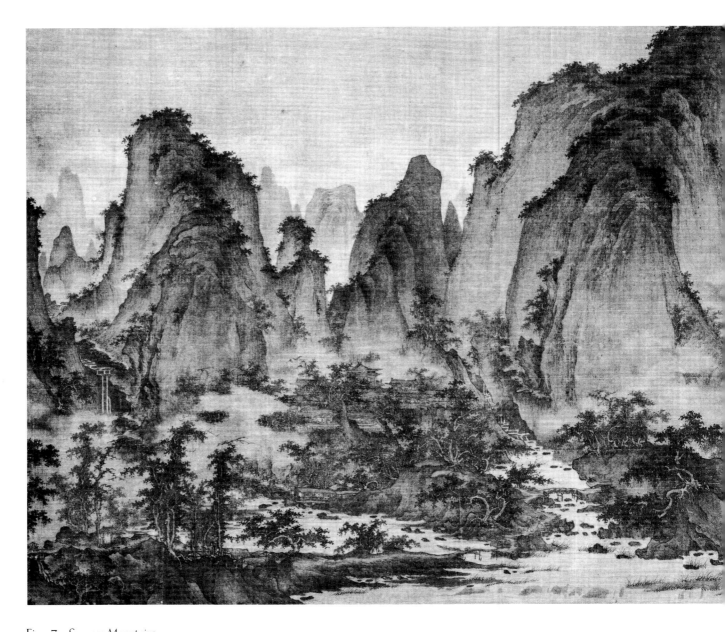

Fig. 7. *Summer Mountains*
Attributed to Ch'ü Ting, active ca. 1023–56
Handscroll; ink and color on silk
The Metropolitan Museum of Art

of 1742. This is an impressive record of provenance going back to the fourteenth century, but the most important document on *Buddhist Retreat* is an exceedingly rare seal reading *Shang-shu-sheng yin*, identified by Wai-kam Ho as a seal of a bureau of the Northern Sung government, probably applied to the painting in the period 1083–1126. The seal has been found on only one other painting in the United States, the exquisite Northern Sung hanging scroll attributed to Li Ch'eng (919–67) in the Nelson–Atkins Museum of Art, Kansas City. The Cleveland and Kansas City pictures thus constitute one of the most exclusive groups in Chinese art history, and we may observe once again that the style of *Buddhist Retreat* and its documentation are in complete agreement.

In the end, we may well want to ignore these details and simply observe and respond to the lucid, inviting space, the simplicity and magnificence of conception, and the visual embodiment of philosophical insight represented by both *The Riverbank* and *Buddhist Retreat by Stream and Mountains*.

Summer Mountains

Chiangnan, the south-central region of China, was in the mid-tenth century an isolated provincial area, cut off from the northern centers of Sung life by its stubborn refusal

古秀芸芳歲月
多鈐印題隷重沂
宣和印看與物
開生面渾是脆
地寬坐堂窊必滴
夏山帝暴雲欲
嘯晴峽漸怳波
高樓百尺軒而
故試一張欄快
多何
戊辰新正月
御筆

to submit to the new Sung imperial house until 975, fifteen years after the founding of the dynasty. By that time, Tung Yüan had been dead for thirteen years. The Chiangnan landscape style was carried to the north by Chü-jan, who accompanied his captive prince, Li Yü, to the Sung capital. There Chü-jan entered the K'ai-yüan Temple, effectively sealing himself and the art of Chiangnan into a general obscurity in northern China, which endured for a century. The landscape art of the Sung capital was overwhelmingly a northern art, dominated in content by the high, rugged, granitic mountains of the north and in style by a crisp, dramatic vision very different from the soft southern manner. The names of the great succession of northern landscape masters constitute a roster of artistic brilliance: Ching Hao, Kuan T'ung, Li Ch'eng, Fan K'uan, Yen Wen-kuei, Hsü Tao-ning, Kuo Hsi. These were the artists who formed the taste and vision of northern landscape, the creators of the works that even today stand most effectively for the monumental landscape art of the Northern Sung period.

Summer Mountains (fig. 7), in the Metropolitan Museum—one of the few landscape handscrolls remaining from this golden age of the art—is a fitting northern counterpart to the southern landscapes of Tung Yüan and Chü-jan.

The magic of a Sung landscape handscroll lies in its power to draw the eye and the mind of its viewer across a thousand miles in a single foot, to become the vehicle for a

unique journey through the hours of the day and the seasons. Each handscroll is a memorable artistic experience, like no other in its essence, but somewhat comparable in shared characteristics of structural form to a musical composition. The mood of a season or a time is like a dominant key—in the case of the Metropolitan's scroll, the rich density of summer. There is a rhythmical pattern of compositional development in the thickly massed conical and flat-topped hills—a pattern that steadily rises toward the major peak, then recedes and is strongly restated in reduced form at the left end of the painting. The major motif of the mountains is joined throughout the landscape by various minor motifs in the play of architectural elements, human figures, boats, and fishing nets; in the water of the foreground river and the streams and waterfalls that enliven the hills; and in the densely growing trees that subtly build in importance from right to left until they vie with the mountain itself. Mist circulates through the hills and valleys, creating a moist, warm atmosphere that emphasizes the crystallinity of the cliffs.

While large hanging scrolls function something like windows opening on distant spaces, handscrolls are miniature worlds, requiring of the viewer a mental reduction in scale, a shift in perspective that figuratively puts him inside the picture. Once this mental adjustment has been made, the figures, pathways, buildings, and groves become familiar points of reference establishing a network of continuity through the landscape, and the mountains, valleys, forests, and waters metamorphose into looming images of reality (fig. 8). To create this transformation, it is necessary only to take the first mental step into the world of the picture.

Sung landscape, whether the monumental *Riverbank* or the intimate *Summer Mountains*, is an art of natural illusion, but a form of illusion quite different from those common to European traditions. There is never a single light source, for example, nor is there a consistent application of anything like linear perspective, both of which have the effect of fixing a single viewpoint. Since one of the aims of the paintings is to encourage a mental shift *into* the landscape and then through it, a single fixed perspective would be inappropriate. Simply by avoiding these devices, which were not unknown in China, the Sung artist achieved the effect of constantly shifting perspective, just as one actually shifts viewpoint first by the physical act of unrolling the scroll, then by mentally joining the travelers and residents in moving through the world of the scroll.

A similar goal is achieved by using mostly tones of gray and black ink wash in painting landscape. There is, in fact, slight color in most Sung landscape, but it is subordinated to the tonalities of ink and has faded so much over the centuries that it is now sometimes barely visible. Monochrome is not specific in the way that rich color is, and yet does not suggest that there is no color in nature. The Sung painter does not paint what anyone can easily see. Rather, his concern is with an idealized image of nature, a universal, timeless, ordered structure that is only sensed. There is no dust, no dirt, no pain; only harmony, order, and an overriding concern for an abstract natural principle, the *li* of Confucianism, which holds that all things have an essential nature to which they are true no matter what specific attributes they may also possess. The Sung landscape painting is thus in a way a release from reality into a higher plain of perception, and each Sung landscape is a unique visualization of a philosophical system.

We are given a gift of natural illusion to grasp initially and with which to make our way until in our minds we have walked the shadowed pathways, paused at the wineshop, talked with the fishermen and woodcutters, heard the cry of the gibbons from the mountains, felt the mist and the wind, and, having ascended the steep cliffs, glimpsed the far blue mountains—rarely absent and always implied in Sung landscape—that are the final bridge to infinity. From our environment, we have proceeded through the familiar terrain of the painted landscape and beyond it to a concept of a perfect world and the rightness of all things in it. This is illusion of a most profound kind.

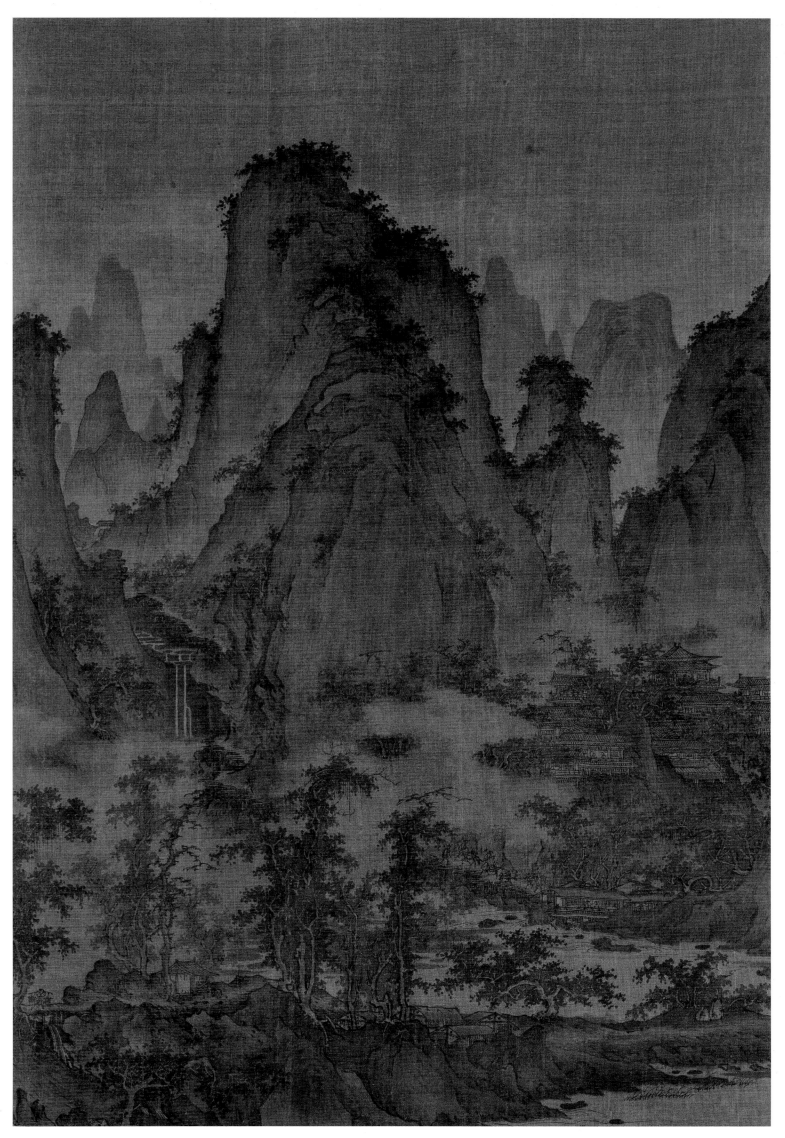

Fig. 8. *Summer Mountains*
Detail

Summer Mountains offers an excellent example of the contributions modern scholars have made toward the understanding of the history of Chinese art. For several centuries the scroll was catalogued in Chinese collections as the work of Yen Wen-kuei, a popular painter active about 1000 in the early Sung period. His style is characterized in early texts by a picturesque emphasis on detailed, lively architectural and genre elements within the landscape structure, seemingly similar to those in *Summer Mountains*. The painting is not signed, however, nor does it bear early colophons identifying the artist. There are moreover two extant works with the signature of Yen Wen-kuei, a handscroll in the Osaka Municipal Museum (Abe Collection) and a hanging scroll in the National Palace Museum, Taipei, both of them in my opinion genuine works of the early Sung period and presumably from the brush of Yen Wen-kuei. *Summer Mountains* clearly was not painted by the same master, even though it shows many affinities with both works. On this basis, one might have been content to classify *Summer Mountains* as the work of an unknown follower of Yen Wen-kuei, since Yen's popular style had many followers throughout the eleventh century.

In his study of *Summer Mountains*, however, Wen Fong discovered that a striking physical and documentary feature of the scroll is its preservation of a portion of its original Northern Sung mounting, one of the few such examples extant. The seals at the top and bottom of the thin strip of yellow silk bordering the painting at the left are those of the emperor Hui-tsung. Each seal was stamped in such a way that half appears on the silk border and half on the painting itself. Subsequent mounters were careful to preserve both silk and seals, since they prove that the scroll was mounted while it was in Hui-tsung's collection between 1101 and 1125.

In the catalogue of Hui-tsung's collection, the *Hsüan-ho hua-p'u*, are recorded the titles of 6,396 paintings by a total of 231 artists. Somewhere within that massive compilation one would assume that the Metropolitan's picture is listed, since it bears the seals and original mounting of the collection. Looking first for Yen Wen-kuei, because of the traditional attribution, one discovers that not only was Yen not included in the collection, he was specifically excluded from it on the grounds that he was artistically inferior. In reading through

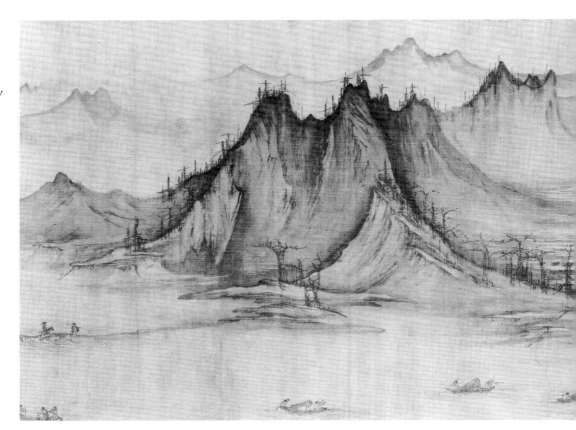

Fig. 9. *Fishing on a Mountain Stream*, ca. 1040s
Hsü Tao-ning, ca. 970–1051/52
Section of a handscroll; ink and color on silk
The Nelson–Atkins Museum of Art, Kansas City

the catalogue, however, one finds the name of the obscure painter Ch'ü Ting (active ca. 1023–56). Scarcely known today, this artist is discussed in the catalogue as a follower of Yen Wen-kuei. His biography reads as follows:

> Ch'ü Ting was a native of K'ai-feng-fu [i.e., the Northern Sung capital], a skillful landscape master, and painter-in-waiting in the academy of Emperor Jen-tsung [reigned 1023–56]. He studied Yen Wen-kuei in painting mountains and forests in the four seasons and the changing appearances of windblown landscapes. In his depictions of the melancholy expansiveness of mists and clouds, the iciness and crystallinity of streams and rocks, he showed much imagination and finesse. Although perhaps he did not attain the summit of excellence, when one looks at his contemporaries he is seen to surpass them by far.

Three paintings by Ch'ü Ting are listed in the collection, and each one is called *Summer Scene*. Since the style of *Summer Mountains* is precisely equivalent to Ch'ü Ting's active period and stylistic lineage and since in this one collection there were three works by him of the same subject, the scroll is now attributed to Ch'ü Ting (see Appendix 2).

One additional factor in testing this new attribution, which adds an important name and monument to the history of Sung painting, stems from the fact that Ch'ü Ting was the teacher of one of the greatest and most distinguished Sung landscape masters, Hsü Tao-ning (ca. 970–1051/52). Hsü's masterpiece, *Fishing on a Mountain Stream* (fig. 9)—a vision of swaying mountain peaks, deep mist-filled valleys, and plunging streams—possesses something akin to the rhythmic clarity and lucid beauty of a Mozart concerto. Almost breathtaking is its dashing technique—free, untrammeled strokes of ink and splashes of wash that, viewed from a single step back, metamorphose into the richest, deepest illusion of space in Chinese art. Only a genius or an alchemist could have achieved this conversion of ink into pure space.

Until *Summer Mountains* was recognized as probably the work of Hsü Tao-ning's teacher, it was not possible to trace Hsü's ancestry closely or to distinguish precisely his inno-

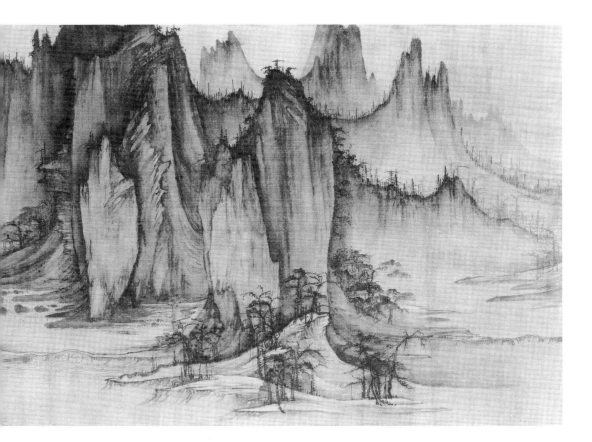

vations from his general artistic heritage. Now, by establishing the direct master-student relationship from Yen Wen-kuei to Ch'ü Ting to Hsü Tao-ning over a period of about fifty years, we are able to discern the gradual emergence of the illusion of real space, the growing mastery of the suggestion of atmosphere, the increasingly successful integration of forms, and the improvement and simplification of brush and ink techniques in quest of ever more effective illusion.

As a group, and in light of the judgments of history, these works will also reveal more about standards of quality in Northern Sung painting than any textual source. They will tell us why Ch'ü Ting receded for many centuries into the shadow of Yen Wen-kuei, and why, of the three, it was Hsü Tao-ning who won the greatest acclaim.

The passage of nine centuries has naturally invested all Northern Sung landscape paintings with the kind of unity distance lends. Although these works are indeed very different from each other, their similar characteristics have come to form the vision of Northern Sung landscape: a vast scale of geography and space, a common focus on a hierarchy of forms culminating always in the "host peak," a perfect balance between ideal structure and descriptive characteristics—something not achieved before the Sung and not repeated later—and an unchanging air of serenity and harmony among all things.

The Classic of Filial Piety and Cloudy Mountains

The last of the eighteen chapters of *The Classic of Filial Piety* speaks of the rites of mourning one's parents:

> The Master said, "When a filial son is mourning for a parent, he wails, but not with a prolonged sobbing; in the movements of ceremony he

Fig. 10. *The Classic of Filial Piety*, ca. 1085
 Li Kung-lin, ca. 1049–1106
 Illustration for Chapter 18: "On Mourning"
 Section of a handscroll; ink on silk
 The Art Museum, Princeton University

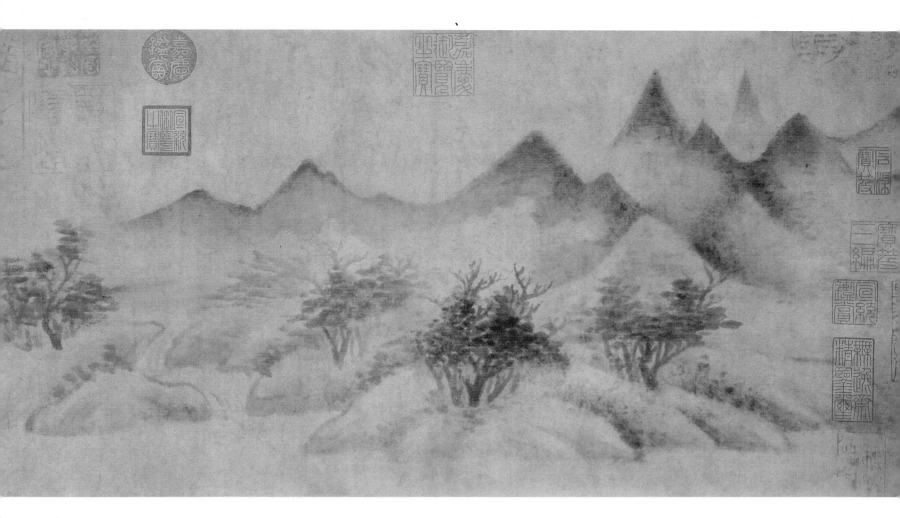

Fig. 11. *Cloudy Mountains*
Mi Yu-jen, 1074–1153
Handscroll; ink on paper
The Metropolitan Museum of Art

> pays no attention to his appearance; his words are without elegance of
> phrase; he cannot bear to wear fine clothes; when he hears music, he
> feels no delight; when he eats a delicacy, he is not conscious of its flavor:
> —such is the nature of grief and sorrow. . . . In spring and autumn [he]
> offer[s] sacrifices, thinking of the deceased as the seasons come round."

Li Kung-lin (ca. 1049–1106), the famed scholar-painter whose illustrations of this Confucian
classic are discussed below in the context of narrative painting, chose to illustrate the final
chapter with a landscape (fig. 10). Whether there was precedent for this choice is not
known, but a more obvious decision would have been to portray men engaged in the ritual
activities of mourning or in the expression of grief. Li's distinguished friend Su Shih, at
any rate, found himself in wonderment at the painter's idea:

> In illustrating the eighteenth chapter, which speaks of the unbearable
> sorrow of all children of man, Li Kung-lin lodged his thoughts in only
> the faintest indication of landscape. No one but the loftiest of men in
> full understanding of the Way of life could have done this.

Li's landscape is indeed the merest idea of natural forms, mountain and water, as if
a primitive reformulation of the ancient term for landscape. A few cliffs by a river, a lone
boat adrift. Shall we see the drifting boat as symbol of the aloneness felt upon the death of
a father? The sage writes that the mourning son ignores his appearance, speaks without ele-
gance, feels no delight in the beauty of music, tastes no flavor—and it seems that the painter
sought to achieve that state of mind. Here then is a painting of landscape not concerned
with vision in the usual sense, but with thoughts, with a state of mind hitherto considered

impossible to convey in art. By only suggesting with a few pale strokes of the brush and not defining form or meaning, the painter requires his viewer to complete the work by interpreting it in its context.

Why, in illustrating a text on mourning, did Li paint a mountain by a river? Why is no one visible in the boat on the river? Why does he use only pale ink and a few strokes of the brush? Why doesn't he define things? When these questions are asked, we understand that Li Kung-lin is involving his audience as something more than travelers passing through: he expects us to transform the painting into a mood, into emotion, to join it to its philosophical context, and to be moved by what we all know of human sadness, of loneliness, and of memory. No vision of the real world is involved, no representation of real forms.

This abbreviated, intellectualized mode of landscape painting found its fullest expression in the art of Mi Fu (1052–1107) and his son Mi Yu-jen (1074–1153), who together created a style based upon ink dots of nondescriptive character, aimed at suggesting the "inexhaustible flavor of nature." They spoke of their paintings as "ink-plays," thus signifying their total rejection of professional craft in favor of amateur ideals. Seeking to elevate painting to a status comparable to that of poetry and calligraphy, they declared loftily that painting is the "depiction of the mind" and hence capable of practice only by high-minded scholars, not "common artisans."

Mi Yu-jen's *Cloudy Mountains* (fig. 11), one of the best-documented of all Mi-style works (see Appendix 1), is as difficult to reconcile with the majestic compositions of Northern Sung as Li Kung-lin's landscape closing *The Classic of Filial Piety*. Cone-shaped hills, rounded earthen banks, and loosely dotted clumps of trees; a flowing stream, mist drifting through the hills—even a simple description of content exaggerates the visual impact of Mi's painting, which is both less and more than a description indicates. There are no natural textures, there is no sense of real objects, there is no drama. Rather, the subject exists in the realm described as between existence and nonexistence, or as if in a dream, as Mi-style pictures are often characterized. These mountains are to be understood as "hills and valleys within the breast," fleeting visual embodiments of the mind of their maker.

Cloudy Mountains and the paintings of Li Kung-lin are among the few surviving landscapes by scholar-artists of the late Northern Sung period. In their intentions, in their simplicity and casualness, in their aesthetic preference for a lofty and distant mood, these works differ fundamentally from nearly every painting before them. The distilled poetic intimacy of their art would appeal to professional masters serving the Southern Sung court during the decades before and after the Mongol destruction of the Sung dynasty, but it was not until the late thirteenth century that the styles and purposes of the Sung scholar-artists would come to be regarded as the very basis of the art of painting. In their own time these artists were daredevil innovators, flaunting traditional practices and expectations and plumbing the depths of an old art for new expressive possibilities.

2

Gods, Sages, and Mortals

Figure Paintings of the Sung Dynasty
(960–1279)

When in about 1075 the distinguished art historian Kuo Jo-hsü analyzed the viability of the various subjects and traditions of painting, he drew a sharp distinction between the categories of landscape painting and figure painting. Modern (that is, Sung) masters, he believed, had achieved the ultimate in landscape, surpassing all earlier efforts, but Sung painters of figure and narrative subjects could never rival the brilliance of their Six and T'ang dynasties predecessors. This dichotomy is a reflection of the relative ages of the two broad categories: figure painting was the older by far, going back to the very beginnings of painting as a craft and an art; landscape, which did not become a viable subject until the T'ang dynasty, had developed most rapidly only after the beginning of the tenth century.

It is difficult today to verify Kuo Jo-hsü's observation. There does not appear to have been a serious decline in the quality or quantity of Sung figure and narrative painting, but knowledge of it is far less certain than that of landscape painting, and the works by which the art is judged are largely anonymous. This condition, which doubtless reflects the tendency of major Sung masters to turn more frequently toward landscape as a subject, is also

Fig. 12. Wall painting
Unknown artist, 12th century
Detail
Yen-shang ssu Temple, Shansi province

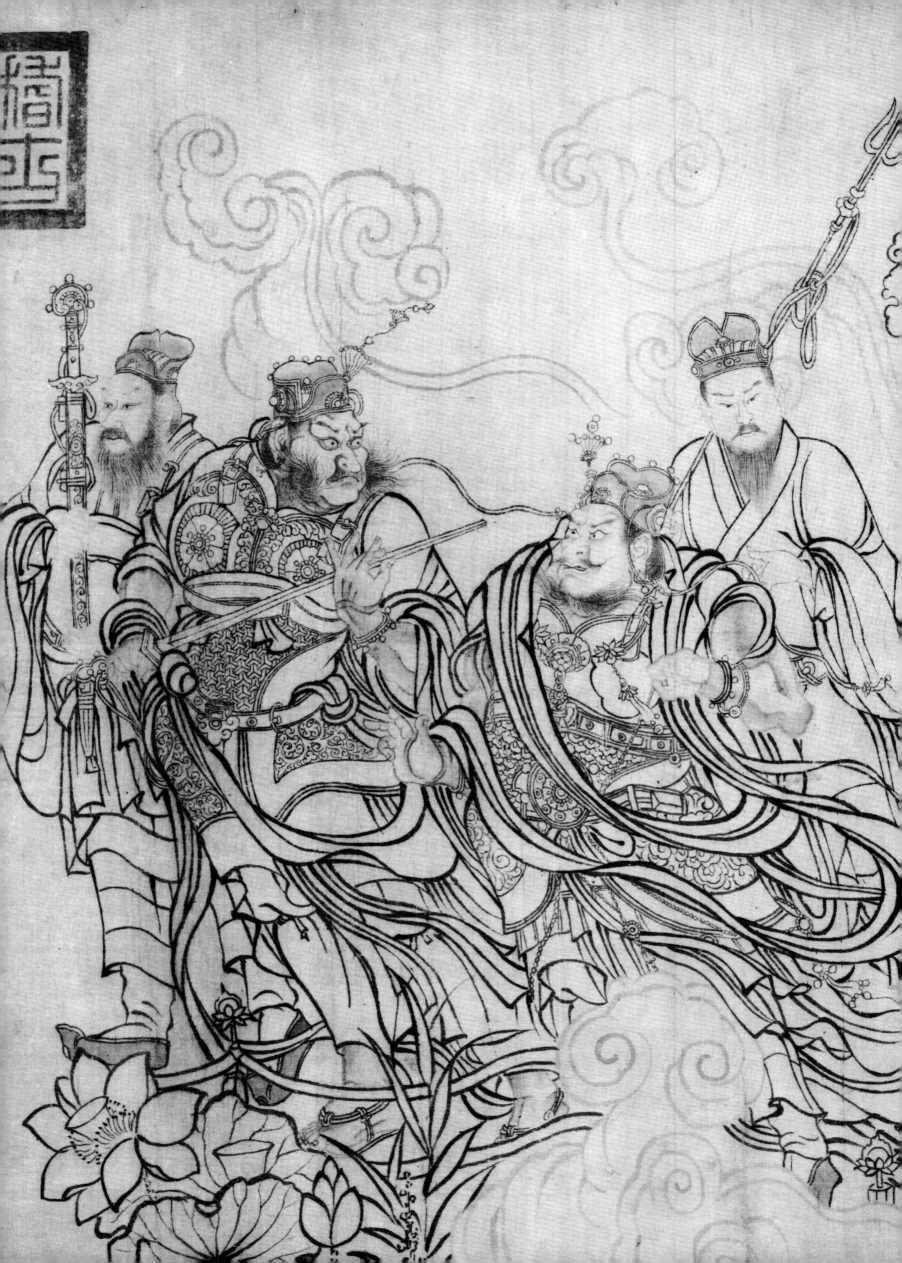

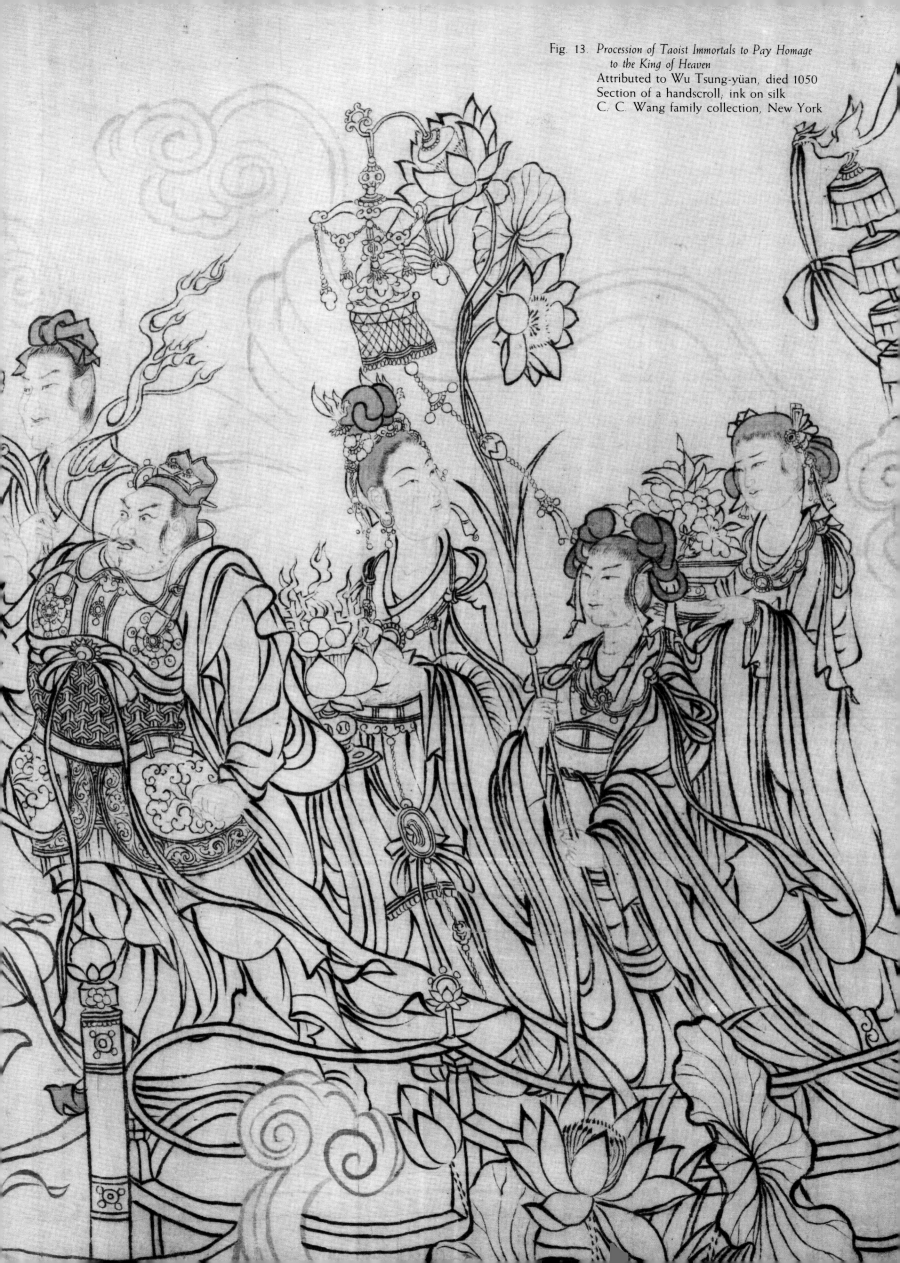

Fig. 13. *Procession of Taoist Immortals to Pay Homage to the King of Heaven*
Attributed to Wu Tsung-yüan, died 1050
Section of a handscroll; ink on silk
C. C. Wang family collection, New York

a result of the taste of later collectors and connoisseurs who lost interest in Buddhist and Taoist subjects and ultimately came to regard landscape as the greater vehicle. It is also true that religious and narrative subjects were usually painted on the walls of temples and public halls, most of which were long ago destroyed. A painting (fig. 12) from a recently rediscovered twelfth-century temple in Shansi province, the Yen-shang ssu, reveals what a high level of art was being practiced by professional wall painters at that time and how much has been lost.

Procession of Taoist Immortals to Pay Homage to the King of Heaven

The great tradition of wall painting that dominates the long period from Han to T'ang continued throughout the Sung dynasty. Were we to see the brilliance of Sung figure painting, it could only be through the now lost walls of the great monasteries, temples, and palaces, especially those in the Northern Sung capital of K'ai-feng, but also in such once-flourishing centers as Ch'eng-tu, Mount Wu-t'ai, and Hangchow, the Southern Sung capital. Here would have been seen the pantheons of Buddhism and Taoism, the stories of ancient glories, and the virtuous heroes of the Confucian and imperial past. A rare reflection of such art is the long handscroll *Procession of Taoist Immortals to Pay Homage to the King of Heaven* (fig. 13). This celebrated work attributed to Wu Tsung-yüan (died 1050), a popular and esteemed master of religious figure subjects whose long life spanned the late tenth century and the first half of the eleventh, preserves something of the drama and spirit of the wall paintings of its time. It appears, in fact, to be a cartoon for a wall design, or perhaps a reduced copy of such a work, aimed at preserving the drawing and iconography of its model. Such works might have been preserved in temples and monasteries for reference in repair and repainting. The style and technique of the scroll indicate that it is not a finished painting in the usual sense.

The great procession that is portrayed is composed of the serene deities and the melodramatically gesturing and grimacing guardians of the Taoist faith, embodiments of the breath and power of existence. Most of them are identified in plaques above: "Immortal Prince of the Great Purity" carries a gift of bonsai; beside him, "Jade Woman of the Almighty Cinnabar" holds a dragon-topped lotus bowl; before them walk the "Attendants of Brightness and of Understanding." Faces, hands, and swirling clouds are painted in pale diluted ink, while the intricate black tracery of lines defining garments, pennants, and attributes pulses vigorously over all. So dense and heavy is the line that one is easily distracted and lost in it, but no line is extraneous: each describes a form, defines a pleat, traces a trailing edge of garment or ribbon. If the original purpose of the painting is uncertain, the style of the work is clearly that of two great artists named Wu—one inaugurated a largely uncolored manner of ink drawing and a style of dramatic movement in painting in the eighth century, and the other brilliantly re-created that manner in the early eleventh century.

Wu Tao-tzu, the T'ang master, seemed to his contemporaries superhuman in creative power and energy. He covered the walls of the two T'ang capitals with his dynamic and startling images of the kings of hell and of heavenly immortals, as well as scenes of history, religion, and myth. Usually, light and transparent colors were washed over his black line drawing, but sometimes the line was left to stand alone. His art is lost, except as it may be glimpsed in a few anonymous tomb paintings dating from his lifetime, in ink rubbings taken from stone engravings of three of his lost works, and, most richly, in *Procession of Taoist Immortals* attributed to his Sung "reincarnation," Wu Tsung-yüan.

For his uncanny ability to emulate his predecessor, the later Wu was almost as highly esteemed in his lifetime as Wu Tao-tzu was in his. The ability to imitate without innovation, however, is ultimately regarded in China much as it is in the West and, had Wu Tao-tzu's art not been completely lost, Wu Tsung-yüan's paintings would be looked upon with only

minor interest and curiosity. Now, however, it is substantially through the later re-creation that we understand the lost works of the primary master.

The earliest documentation on the scroll, in the form of seals attributed to the Northern Sung emperor Hui-tsung (reigned 1101–25), is followed chronologically by a colophon dated 1172 attributing the scroll to the great T'ang master Wu Tao-tzu himself. In a second colophon, dated 1304, the distinguished scholar and artist Chao Meng-fu corrected that attribution on the basis of works he had seen by Wu Tsung-yüan, and ascribed the painting to the later Wu (for both colophons, see Appendix 1). There are many uncertainties concerning these matters, including doubts about the authenticity of the Sung imperial seals as well as doubts about the physical relationship of the earliest colophons to the painting itself (the silk between colophon and painting is split), but in any case the name of Wu Tsung-yüan is not associated with the painting before 1304, two and one-half centuries after his death.

It seems clear that the painting was an anonymous iconographic drawing, cartoon, or record when it first reached a collector's hands and that its subsequent history reflects the efforts of later owners to give it a history and an attribution. This is a common experience in the case of old anonymous paintings. Even if we choose to ignore all documentation prior to the Ch'ing period, when it is undoubtedly secure, we would still probably come to the conclusion that the work preserves the style of the Northern Sung period and of such a master as Wu Tsung-yüan (see Appendix 2). The discovery in 1972 of a series of Buddhist wall paintings in the buried foundations of two pagodas at Ting-hsien, Hopei, datable to the late tenth century, places the style indisputably within the lifetime and the geographical area of Wu Tsung-yüan.

What then are the achievements of Wu Tao-tzu, as we are able to assess them in the work of one of his Sung heirs? First, the brush line has been freed from the task of finely and evenly defining a contour. The brush line, while rarely swift or casual in *Procession*, fluctuates broadly from delicate to heavy impresses and in some areas of drapery suggests forms turning in space. This is an altogether different technique from the fine "iron-wire" lines of earlier artists and implies a different approach to representing form in brush and ink. In its texture, shape, and movement, the brush line begins to have an interest of its own, as the painter reduces the various stages of representation with contour, shading, and color to the single step of direct, varying brush line that is able to suggest both two-dimensional contour and the turning of form in space.

This change in brushwork created a new impression of movement in the painted forms that was imparted by the artist's restless rhythms of line and his deliberate emphasis on exaggerated gesture and expression. This vitality is seen, for example, in the faces of the immortals and their postures: the fierce, glaring eyes and flame-issuing mouths; the prancing, proud attitudes; the bulging muscles. The female attendants, whose inclusion marks the subject as unmistakably Taoist, smile gently as they sweep slowly forward in a continuous, rhythmic play of curving lines. These lines—graphic, tactile, boldly and deliberately imprinted on the creamy silk—finally make so lively and timeless an impression that, as in sketches or drawings, the line itself recalls the existential act of creating. In that important respect, *Procession of Taoist Immortals* differs from most other early Sung figure paintings and shares instead certain characteristics of the landscape painting of its time, anticipating the dominantly calligraphic art of later centuries. It was these qualities and the uniqueness of *Procession* that led C. C. Wang to adopt one of his studio names: Pao Wu-t'ang, "The Hall for Preserving Wu [Tsung-yüan]."

The Classic of Filial Piety

Traditionally, Chinese art historians have regarded Li Kung-lin as the greatest Sung master of figure painting and as the true heir to the great masters of the classical tradition

Fig. 14. *The Classic of Filial Piety*, ca. 1085
Li Kung-lin, ca. 1049–1106
Illustration for Chapter 5: "Entertaining Elderly Parents"
Section of a handscroll; ink on silk
The Art Museum, Princeton University

preceding him. Only three of his works survive: *Five Tribute Horses*, reportedly in Japan; *Pasturing Horses*, a long, beautiful handscroll in the Peking Palace Museum painted for the Sung emperor Che-tsung (reigned 1086–1100); and his illustrations for *The Classic of Filial Piety*, a handscroll in ink on silk.

The Classic of Filial Piety consists of eighteen chapters, each of which was illustrated by the artist. Only fifteen paintings remain, along with Li's own transcription of the text, written in the old-fashioned style of the third-century master calligrapher Chung Yu. The style of the paintings is equally old-fashioned, but, like the calligraphy in its context, fresh and new as an artistic-intellectual idea. In emulating the first master of Chinese painting, Ku K'ai-chih (344?–405?), Li chose a long-neglected style and model with which to convey the truths of the hallowed principle of filiality. This was a startling and original choice, immediately recognized as profound in its implications and potential. The concept, later ubiquitous in Chinese painting, of using past styles to convey formal and expressive meanings intrinsic to them begins with Li Kung-lin. It was, as we observed in considering the landscape painting of the late Northern Sung period, only one aspect of the efforts by scholars, calligraphers, and poets of that time to reform the art of painting, to intellectualize and personalize it so that it no longer remained the exclusive preserve of professional painting masters.

Li Kung-lin, however, while a scholar and poet as well as antiquarian and government official, was above all a painter, and the painterly qualities of his art are most enduring and ultimately most interesting. He is associated with the formation of a new technique called *pai-miao*, "uncolored outline," which drew upon the earlier practice of sketching or preparing cartoons for wall paintings, as represented by *Procession of Taoist Immortals*. Sketchbooks and model books were in his collection, and he was also probably familiar with the practice among wall painters of drawing directly in black line, then adding color later. Sometimes these initial drawings were left uncolored, either deliberately or by chance, and were called *pai-hua*, "uncolored paintings." Painting in ink line alone was not new and landscape painters had already popularized the idea of monochromatic pictures, but Li's art represents something new nonetheless. He set out to create a style from uncolored ink lines and he sought a casual, direct, sketchy quality that is nearest in practice to the art of calligraphy. This spontaneity, combined with the enriched formal vocabulary drawing upon ancient and classical sources, created what seemed like a new art, as suggested by the twelfth-century scholar Liu K'o-chuang:

> The great masters of previous generations . . . were all unable to do without color. That is why their names are listed under the two words red and green. Li Kung-lin was the first to sweep away these cosmetics. His pale brush and light ink are lofty, elegant, and surpassing, like a great scholar living in retirement, wearing coarse clothing and grass sandals, his life simple and far from the world of ordinary men. He has no need to enhance himself with fancy embroidered robes or ceremonial headdress. Ah, truly! His should be regarded as the supreme art of the nation!

When Li Kung-lin painted *The Classic of Filial Piety* about 1085, he was searching for a new way of expression as well as for new standards and new forms. Paradoxically, the new is here given the guise of the old, an idiosyncratically Chinese mode of revolution. The various elements and styles Li explored are coalesced around the personality, character, and spirit of the artist himself and of his subject—in this case, the human ideal of filial piety.

Chapter 5 of *The Classic of Filial Piety* is concerned with the appropriate filial behavior of government officials:

> As they serve their fathers, so they serve their mothers, and they love them equally. As they serve their fathers, so they serve their rulers, and

they reverence them equally. Hence love is what is chiefly rendered to the mother, and reverence is what is chiefly rendered to the ruler, while both of these things are given to the father. Therefore when they serve their ruler with filial piety they are loyal; when they serve their superiors with reverence they are obedient. Not failing in this loyalty and obedience in serving those above them, they are then able to preserve their emoluments and positions, and to maintain their sacrifices:—this is the filial piety of the officials.

It is said in *The Book of Songs*,
"Rising early and going to sleep late,
Do not disgrace those who gave you birth."

Li Kung-lin's illustration (fig. 14) concentrates upon the basic human relationships at issue: here, the service of children toward their parents. A family group is shown entertaining its mother and father, providing food, drink, and a magic show with music and dance. The bare-bottomed grandchildren sit in the foreground among the entertainers, while the parents watch from the side, attentive to their own parents' needs. It is delightfully informal representation, painted without pretense directly onto the silk surface, without preparatory drawing and without the addition of coloring or even shading. Expressions and attitudes are lively and human, if without extremes, and the brushwork is spontaneous, easy, and immediate. In this mode mistakes are not corrected, and an image is brought into view casually, using none of the traditional techniques of painting.

In his illustration to Chapter 8 (fig. 15), Li focuses upon the annual ceremonial encounter between the emperor and a delegation of widows, widowers, and orphans, sym-

Fig. 15. *The Classic of Filial Piety*
Illustration for Chapter 8: "The Ruler Greeting the Orphaned and the Elderly"

bolizing the ruler's humane concern for the unfortunate of his empire. They gather below, bent and crippled, as the emperor looks serenely down upon them, surrounded by his attentive, keen-eyed advisers. Two bailiffs stand guard. The composition is done simply, in the form of a loose circle of those involved in the ceremony, separated by position and by the wall that stands between them. Each human type is captured quickly and effectively, drawn easily as if sketched. The human qualities of each image offer confirmation of the impact of Li's art upon his admirers:

> He was able to distinguish all manner of appearances so that even from afar one could see whether individuals were from the imperial court, from the official ranks, from the mountains and forests, or from the fields and plains; whether they were country villagers, servants, laborers, or clerks. As for their movements and attitudes, he distinguished with dots and lines the expression of a face, the angle of vision, size, beauty, even the differences of north, south, east, and west. Exalted or humble, rich or poor, each was distinctive.

Seen in its historical context, Li Kung-lin's *Classic of Filial Piety* represents both the formulation of a new style and expressive mode and the revitalization of an old art: the humanization of narrative painting, an achievement vital to the development of both figure and narrative painting in the succeeding Southern Sung period. Li's ultimate impact upon figure painting would occur in the fourteenth century, when his *pai-miao* style was acknowledged as the classical manner of figure painting and adopted by nearly all scholar-painters from that time on.

Fig. 16. *Duke Wen of Chin Recovering His State*
Attributed to Li T'ang, active early 12th century
Scene 1: "Duke of Sung Making a Gift of Horses"
Section of a handscroll; ink and color on silk
The Metropolitan Museum of Art

Duke Wen of Chin Recovering His State

To read the titles of early Chinese narrative paintings is to read in outline the early history of the Chinese people. Scarcely a major event or personage was not portrayed in art, from the founding of dynasties and the life, mores, heroes, and villains of an age, to the decline and fall of ruling houses. Among the few surviving Sung narrative paintings is the long handscroll in the Metropolitan Museum illustrating a significant period in the life of Duke Wen, a prince of the state of Chin in the Spring and Autumn period (770–476 B.C.) whose life came to exemplify the recovery of lost rule.

In a series of loosely linked compositions filling a scroll of silk approximately one foot high by more than twenty-seven feet long and punctuated by passages of text from the *Spring and Autumn Annals*, six encounters during the duke's exile are illustrated. The style of their presentation can be understood as a synthesis of the classical narrative manners common to the period from about the fourth century to the early eleventh, combining traits seen in the banner paintings of Tun-huang, in the murals from the T'ang imperial family tombs at Ch'ien-ling, and, in prototypical form, in the two Chinese handscroll compositions attributed to "the father of Chinese figure painting," Ku K'ai-chih—*Admonitions of the Court Instructress* (British Museum) and *The Nymph of the Lo River* (versions in the Peking Palace Museum and elsewhere). Whether continuous in compositional development or monoscenic, each incident is populated by a group of figures set against a highly selective backdrop of landscape or architectural elements. The figures are defined by a tense, thin iron-wire

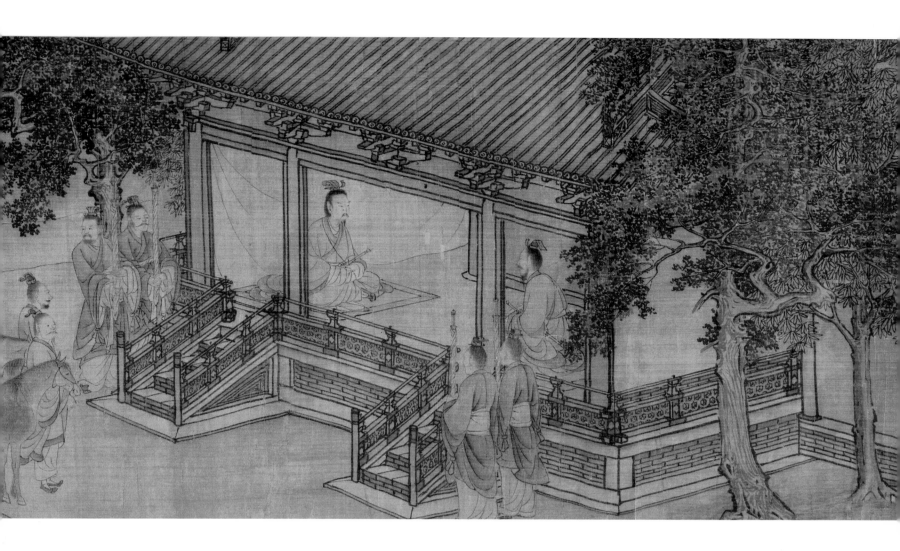

line, slight shading, and mainly transparent colors. There is no natural light source, no perspective, and shading that is only schematic, decorative, and nonillusionistic. Meaning is suggested first in gesture and expression, however restrained and undramatic these may seem, second in the manipulation of space around and between protagonists, and third in the echoing or contrasting forms of background landscape or other elements. The mode— one of decorum, balance, and restraint, although color and pageantry may momentarily intensify—embodies Confucian standards of taste and expression. As in Sung landscape painting, the specific is freed to become ideal and symbolic. Viewing the scroll from right to left, the individual reads the text, looks at the accompanying picture, recalls his knowledge of the events portrayed, and reads into them his understanding of the emotions, thoughts, and reverberations, both personal and national, presented there.

The subject of the scroll, Ch'ung-erh, later Duke Wen of the state of Chin, wandered in exile through the contending states of China for nineteen years before returning home in 636 B.C. to assume leadership of the central states against the threat of Ch'in in the northwest and Ch'u in the south. During his exile he visited most of the states that were either allied with or in opposition to his own state of Chin, and events connected with those visits provide the subject of each of the paintings.

The scroll, which is not complete, opens with the future duke's cordial meeting with the ruler of the Sung state (fig. 16); the two converse ceremoniously as twenty teams of horses, the duke of Sung's gift to Ch'ung-erh, are brought in by grooms. The colorful composition begins with the tree-shaded raised porch within which the men sit, their attendants

Fig. 17. *Duke Wen of Chin Recovering His State*
Scene 1: "Duke of Sung Making a Gift of Horses"
Detail

waiting below, continues through the lively parade of presentation horses winding in from behind a long fence, and ends with the empty waiting carriage of Ch'ung-erh, with one groom napping beneath the trees (fig. 17). It is then followed by a single line of text: "When he reached Sung, Duke Jang presented him with a gift of twenty teams of four horses." Throughout the scene the artist reveals his interest in pictorial narrative of the traditional kinds, effectively highlighting the central meeting by enclosing the two main figures within a structure of trees, architecture, and attendants, elaborating upon the drama of the parade of horses by bringing them in from outside the picture, beyond the fence, and having those led by the third groom shown fighting their halters. The opening image is neatly echoed in the two trees that close the compositional unit. The trees and the horses here, as elsewhere in the scroll, are beautifully drawn. The sleeping groom typifies the painter's interest in picturesque human detail.

The third scene, the most dramatic and richly painted of the group, illustrates a celebration of power and pomp (fig. 18). After being unceremoniously insulted by the duke of Cheng, Ch'ung-erh visits the powerful ruler of the southern state of Ch'u, and there, in a tense confrontation, courageously demonstrates his generosity and determination, impressing the ruler of Ch'u with both his fairness and strength. The painting apparently illustrates the triumphant departure of Ch'ung-erh from this success, his entourage now greatly increased with the gifts of horses and grooms; the carriages, preceded by swirling banners and surrounded by jagged boulders, stunted trees, and billowing clouds, rumble through the mountain pass (fig. 19). Ch'ung-erh is in the last of the three visible carriages, just emerging from a narrow defile. Rarely is Chinese figure painting so outwardly colorful in its drama.

Fig. 18. *Duke Wen of Chin Recovering His State*
Scene 3: "Departure from Ch'u"
Detail

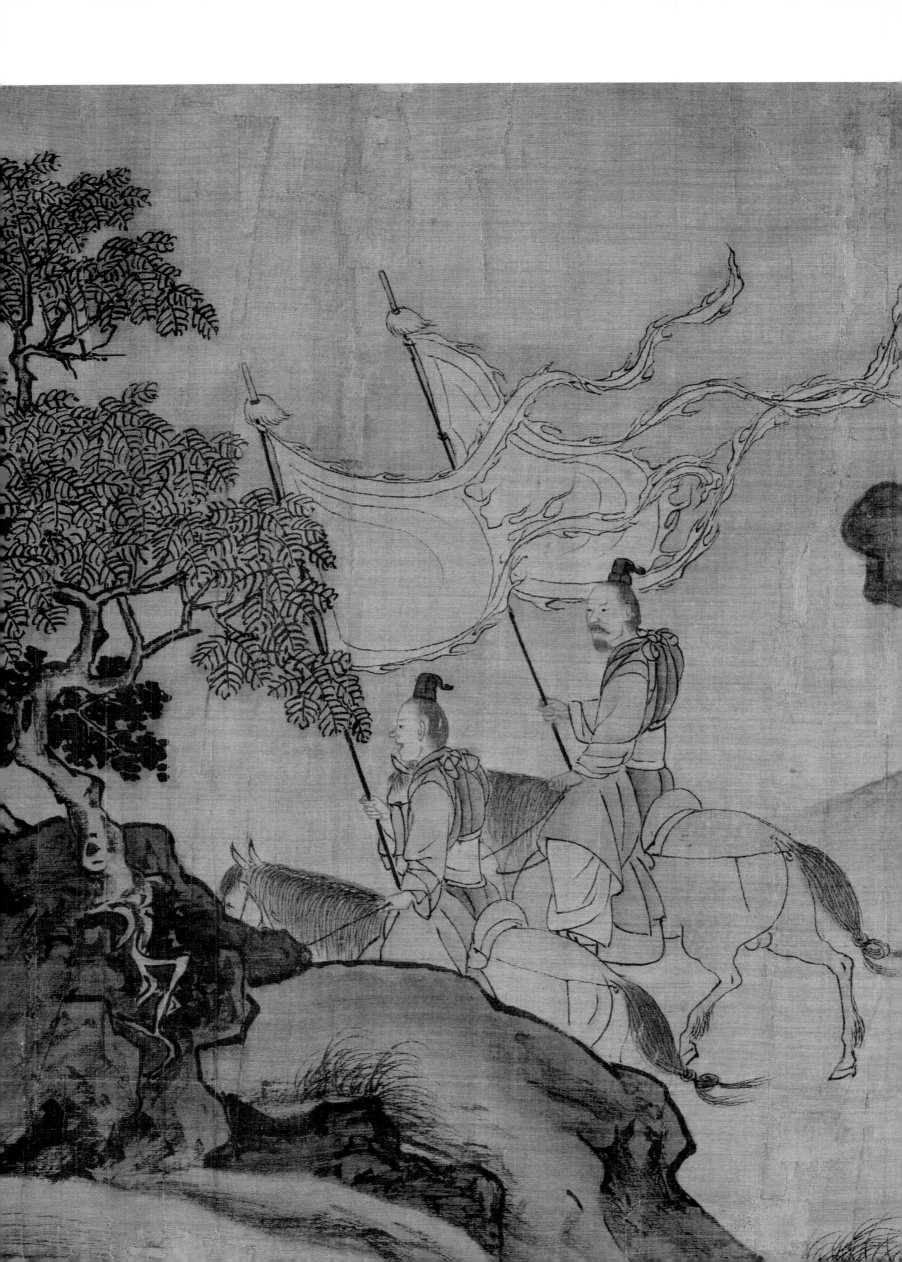

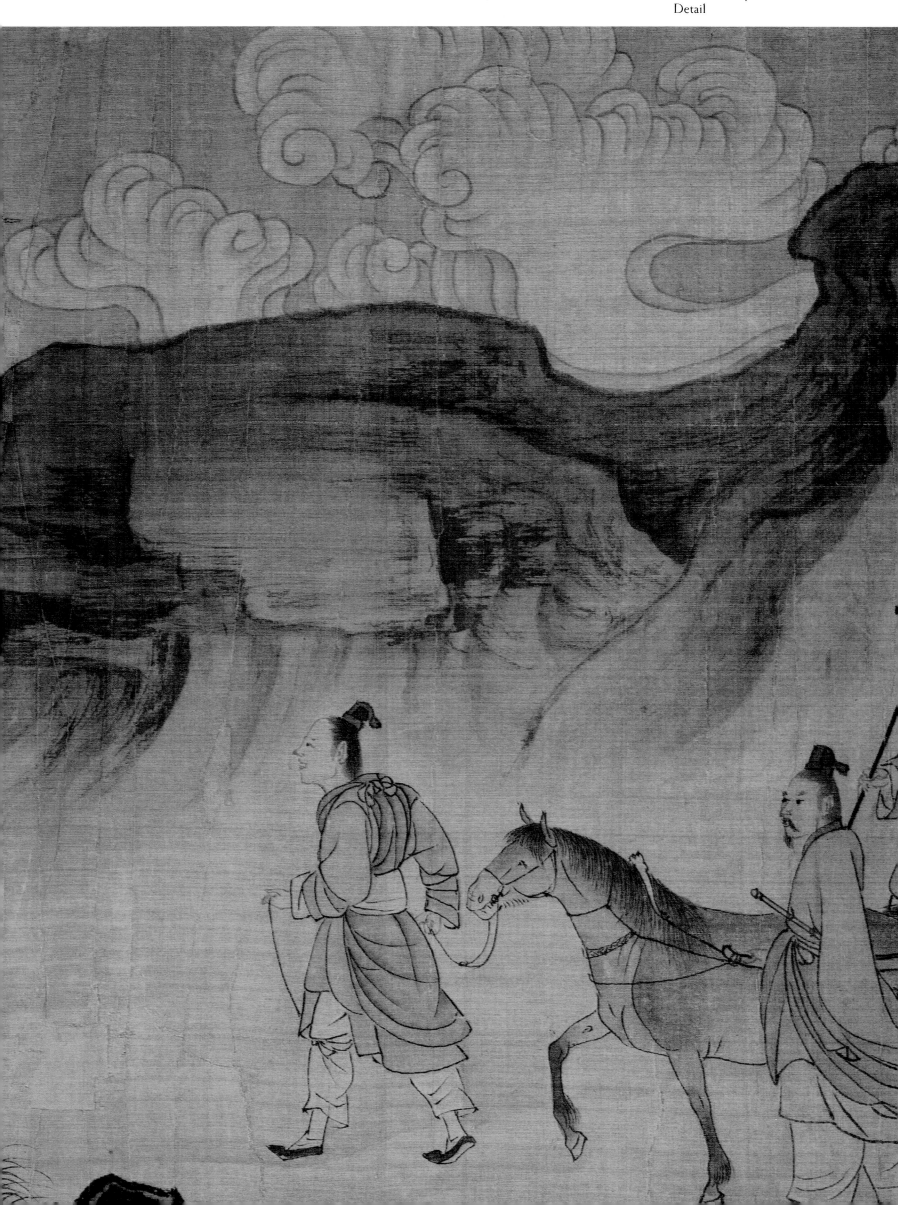

隆辭稽首公降一級而辭焉以佐
公子賦河水公賦六月趙衰曰重耳拜賜公子
日公享之子犯曰吾不如衰之文也請使衰從
怒曰秦晉匹也何以卑我公子懼降服而囚他
秦伯納女五人懷嬴與焉奉匜沃盥既而揮之

Fig. 20. *Duke Wen of Chin Recovering His State*
　　　Scene 4: "Received by the Ladies of Ch'in"

As if to create an opposite effect, the next scene (fig. 20), in the state of Ch'in, is painted in soft greens and pink and concentrates not upon drama but feminine beauty, as the hero is presented with five wives by the Ch'in ruler, who hopes thereby to placate his future rival. No setting interferes with the main group, placed on a plain background, while a beautifully painted pine tree and pavilion anchor the composition at the left. It is a moment of quiet and simplicity in a succession of highly charged incidents.

The final triumphant scene of the return to Chin is preceded by another complex composition interweaving figures and landscape (fig. 21). On the eve of Ch'ung-erh's return, upon reaching the banks of the Yellow River, one of his senior advisers, Tzu-fan, presents him with a jade disk, berates himself for his many failures, and asks to be punished.

Fig. 21. *Duke Wen of Chin Recovering His State*
　　　Scene 5: "Tzu-fan Presenting a Jade Disk"

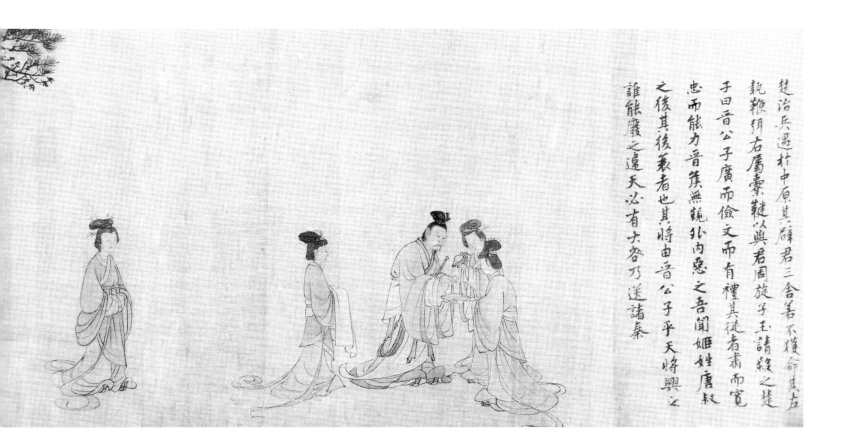

楚治兵遇於中原其辟君三舍若不獲命其左
執鞭弭右屬櫜鞬以與君周旋子玉請殺之楚
子曰晉公子廣而儉文而有禮其從者肅而寬
忠而能力晉襃無親外內惡之吾聞姬姓唐叔
之後其襃者也其將由晉公子乎天將興之
誰能廢之違天必有大咎乃送諸秦

Ch'ung-erh throws the disk into the river, indicating his rejection of Tzu-fan's confession, and declares his faith in the older man. This emotional scene is played out on a rocky ledge by the river, as Tzu-fan presents the jade disk to his lord beneath a graceful pine, its trunk and branches juxtaposed over those of a somewhat smaller tree behind. At the left, in successive pockets of space between the cliffs, are glimpses of the river and a waiting boatman and of the future duke's entourage of carriages and attendants preparing for the great return to Chin, with which the narrative ends.

Although the scroll bears no signature or seals of its artist, it has traditionally been attributed to the early twelfth-century painter Li T'ang, an academician known for his ability to transmit classical models. Scholarly dispute over its authorship goes back at least as far

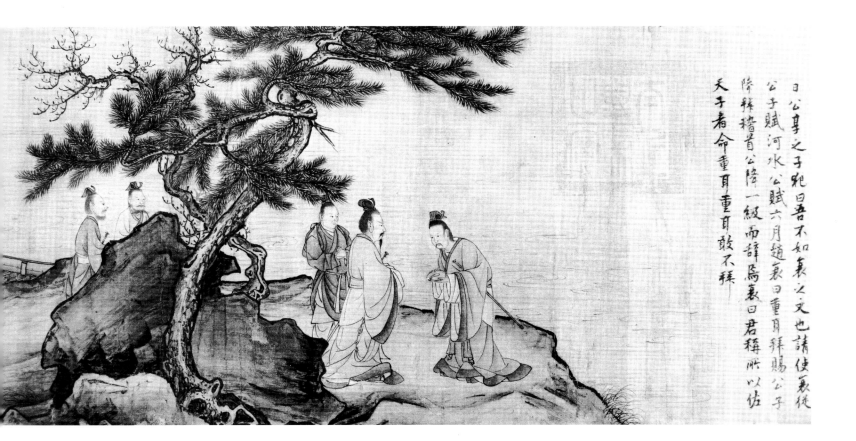

曰公身之子妃曰吾不如襃之文也請使襃從
公子賦河水公賦六月趙襃曰重耳拜賜公子
降辭稽首公降一級而辭焉襃曰君稱所以佐
天子者命重耳重耳敢不拜

as about 1300, when the original colophons, preserved now in copies, were written for the work (see Appendix 1). Along with other textual documents involving the same scholar-connoisseurs, the colophons tell us that when acquired by Ch'iao K'uei-ch'eng in the late thirteenth century, the painting bore an attribution to the mid-eleventh-century painter Wu Yüan-yü, and the calligraphy to the great poet and master calligrapher Huang T'ing-chien (1045–1105). Because the collector's family owned another version of the subject painted by Li T'ang, considered to correspond exactly to the present work except that it included four earlier compositions in the proper sequence of ten, Ch'iao concluded that Li T'ang had painted both versions. Supporting this reattribution was Ch'iao's assessment of the calligraphy accompanying the Metropolitan's picture, which he believed was written by the Southern Sung emperor Kao-tsung (reigned 1127–62), not Huang T'ing-chien. Because it did not exactly resemble the more typical writing of Kao-tsung, Ch'iao argued that the calligraphy was done at a relatively early period in Kao-tsung's career, when the emperor was imitating Huang.

Clearly, since these problems of authorship already troubled the leading connoisseurs and collectors of seven hundred years ago—scholars who had access to many more related works than we have—there is little chance that they can be resolved today. Wen Fong discusses these issues at length in *Sung and Yuan Paintings*, the most comprehensive examination of the scroll in recent years. Most revealing and significant is his discovery of a highly plausible and persuasive context for the painting of this particular subject in the restoration efforts of Emperor Kao-tsung, whose reign in the years following the occupation of north China by the Chin Tartars in 1126 was concerned with the reestablishment of dynastic stability and of effective imperial control. These concerns are precisely the subject of the scroll, and its newly defined political context adds to our understanding of it. Li T'ang, furthermore, spent his last years as a painter in Kao-tsung's court and was regarded as the leading academic master of such subjects. Another of the major propaganda works of the restoration is a set of pictures titled *Auspicious Omens of Dynastic Revival*, some sections of which are in the Shanghai Museum. The paintings were done by Li T'ang's leading follower, Hsiao Chao, in a style closely related to that of the Metropolitan's scroll. Far more than simply ancient history, then, *Duke Wen of Chin* is an essential reflection of Emperor Kao-tsung's reign and of the circumstances of Imperial China in the second quarter of the twelfth century. Its restrained but colorful personae and bold pageantry speak of the oldest traditions, especially narrative styles that have now all but disappeared. When it is compared with other examples of the "large-figure" tradition, the scroll proves to be among the earliest and finest works of its kind. Discovery in recent years of wall paintings of the High T'ang period, when such art was at its zenith, further establishes close bonds between the style of this work and its classical prototypes of the seventh and eighth centuries. *Duke Wen of Chin* is one of the last important examples of a tradition of narrative painting that is nowhere else so perfectly represented, a tradition that did not survive the Southern Sung court.

Eighteen Songs of a Nomad Flute

The paintings considered above owe important elements of their style to still older styles. Intervening between the origins of each manner and the Sung continuation or revival of it were the birth and dramatic evolution of landscape painting, discussed in Chapter 1. This development vastly extended the illustrative capacity of narrative painters. In fact, the union of figural narrative and full landscape settings during the Sung period extended the art to the most advanced state it attained in China before its sudden decline to the level of craft.

One of the most celebrated Sung narratives of this advanced type is *Eighteen Songs of a Nomad Flute*, first painted in the twelfth century by an unknown artist. The work, now

Fig. 22. *Eighteen Songs of a Nomad Flute*
Unknown artist, 14th century
Copy after anonymous Southern Sung academy painter, ca. 1140
Scene 3: "Desert Night"
Section of a handscroll; ink, color, and gold on silk
The Metropolitan Museum of Art

incomplete, served as the model for the Metropolitan's fourteenth-century copy (see Appendix 2). The paintings illustrate a cycle of songs or poems by the eighth-century poet Liu Shang, telling of the life in captivity of Lady Wen-chi, who was abducted by the Hsiung-nu Huns late in the second century, taken by them to Mongolia, and forced to marry a Hsiung-nu chieftain and bear his children. After years in the steppes, she was ransomed and returned to her home, leaving behind her husband and children. Her story is a true one and Liu Shang's cycle of songs follows the original cycle attributed to Wen-chi herself.

Since the Metropolitan's scroll has been fully published in Robert A. Rorex and Wen Fong's *Eighteen Songs of a Nomad Flute: The Story of Lady Wen-chi*, I will limit my discussion to two of the eighteen compositions, all of which suggest the nature of an art at the zenith of its evolution. In the first example (fig. 22), Wen-chi walks out into the desert night to gaze at the moon—the moon of the steppes and of her distant home. Her poem, which speaks of vain, restless dreams, of hopes faded, ends:

> In the vast barbarian sky my cries are unanswered,
> Yet the bright Han moon should know me!

Behind her is a campsite, foliage burning with the fires of autumn; in front, a bleak expanse of barren hills; the moon is far away, the lady lost.

With this union of human drama and natural setting, the pictorial scope of painters was enormously extended. At the same time, the style becomes fully contemporary, mak-

莫以胡兒可著恥恩情亦各言其子手中

第十四拍

Fig. 23. *Eighteen Songs of a Nomad Flute*
Scene 13: "The Farewell"

ing no bows in the direction of the past. The costumes and accouterments of the tribesmen are those of the early twelfth-century nomadic peoples, the Khitan Liao, not the second-century Hsiung-nu, and the architecture and costumes of the Chinese city that opens and closes the cycle are those of the Sung dynasty, not the Han.

The second example illustrates an event later in the cycle (fig. 23). After giving birth to and raising two children, Wen-chi is ransomed by Chinese envoys and must say her painful good-byes to the family she will not see again. The farewell is treated as a broad panorama, and as we encounter the scene at the right, we see instantly the emotional focus. Wen-chi's children tug at her skirt, reaching out for her; her husband covers his face in grief, as all around them weep. She raises her sleeves to her mouth, choking back her sobs, but her emotions are equivocal. She is the Chinese daughter of a great Han family, and this second life was forced upon her. Yet she loves her children and feels great affection for their father. The moment is not prolonged. We see the ceremonial banquet tables, empty and unused; the saddled horses, the camels, carriages, and attendants are ready for departure; over the hill the brilliant red, blue, and yellow banners of China point home.

The overall structure of such paintings is generally dictated by narrative content.

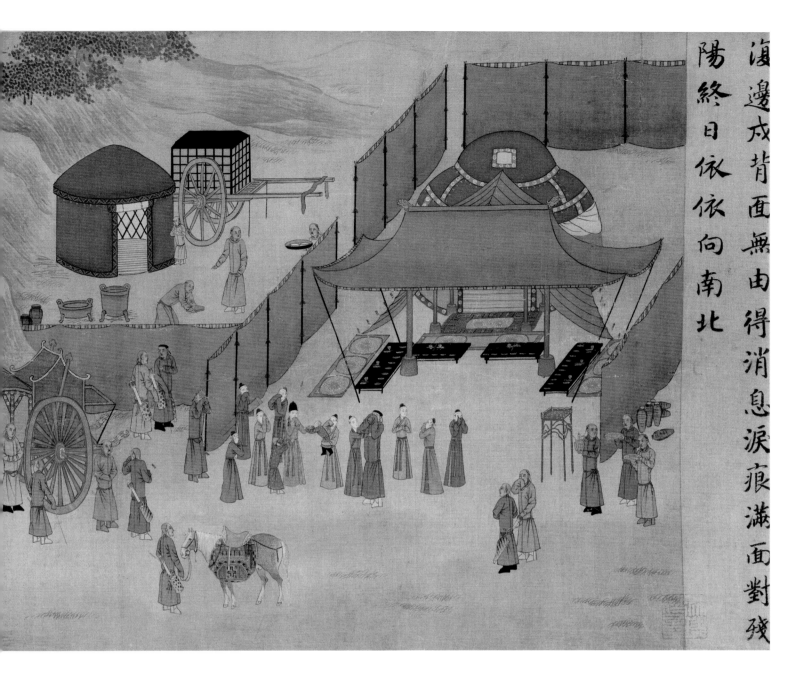

復邊戍背面無由得消息淚痕滿面對殘

陽終日依依向南北

In this case, the same overview of a Chinese city, focused on the residence of Wen-chi, opens and closes the cycle: first as the barbarians attack and capture their hostage, a scene of chaos and destruction, and then years later as she is peaceably returned to her family. Between, bleak distant views of the northern reaches alternate with more intimate glimpses of nomad life. Several basic compositions are repeated so that there is both continuity and variation. We finish the scroll with a sense of having experienced something of the life and environment of the nomads and the moods, emotions, and longings of Lady Wen-chi throughout the years of her ordeal.

This combination of literature and art—landscape and human events, calligraphy, poetry, and painting—represents the fullest flowering of the narrative tradition. The style of the paintings similarly reflects the highest degree of illustrative subtlety in human drama that would be attained. Four darkened compositions, now in the Museum of Fine Arts, Boston, remain from the model, which was painted at the court of Emperor Kao-tsung as part of the same dynastic restoration effort that produced *Duke Wen of Chin Recovering His State*. Comparison of the two versions of the *Eighteen Songs* shows how effectively many of the famous compositions of ancient China have been preserved through reproduction; care-

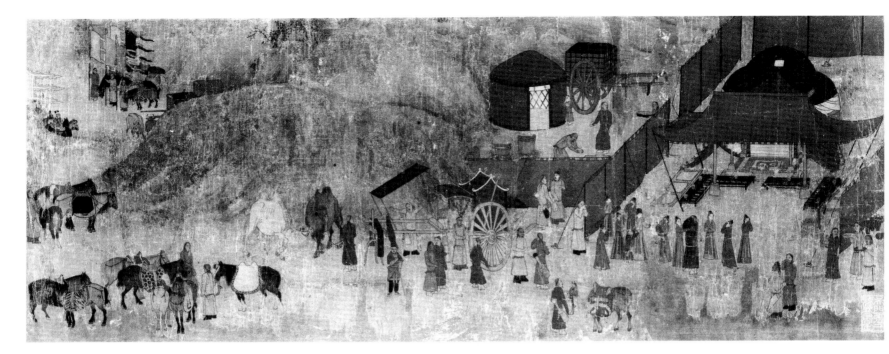

Fig. 24. *Eighteen Songs of a Nomad Flute*
Unknown artist, 12th century
Scene 13: "The Farewell"
Album leaf; color on silk
Museum of Fine Arts, Boston

ful study also suggests the subtle changes and slight losses of quality that inevitably occur in the process of reproduction. The Boston paintings (fig. 24) are finer in detail, softer in execution, and richer in descriptive nuance, but something of the original brilliant color is better seen in the Metropolitan's copy.

Odes of the State of Pin

The name of the Southern Sung painter Ma Ho-chih (active ca. 1130–70) stands high in the roster of China's greatest artists, even though we know next to nothing of his life. Thought by some to have been a classically trained scholar and degree holder in the service of Emperor Kao-tsung and by others to have been a leading master in Kao-tsung's painting academy, Ma Ho-chih directed a substantial portion of his life toward the illustration of the more than 300 poems of the Confucian classic *The Book of Songs*. This volume, the earliest collection of Chinese poetry, preserves 311 songs (six with title only) composed during the early centuries of the Chou dynasty, roughly between 1000 and 700 B.C. They were traditionally believed to have been selected and edited by Confucius. There are three basic sections of *The Book of Songs*: the *Kuo-feng*, popular songs from fifteen different states of the Chou realm; the *Ta-ya* and *Hsiao-ya*, courtly songs distinguished by type of musical accompaniment; and the *Sung*, sacrificial or temple songs from the states of Chou, Lu, and Sung. It has become common to translate all three types as "odes." Hence, as illustrated by Ma Ho-chih, there are "Twelve Odes of T'ang from the *Ta-ya* section of *The Book of Songs*," "Seven Odes of Pin from the *Kuo-feng* section," "Six Odes of P'ei from the *Hsiao-ya*," and so forth. The text of each poem (since the music is lost the odes exist only as texts, or poems) was transcribed beside the relevant picture in the precise, elegant hand of Kao-tsung himself, or, more often, that of an associate imitating him. There is sufficient stylistic variation among the twenty or so scrolls extant to suggest that more than one painter and calligrapher were involved in the project. As several sections exist today in two twelfth-century versions (including the Metropolitan scroll), it appears likely that duplicates of

some or all of the sections were made at the time, one indication among many of the importance attached by Kao-tsung to the enterprise.

Ma Ho-chih was not telling a story in the manner of *Duke Wen of Chin* or *Eighteen Songs of a Nomad Flute*, but, like Li Kung-lin, he was illustrating part of the Confucian canon of classics. The poems in *The Book of Songs*, furthermore, were universally understood to be political and social comments, interpreted anew by each age, and their illustration was a fundamental part of the same program of court-sponsored restoration documents that produced both *Duke Wen of Chin* and the *Eighteen Songs*.

The illustration of such classical texts as *The Book of Songs* began in the Han dynasty, when the Confucian canon first took form under imperial sponsorship. It would seem likely that Ma Ho-chih was aware of and perhaps drew upon earlier examples. Like the painter of *Eighteen Songs of a Nomad Flute*, however, Ma utilized every pictorial device at the service of a twelfth-century artist. Delicate landscapes alternate with elaborate figure-in-architecture compositions. Large individual or paired figures without background or setting—in the large-figure style—are followed by small figure groups in landscape—the small-figure style—in textbook illustration of these major traditions. His use of color is particularly subtle, varied, and beautiful. In a handscroll in the Museum of Fine Arts, Boston, illustrating *Six Odes of P'ei from the Hsiao-ya*, bright red and green are emphasized as if to illustrate the ancient term for painting itself—"the red and green." In the British Museum is another fragmentary section of *The Book of Songs* with a lovely cool blue green silver palette; and in the Metropolitan's *Odes of the State of Pin* extensive use was made of gold as well as silver, although both have largely disappeared through chemical deterioration.

The opening section of the *Odes* (fig. 25) is one of the most elaborate of Ma Ho-chih's surviving compositions, as it attempts to represent a long and detailed song, "The Seventh Month," describing agricultural activities in an arcadian community. The following excerpts from Arthur Waley's translation convey the flavor of the text and include the principal images the painter chose to illustrate:

> In the days of the Third they plough;
> In the days of the Fourth out I step
> With my wife and children,
> Bringing hampers to the southern acre
> Where the field-hands come to take good cheer. . . .
>
> But when the spring days grow warm
> And the oriole sings
> The girls take their deep baskets
> And follow the path under the wall
> To gather the soft mulberry-leaves. . . .
>
> In the seventh month the Fire ebbs;
> In the eighth month they pluck the rushes,
> In the silk-worm month they gather the mulberry leaves,
> Take that chopper and bill
> To lop the far boughs and high,
> Pull towards them the tender leaves. . . .
>
> In the tenth month they clear the stack-grounds.
> With twin pitchers they hold the village feast,
> Killing for it a young lamb.
> Up they go into their lord's hall,
> Raise the drinking-cup of buffalo-horn:
> "Hurray for our lord; may he live for ever and ever!"

Fig. 25. *Odes of the State of Pin*
Ma Ho-chih, active ca. 1130–70
Scene 1: "The Seventh Month"
Section of a handscroll; ink and color on silk
The Metropolitan Museum of Art

Each of the activities described appears in the painting: plowing, carrying food to the workers, picking rushes and mulberry leaves, feasting, and entertaining the lord (fig. 26). Thirty-six small figures are arrayed across the landscape of mulberry trees, fields, paths, and the tree-surrounded house of the lord of the manor. The setting is depicted with remarkable liveliness through Ma Ho-chih's always restless brushwork, the most insistent element in his distinctive style.

The extraordinary calligraphic vitality of Ma Ho-chih's brush leaves scarcely a stroke or dot without its own interior energy and movement. His brush is not an anonymous instrument, but the obvious and urgent transmitter of his will. The personality conveyed through his brush is unlike that of any other Sung painter and only those who directly imitated him could ever be mistaken for him. This transformation of brushwork into an indelible impress of individuality began in *Procession of Taoist Immortals*, continued in Li Kung-lin's *Classic of Filial Piety*, and was achieved most idiosyncratically by Ma Ho-chih.

Two other examples from the scroll indicate the range of imagery and the variety of compositional modes employed by the painter to illuminate the text. The second poem in the group is "The Kite-Owl" (fig. 27):

> Oh, kite-owl, kite-owl,
> You have taken my young.

Fig. 26. *Odes of the State of Pin*
Scene 1: "The Seventh Month"
Detail

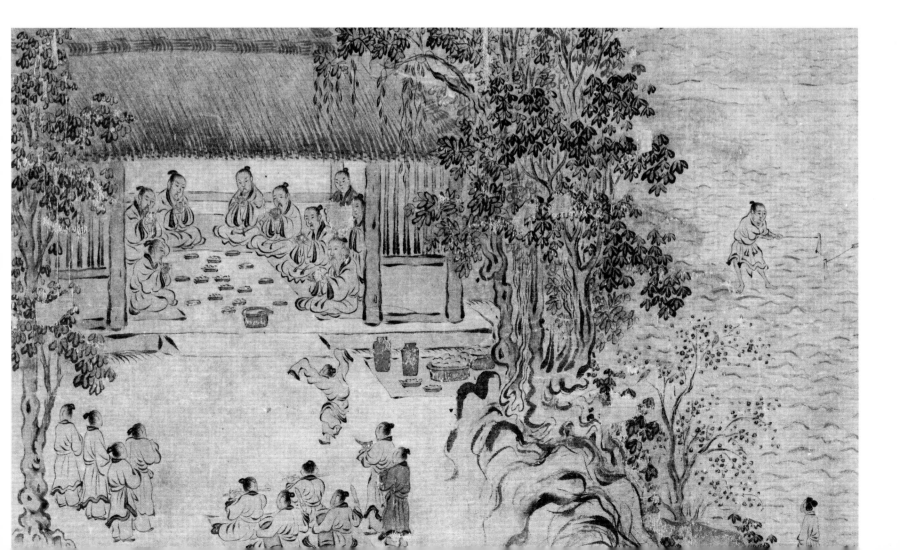

Do not destroy my house.
With such love, such toil
To rear those young ones I strove!

Before the weather grew damp with rain
I scratched away the bark of that mulberry tree
And twined it into window and door. . . .

My hands are all chafed
With plucking so much rush flower;
With gathering so much bast
My mouth is all sore.
And still I have not house or home!

My wings have lost their gloss,
My tail is all bedraggled.
My house is all to pieces,
Tossed and battered by wind and rain.
My only song, a cry of woe!

In the branches of a wind- and rainswept mulberry tree a bird sits guarding its nest, while its mate flies in from the right with a bit of rush in its beak to repair their battered "house." To convey the sense of damp and gloom, the painter blew a spatter of ink across the silk, letting it mix with the gold, silver, and color of the painting beneath. The old tree seems almost alive in its jagged, pulsing lines. Considering all the possible subjects, images, and methods the painter might have chosen to illustrate this poem, it is surprising that he selected, in effect, the traditional theme of old tree, bamboo, and rock, with only the addition of

Fig. 27. *Odes of the State of Pin*
 Scene 2: "The Kite-Owl"

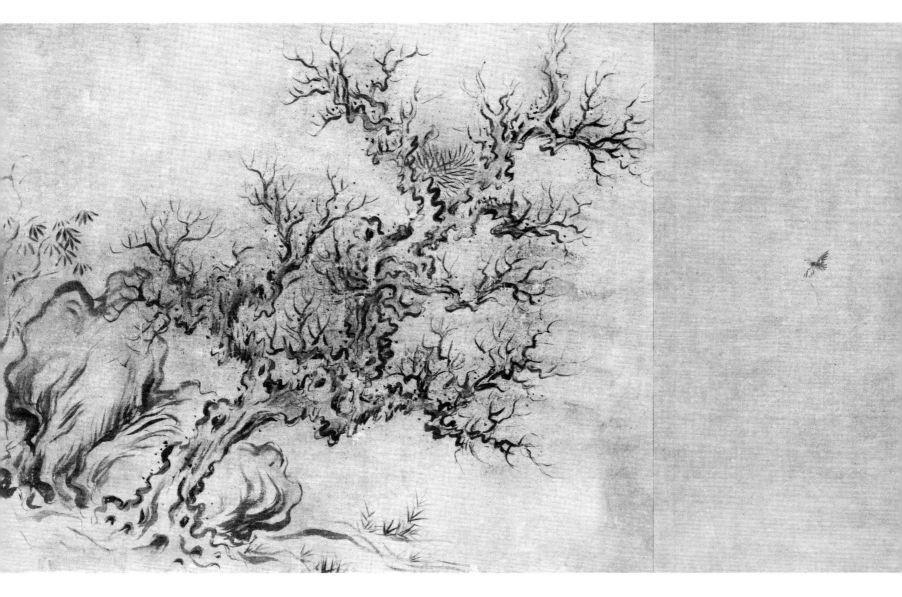

Fig. 28. *Odes of the State of Pin*
Scene 4: "Broken Axes"
Detail

two small birds to suit the specific needs of the subject. It is also surprising how effectively he utilized these common images and with what painterliness he created from them a sense of wet wind, gloomy darkness, and the fear felt by the innocent, forlorn birds threatened by the unseen kite-owl.

Ma's large-figure style is seen in his illustration for the fourth poem of the sequence, "Broken Axes" (fig. 28), which contains these lines:

> Broken were our axes
> And chipped our hatchets.
> But since the Duke of Chou came to the East
> Throughout the kingdoms all is well.
> He has shown compassion to us people,
> He has greatly helped us.

The two large figures are placed against the plain silk. The one on the right, holding a broken ax head, points and gestures, as if telling his companion, "Broken were our axes." The effect of simplicity is well described by Wen Fong: "The movements of the figures are slow, symbolic, and balletlike. With each scene conceived as a didactic tableau, the figures are identities by themselves: they do not suggest dramatic interaction with each other." The figures are symbols, recalling Confucius and his lofty philosophical ideal state, suggesting the moralistic interpretation with which the poems in *The Book of Songs* were invested. There are no real people here, only idealized disembodied images performing ritual gestures.

3

Lyric Moments

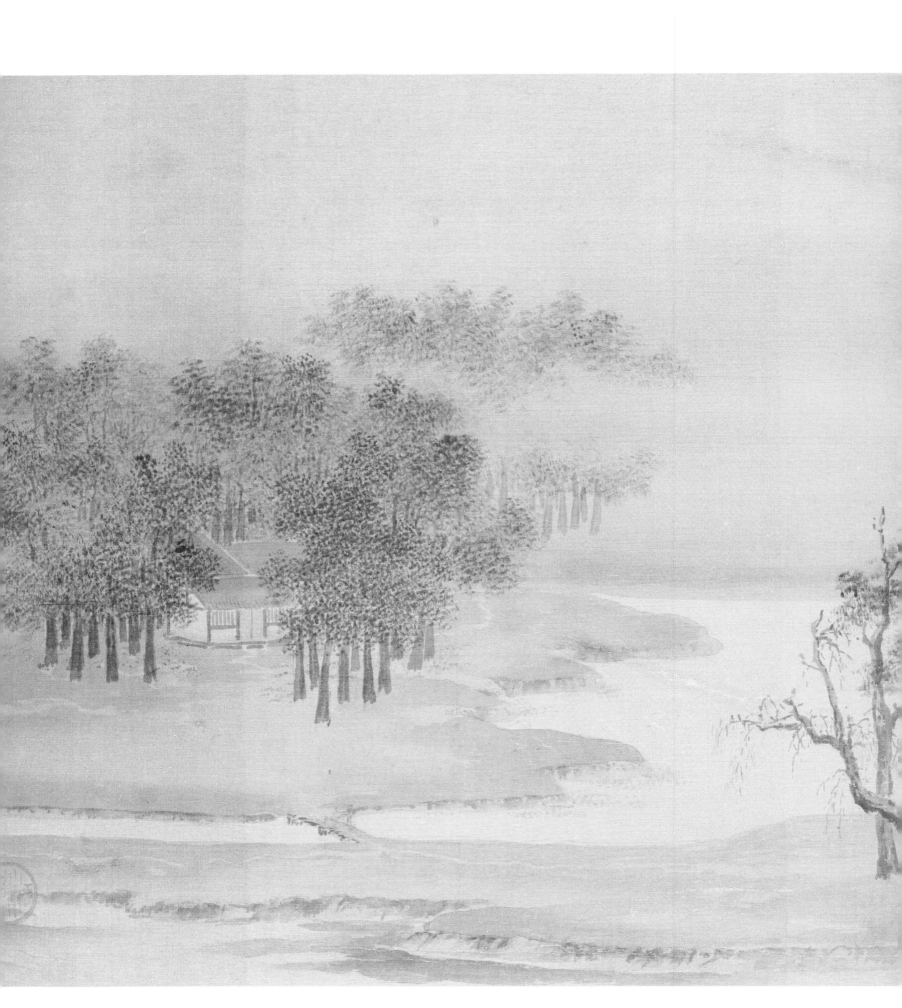

Fig. 29. *Cottages in a Misty Grove*, dated 1117
Li An-chung, active ca. 1100–40
Album leaf; ink and color on silk
The Cleveland Museum of Art

Album Leaves of the Southern Sung Dynasty
(1127–1279)

During the century between 1150 and 1250 an art that was in many respects the antithesis of the Northern Sung monumental style was realized by several generations of artists serving the Southern Sung emperors in the Imperial Painting Academy. These men held official ranks equivalent to government posts, but their profession was painting. Together with their imperial sponsors, they sought to bring to the art of painting standards, rules, techniques, ideals, and educational practices that would be comparable to those of other professions. If we should speak of the Northern Sung masters as, mutatis mutandis, artistically comparable in heroic scale, breadth of vision, and structural composition to Bach or Beethoven, then the leading Southern Sung masters might be likened to Chopin or Schumann—not lesser artists but concerned with smaller forms and, by narrowing focus, attempting to achieve more with less. Theirs is also a frankly romantic art in its utilization of sentiment and lyrical emotion of expression.

Because of their professionalism and because finally they were too intimately associated in later minds with the Southern Sung court, which lost China to the Mongols in 1279, Southern Sung academicians were largely discredited in later centuries. Their styles came to epitomize all that true artists were to avoid in terms of obviousness and vulgarity. Furthermore, because they were professional painters, their lives were not considered worth recording, and accordingly little more than birthplace and artistic lineage is known of any of them. All of this is most unfortunate. Without bias, it is easy to see that their art is one of the supreme lyrical modes of expression.

All of the paintings selected to illustrate this era are "album leaves," intimate scenes painted on round or square pieces of silk averaging about ten inches across, and thus conceptually as well as physically polar opposites to the cosmic vision and great scale of Northern Sung art. Small paintings of this kind had a long history in China, going back at least six or seven hundred years, but never before had they been the focus of such serious and concerted artistic interest. In all probability, most of these paintings were not designed as album leaves at all, but became so in the hands of later collectors. Originally, many of them were fans with a painting on one side and a poem or couplet inscribed on the facing side, usually written by an emperor or one of his consorts but sometimes by a scholar or an official. Rare examples of this format, combining painting and calligraphy, are preserved in the Cleveland Museum and the Museum of Fine Arts, Boston, but generally the paintings and their accompanying poems have been separated and preserved individually, so that today their original context and relationship are lost. We can nonetheless say with some certainty that nearly every Southern Sung fan or album leaf is the visual equivalent of a poem or poetic couplet, a dimension of their original nature as art that deserves to be remembered.

Most of the paintings we will consider represent the fully developed academic manner, a manner that evolved over a fifty-year period spanning the transition from late Northern Sung until the reestablishment of a Sung government at Hangchow. This chaotic period saw the destruction of the Sung capital of K'ai-feng in 1126 by the invading Chin Tartars, the capture of the last two Northern Sung emperors, including Hui-tsung (1082–1135), and

the flight of the survivors to the south. There at last they were able to conclude a treaty with the Chin, who remained in control of the north, and to resume government of a now reduced sphere—Southern Sung, half the former nation. This political situation endured until the 1270s, when the Mongols for the first time in history imposed a foreign rule over the entire country.

Cottages in a Misty Grove

Some elements of the Southern Sung academic style were formed in the late years of Northern Sung under the patronage of Hui-tsung, who was himself a gifted painter and calligrapher. The earliest of our album leaves, *Cottages in a Misty Grove* (fig. 29), is dated 1117. Its painter, Li An-chung (active ca. 1100–40), who was a minor academician in Hui-tsung's academy (see Appendix 2), was better known for his bird and flower paintings, several of which are still extant. *Cottages* is his only known landscape. In it, ten years before the beginning of Southern Sung, a number of elements that would be typical of the Southern Sung academy are visible. For example, the small composition is cut by a strong diagonal from the bottom-left to the top-right corner. While this is not quite the "one-corner" composition of fifty years later, it is very different from the centralized compositions common until this time, and shows strong new interest in the effects of space, mist, atmosphere, and emptiness. There are in fact few of the old elements of landscape at all: none of the great mountains, villages, temples, or wineshops; only a single secluded cottage on a marshy bank, a grove of mist-filled trees, and two isolated trees in the lower-right corner. All these forms are defined in a soft, delicate ink wash that conveys more an impression of landscape than a definition. The mood is one of peaceful retirement, of withdrawal and contemplation.

The treatise *Shan-shui ch'un-ch'uan chi* is an important textual counterpart to Li An-chung's painting. Written in 1121 by Han Cho, a member of the academy and a painter of landscape himself, the treatise indicates interests far different from those of the preceding period and enumerates many of the techniques and standards that would prevail throughout the later Sung period. One example from the text will indicate the new attitude:

> Master Kuo [Kuo Hsi, the great Northern Sung monumental landscape painter] wrote that there are three ways of representing distance in painting mountains: to look up at the top of a mountain from its base, with pale mountains in the background, is called "high distance"; to see from the front of a mountain through to its rear is called "deep distance"; to see from the side of a nearby mountain across to low-lying mountains is called "level distance." I have a theory about three additional ways of representing distance: from the near bank of a broad body of water, to see mountains far, far off is called "broad distance"; when mists and clouds cloak and obscure, and, cut off by a wilderness stream, one can see almost nothing beyond it, this is called "amorphous distance"; when the objects in a scene are extremely fragmentary and everything is indistinct and shrouded, this is called "mysterious distance."

High, deep, and level distance compositions and notions of space describe well the basic modes of Northern Sung monumental landscape and its concern for architectonic structure and tactile forms; even the terms imply an almost geometric certainty of mass and structure. Han Cho's new modes are wholly visual, indistinct, vague, suggestive. Each of them has precedent in mid- to late Northern Sung art, especially in the paintings of Kuo Hsi. Kuo's *Trees on a Low Plain* (Metropolitan Museum), painted in the 1070s, is an early example of Han's "amorphous distance." This is not at all surprising, considering that Kuo was a pillar of the earlier academy and that his follower Wang Shen (ca. 1046–after 1100) was a friend

Fig. 30. *Hermitage by a Pine-Covered Bluff*
Unknown artist; mid-12th century
Album leaf; ink and color on silk
The Metropolitan Museum of Art

and associate of Han Cho. Still, it is only in the twelfth century that we begin to find painting predominantly concerned with the visual effects of atmosphere, space, and emptiness implied in Han's "three distances." *Cottages in a Misty Grove* is amorphous not only in its cloaking mists and space, but in its absence of dramatic forms of any kind and its disinterest in structure of the earlier type. Unity of vision is here replacing the hierarchical sequential mode of Northern Sung, a unity achieved through the almost tangible suggestion of atmosphere.

If *Cottages* owes elements of its style to any painter other than Li An-chung, it would be to Chao Ta-nien (active ca. 1070–after 1100) of the Sung imperial family, whose *River Village in Clear Summer*, dated 1100 and now in the Museum of Fine Arts, Boston, anticipates many motivic features of *Cottages*, although not its richness of space and atmosphere or its easy, masterful manipulation of ink wash. Chao Ta-nien played an important role in refocusing vision on smaller worlds than the macrocosm, following the direction of Li Kung-lin and Mi Fu. An anonymous album leaf in the Metropolitan Museum, *Hermitage by a Pine-*

Covered Bluff (fig. 30), painted about the middle of the twelfth century, still shows elements related to Chao Ta-nien as well as to another of the key figures in the transition, Li T'ang. Here again the detail, isolated and fragmentary, stands for the whole, and the diagonal structure is insistent and systematic. All solid forms—rocks, trees, building, bridge—are packed into the dense right center, from which pours a stream that enters the soft, bending marsh grass and flows out until it merges with the water and the sky, as if the image were a metaphor for the dissolving of rock by water and the evaporation of water into air, an endless cycle enclosed within the revolving contour of the fan itself.

The mood of the painting—a hot summer day, no one visible behind the closed gates of the hermitage—is common to descriptions of summer, suggested repeatedly by poets from T'ao Ch'ien (died 427) to Fan Ch'eng-ta (died 1193). Fan's verse is exactly contemporary with the painting:

> Long and serene my solitary day
> Hedged in with summer, and never a passer-by,
> Except these bright-wing'd insect-travellers
> Going about their glittering affairs.

The lines suggest the solitude of the scene, which is emphasized by the reference to insects buzzing about in the heavy atmosphere. T'ao Ch'ien, the hermit poet, frequently described this secluded life of retirement, the slow passage of time through the long summer days, as in these lines, which are perfectly in harmony with the still remoteness of *Hermitage*:

> Here in the country human contacts are few
> On this narrow lane carriages seldom come.
> In broad daylight I keep my rustic gate closed,
> From the bare rooms all dusty thoughts are banned.

Fig. 31.
Watching Deer by a Pine-Shaded Stream
Ma Yüan, active ca. 1190–1225
Album leaf; ink and color on silk
Mr. and Mrs. A. Dean Perry collection, Cleveland

The style of this anonymous painting is very close to that of two other fans of roughly the same period in the National Palace Museum, Taipei. One, called *Pavilion by a Pine Bluff*, is signed by Yen Tz'u-p'ing, active in the third quarter of the twelfth century, and the other, *A Myriad Trees on Strange Peaks*, is attributed to Yen's teacher, Li T'ang. A photograph of the lower-right border of *Hermitage* taken before the painting's recent repair, cleaning, and remounting shows the traces of a tiny signature (see Appendix 1) between the trunks of two trees. The first of the two characters appears to read *Tz'u* as in Yen Tz'u-p'ing or in Yen Tz'u-yu, his younger brother. The younger Yen's style is quite different, however, and since the style of the Metropolitan's fan agrees closely with Tz'u-p'ing's only work with an indisputably authentic signature, the lost characters may have been his. The similarity of both *Hermitage* and *Pavilion* with *A Myriad Trees* might also indicate that the attribution of the latter work to Li T'ang should be reconsidered.

"On Visiting a Taoist Master at the Tai-t'ien Mountains and Not Finding Him"

The Southern Sung academy offers another excellent opportunity to evaluate standards of quality in Chinese painting. All the court artists working in Hangchow must have been subject to much the same training, requirements, and expectations. While this general uniformity of conditions did not by any means prevent individuality, it did, in effect, ensure the existence of a coherent school of painting. Surveying the artistic record of this school, Chinese critics have singled out two masters, Ma Yüan and Hsia Kuei (both active ca. 1190–1225), whose works epitomize the finest achievements of the academy as a whole. Of the two, it was probably Ma Yüan who most perfectly crystallized the formal and expressive potential of the small format. His achievements are well illustrated by two album leaves— *Watching Deer by a Pine-Shaded Stream* (fig. 31) in the collection of Mr. and Mrs. A. Dean Perry, Cleveland, and *Scholar by a Waterfall* (fig. 32) in the Metropolitan Museum.

Fig. 32.
Scholar by a Waterfall
Ma Yüan, active ca. 1190–1225
Album leaf; ink and color on silk
The Metropolitan Museum of Art

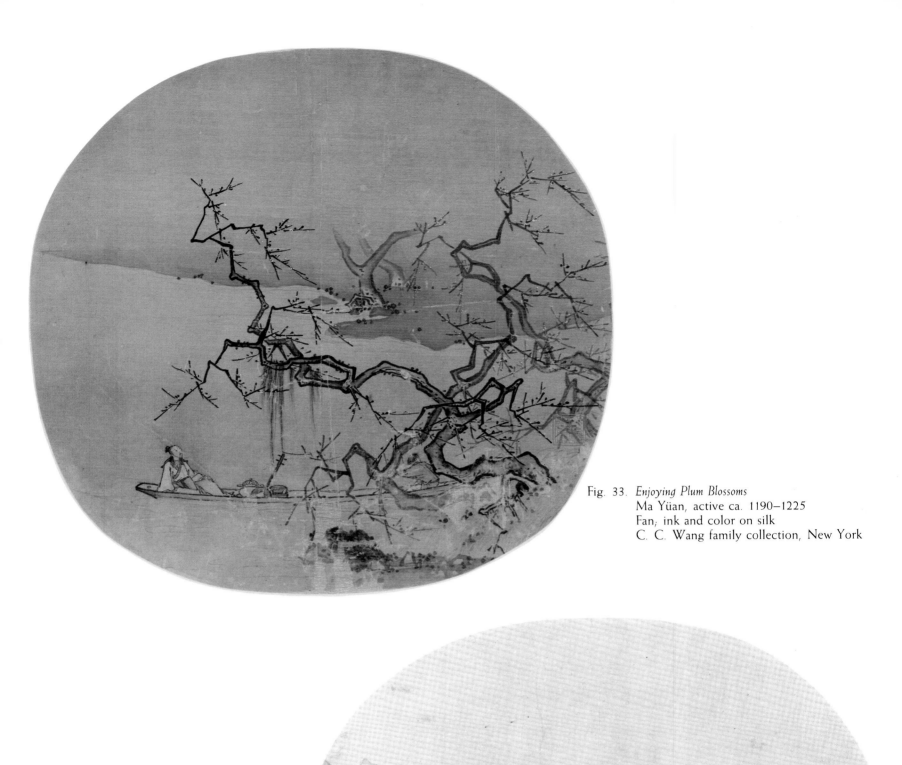

Fig. 33. *Enjoying Plum Blossoms*
Ma Yüan, active ca. 1190–1225
Fan; ink and color on silk
C. C. Wang family collection, New York

Fig. 34. *Plum Blossoms by Moonlight*
Ma Yüan, active ca. 1190–1225
Fan; ink and color on silk
John M. Crawford, Jr., collection, New York

The two rectangular album leaves, both measuring 9¾ by 10¼ inches, were long preserved as a matched pair, and they may well have been painted together. The same wooden balustrade appears in the two pictures, a feature too distinctive in its specific character to be accidental. It may also be that we are looking at the same wandering scholar and young attendant in both. If these works were originally a pair or two from a still larger group, then it is likely that behind them was a program of some kind. Since the same summer season is represented in both, it could not have been a seasonal cycle of the kind we know Ma Yüan painted. One suggestion is that they illustrate a poem by the T'ang poet Li Po, "On Visiting a Taoist Master at the Tai-t'ien Mountains and Not Finding Him":

> Where dogs seem to bark from roaring waters,
> Whose spray darkens the petals' colors,
> Deep in the woods deer at times are seen,
> At noon in the valley no bells can be heard.
> Wild bamboo cuts across bright clouds,
> A flying cascade hangs from a green peak.
> No one knows where you have gone,
> In my melancholy two, now three pines I have
> leant against.

The Perry picture would illustrate lines three and four—deer drinking at a stream in a quiet wooded valley—and the Metropolitan's picture lines five and six—clouds, cut by sharp bamboo, billowing through a ravine into which plunges the thin stream of a waterfall.

The formal idiom is one of sharp-cut rocks, dramatically angular pine, and soft, amorphous ink wash gradually obliterating forms lying beyond the foreground. James Cahill's description of the Perry album leaf suggests the formal and expressive character of nearly all of Ma Yüan's paintings:

> In delicate gradations of ink tone, he opens behind the sharply drawn foreground group a middle distance bounded by the dim silhouettes of leafy trees, and a limitless void beyond that. The gaze of the viewer is inevitably drawn back into this void, moving from the material world to one without substance; and the universal human proneness to associate space with spirituality gives to the experience a touch of the mystical.

If the relationship between Ma's paintings and Li Po's poem is as suggested, then the idea of spirituality is not accidental but the very point of poem and paintings: in failing to find his friend the Taoist master in the mountains, Li Po is silently instructed by the experience nevertheless. The journey to the mountains is a spiritual journey, and the poet, gazing down into the swirling waters or across at the peaceful deer, is the eternal pilgrim in search of enlightenment.

It is difficult to conceive a more perfect union of style and meaning than is conveyed in these small pages. The selection process involved in their creation is clearly crucial to successful expression. When great mountain ranges are suggested by only a few rocks or a bit of a hill, when all the trees of the forest become a single pine, and when half the compositional surface is treated as amorphous space without visible forms, then everything in this reduced world must be precisely right. Otherwise the impact of the crystallized, focused vision is lost through diffusion or overelaboration. Everything depends upon the immediate apprehension of fleeting phenomena.

A case in point is a round fan in the Wang collection attributed to Ma Yüan, titled *Enjoying Plum Blossoms* (fig. 33). As with the previous pair, this fan too was originally part of a set of matching compositions illustrating a common theme. Possibly in such instances,

judging by the pair just discussed, only one of a set was ordinarily signed. Here, Ma Yüan's signature is found only on the matching fan, *Plum Blossoms by Moonlight* (fig. 34), in the collection of John M. Crawford, Jr., New York; the Wang fan is unsigned. The two are again virtually identical in measurement. It seems likely that both illustrate some of the "twenty-six fitting occasions for plum blossoms" defined by the late twelfth-century connoisseur of plum blossoms, Chang Tzu. Chang cited the following circumstances, among others, as particularly appropriate ones in which to admire the purity and beauty of the flower:

> In light shadows,
> In the morning sun,
> In slight cold,
> In fine rain,
> In thin mist,
> Under a fine moon,
> In the setting sun,
> In faint snow,
> Among evening clouds,
> On a clear stream,
> From hoary cliffs,
> By green moss,
> With a *ch'in* [zither] across one's lap.

The painter may have combined several of these conditions for each composition, or perhaps poems combining them had been composed. One such poem, by Yang Wan-li (1127–1206), one of the finest Southern Sung poets, has been cited by its translator, Jonathan Chaves, as echoing the Crawford fan:

> I stand by the stream waiting for the moon to rise,
> but the moon knows my impatience and takes its time.
> Tired of waiting, I go home and close the door;
> suddenly the moon comes flying up over a thousand peaks.
> So I climb to the Fishing Boat cliff in the snow and
> gaze at the icy wheel hanging from the pine tips.
> "As a rule, poets prefer the mid-autumn moon," someone
> says, but I shake my head:
> "The twelfth month is the month for the moon,
> when it's washed by snowflakes and scoured by frost.
> Ten thousand miles of deep blue sky, like a pond
> with a plate of white jade floating across it,
> And then there are the plum blossoms . . .
> Mid-autumn has none of these things."

Such compositions were so common among scholars and so similar in setting and focus that it is impossible to be more precise about the actual poetic counterpart to the painting. It is a striking feature of the Crawford fan, however, that the cliff at the left looks very much like the "Fishing Boat cliff" to which the poet climbs.

Chang Tzu's capsulation provides all of the prized elements employed by Ma Yüan. On the Crawford fan, a scholar has climbed high into the mountains, not forgetting his *ch'in* carried by his attendant, to look out at the moon under the blossoming wild plums. In the scene on the Wang fan, he drifts along a moonlit stream through evening mist as the looming black branches of the plum approach and fade, spreading fragrance through the air.

Artistic quality in the two fans is closely comparable, but some will regard the Crawford fan as the finer work of art, a judgment based in great part on the artist's selection process. the ink tonality and the structure of the composition are focused on the twisted old plum tree in the center. Surrounding forms are subordinated to it and all call attention to the line of vision linking the seated scholar and the moon. In the Wang fan there is less clarity; moss hangs heavily from the central tree and there is a more complex and ambiguous structure. Perhaps these features can be attributed to the shadowed mysterious effect the painter wished to achieve, in contrast to the silvery clarity of his moonlit night.

In any case, the almost identical measurements, same silk, and similar style of the two pictures make certain the conclusion that they were painted by the same hand. Naturally, the question must be raised whether that hand is Ma Yüan's or an early follower's. The point can be argued, but I believe Ma Yüan was the painter—in one instance, succeeding and, in the other, failing to achieve the correct balance of forms, tonality, and structure.

Ma Yüan's art, like that of nearly all Chinese painters, has not yet been systematically studied, and his oeuvre is not clearly defined. Paintings with his signature range broadly in style—something one expects of any artist—even after those works clearly later in date have been set aside. It is possible that some paintings freer and looser in technique than the pairs we have examined represent either his later manner or his informal personal style. Two round fans in the Wang collection, *Scholar and Crane* (fig. 35) and *Scholar by a Pine Stream* (fig. 36), of virtually identical measurement and apparently identical silk, are of this character. The signatures here are more freely written than on the Metropolitan and Crawford fans, and lack the character *ch'en*, which, on court-commissioned works, precedes the artist's name. This omission implies that Ma did not do these works at imperial order, but as a private artist for private reasons. The delicacy and sharp precision of the brushwork noted elsewhere as typical of Ma's style are here replaced by a blunt, strong technique of brush drawing and more broadly applied washes of ink, more swiftly and easily done, it seems, than in more characteristic works. Arguing most strongly for the hand of Ma Yüan, especially in *Scholar by a Pine Stream*, are the finely ordered structure of space and the tense balance of elements focused upon the seated figure, whose meditation is the point and purpose of the painting. The vision of a painter and the perceptions of a time abide within the wide range of techniques and styles that convey them.

We have no textual evidence to tell us how long Ma Yüan lived, whether he retired from court service or when, or whether, like some later court painters, he maintained a private studio as painting master and there, in addition to his official duties, served a wider audience. The paintings plausibly bearing his signature, however, suggest that he was a more complex artist than the almost nonexistent records indicate, and perhaps we will one day learn to read these works both as art and as documents.

It should also not escape attention that all of the paintings here ascribed to Ma Yüan appear to have been parts of sets or pairs of compositions on a variety of poetic themes. They are thus not quite the frozen vignettes they sometimes seem, but were intended to form a linked succession of lyrical moments far more like the character of the handscroll— and of poetry—than has been noticed. What they are today is not what they once were, and time has lent them a mystery and distance far from their intended purpose.

Another case in point is *Windswept Shore* (fig. 37), a landscape fan in the Metropolitan that was painted by a follower of Hsia Kuei, Ma Yüan's greatest contemporary. While the exact title and theme of the painting are not known, upon examination of the figures it becomes clear that the subject of the fan is the parting of two old friends, one of whom kneels in sorrow in the boat that ferries him from the shore, while the other turns and walks dejectedly away. Around them sweeps a strong wind, whipping the leaves and emphasizing the melancholy mood. The scene recalls any number of poems on the theme of parting, possibly the single most common subject in Chinese poetry. This one is by Wang Wei:

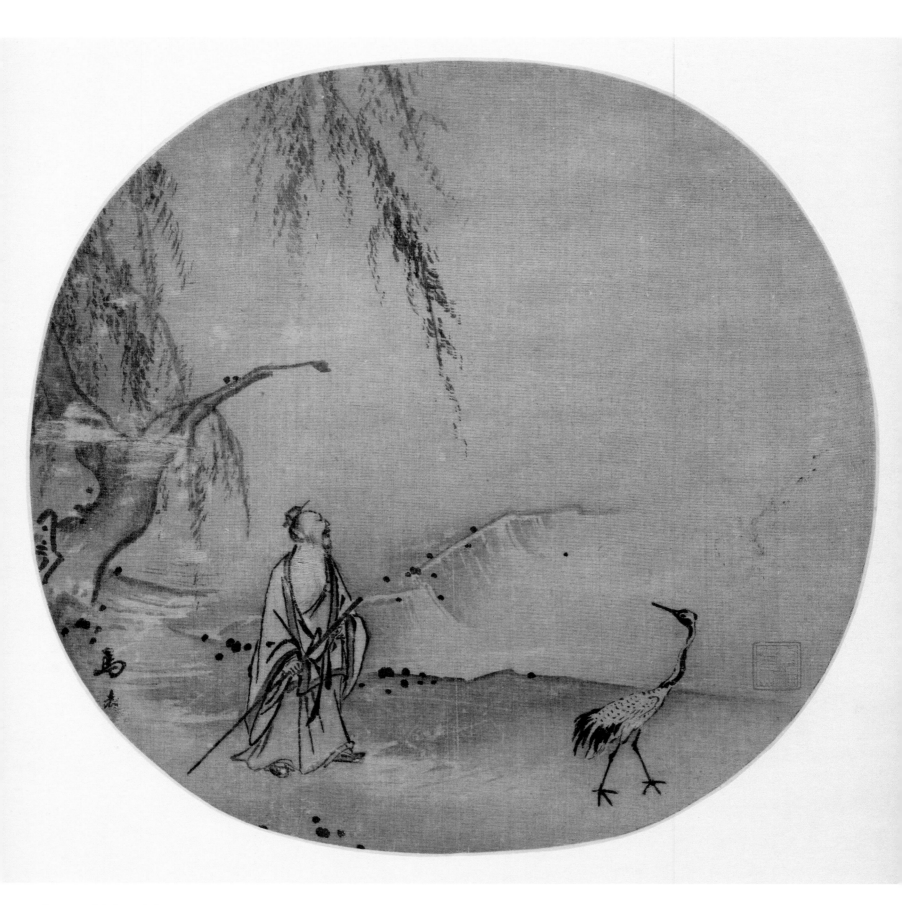

Fig. 35. *Scholar and Crane*
Ma Yüan, active ca. 1190–1225
Fan; ink on silk
C. C. Wang family collection, New York

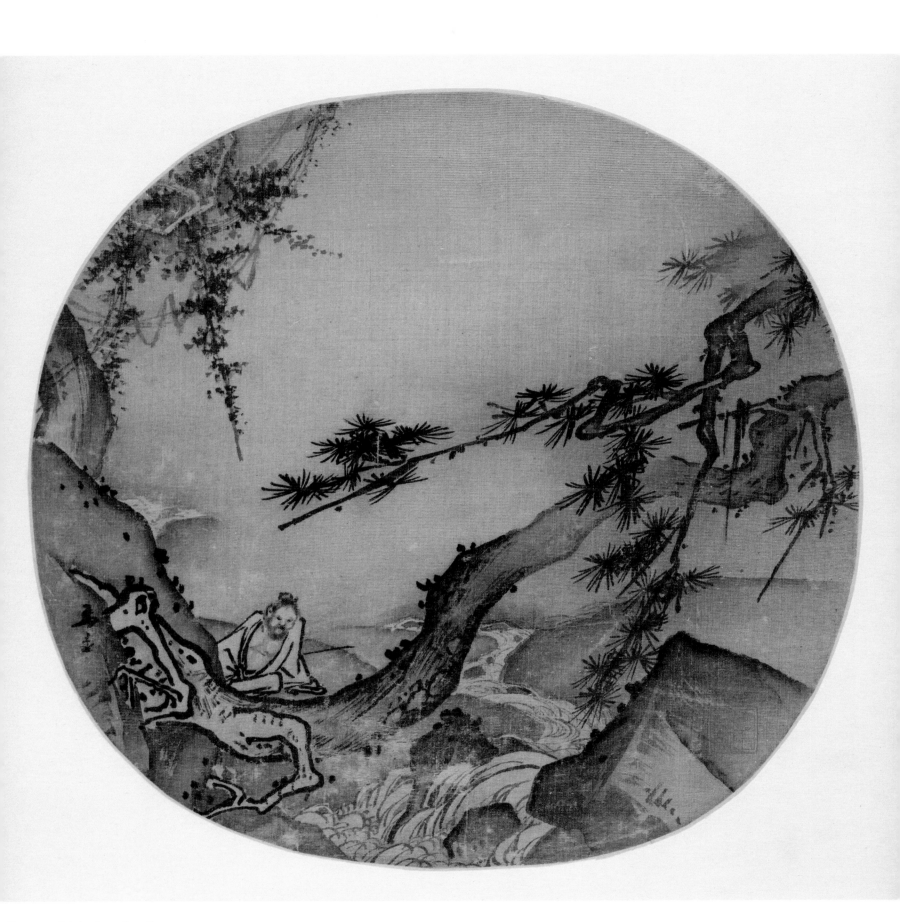

Fig. 36. *Scholar by a Pine Stream*
Ma Yüan, active ca. 1190–1225
Fan; ink on silk
C. C. Wang family collection, New York

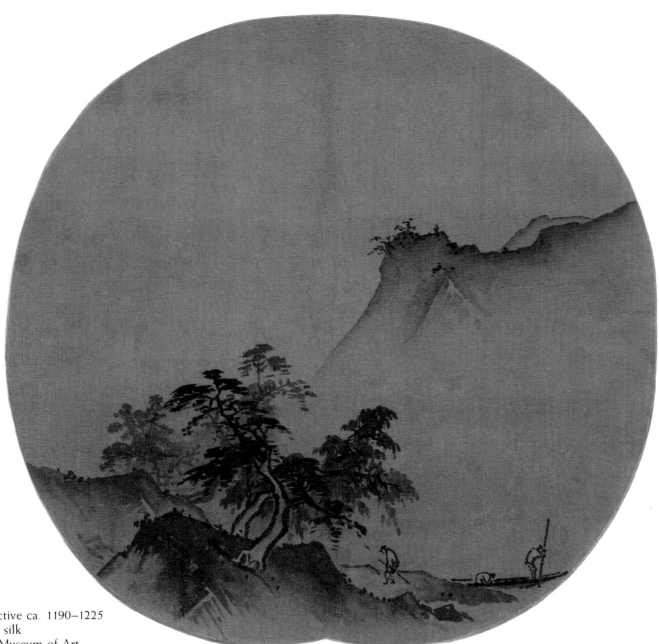

Fig. 37. *Windswept Shore*
After Hsia Kuei, active ca. 1190–1225
Album leaf; ink on silk
The Metropolitan Museum of Art

> I see you off by the southern shore, my tears like threads.
> Your departure for the eastern provinces causes me grief.
> You can tell them their old friend is haggard,
> No longer what he was in those Lo-yang days.

Or again:

> Far mountains sharp on the cold sky
> Long river racing in the dusk,
> Boat cast off and you drift away
> Beyond my gaze while I stand here still.

Hsia Kuei never emphasizes his human actors to the extent that Ma Yüan does. Hsia's subject is more obviously landscape and he paints it in a more broadly washed style. Poetic sentiment seems to have been less important to him as well, and in his great *Pure and Remote Views of Streams and Mountains* (National Palace Museum, Taipei) he created one of the few extant Southern Sung examples of pure landscape on a monumental scale unrelated to literary sources. In the Metropolitan's fan, nonetheless, the abbreviated landscape com-

position takes its meaning and expression directly from the tiny figures in it in a manner common to Chinese poetry, especially of the kind that speaks of human affairs only after a description of nature. Wang Wei's well-known "Song of Wei City" is a perfect example:

> The morning rain of Wei City wets the white dust.
> The inns are green with willows in spring.
> May I advise you to empty one more cup,
> For west of the Yang Pass you will find no old friends.

After we locate the meaning of the landscape in its human significance, we then read back into it a greater expressive function than it had on first reading. Similarly, when we realize what the figures in the Metropolitan painting are doing, we realize better what the landscape is meant to suggest.

Chickadee, Plum Blossoms, and Bamboo

The repertoire of the Southern Sung academy included virtually all of the traditional subjects, from hallowed figure narratives such as *Duke Wen of Chin Recovering His State* and *Eighteen Songs of a Nomad Flute* through landscape; bird and flower subjects; genre painting; fish, dragons, and insects; and bamboo, plum blossoms, and orchids. The bird and flower painting of the academy may represent the quintessence of the entire Southern Sung aesthetic; certainly it represents the nearest thing to magic realism in all Chinese art.

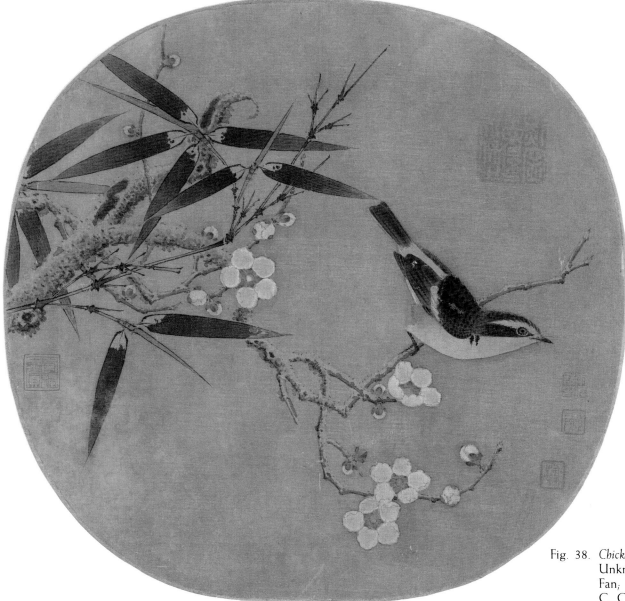

Fig. 38. *Chickadee, Plum Blossoms, and Bamboo*
Unknown artist
Fan; color on silk
C. C. Wang family collection, New York

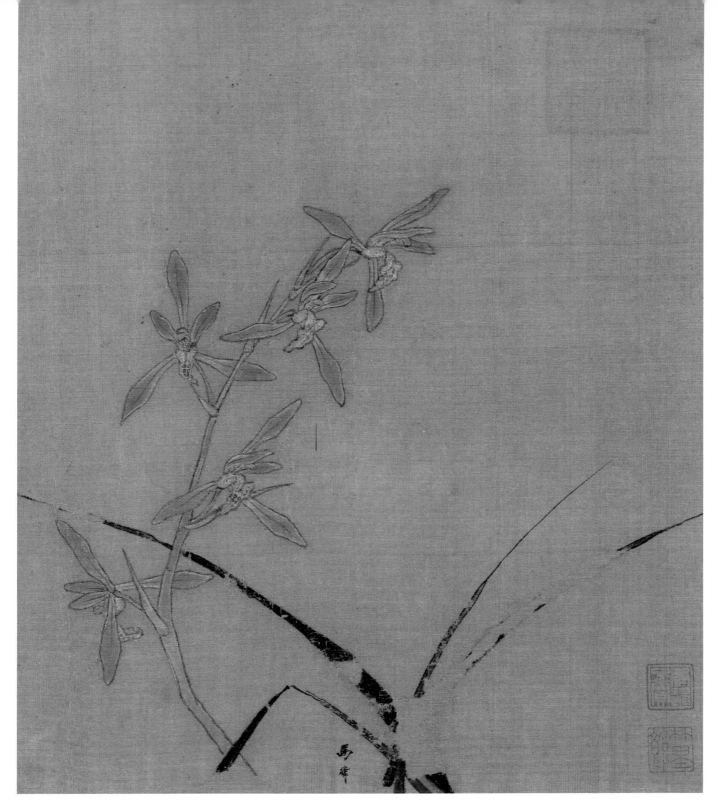

Fig. 39. *Orchids*
Ma Lin, active ca. 1250
Album leaf; ink and color on silk
The Metropolitan Museum of Art

 Chickadee, Plum Blossoms, and Bamboo (fig. 38) is an unsigned painting in a minutely descriptive, colorful style associated with two academicians, Lin Ch'un (active ca. 1174–89) and Wu Ping (active 1190–95). It is possible that Lin Ch'un is the painter of the fan, since it agrees closely with the best of his signed works. However, the manner is derived from that favored by Emperor Hui-tsung in his own painting and in his academy during the first quarter of the twelfth century, and it changed very little thereafter until the end of the Sung dynasty. It is characterized by an artful arrangement of a few carefully selected elements, each one carefully described: in this case, a yellow-tinged chickadee perched on the branch of a flowering plum tree pierced by a shoot of bamboo. Technique and brush mannerisms of the kind common to contemporary landscape painting are totally subservient to preci-

sion of representation, even to the point, unusual in Chinese painting, of maintaining throughout the structure of the twisting branch the appearance of natural light falling from above. The perky little bird seems to have just alighted on the slender branch, pushing it down with his weight and still finding his balance; but this fragile sense of slight movement is unfortunately flawed by the artist's placement of the bird's tail too close to the bamboo leaf above it. On that account it might be concluded that, despite its many fine qualities, the painting is not entirely successful.

Flawed only by the damage of time is Ma Lin's *Orchids* (fig. 39), one of the finest Sung flower paintings to survive and as restrained a statement of the flower's delicate beauty as there is in art. In a typically irregular composition of line and pale colors, the painter—active about 1250, son of Ma Yüan, and last of the great Ma family of Sung academicians — etched out the slender petals in tones of lavender heightened by opaque white within precise ink outlines that are deliberately encroached upon and softened by the color. The crisscrossing accents of the leaves below—which have lost much of their original green pigment—continue to function in formal opposition to the all but transparent blossoms drifting above them, emphasizing what Wen Fong has called "the principle of yin and yang asymmetrical balance."

Fig. 40. *Birds in a Tree Above a Cataract*
 Li Ti, 12th century
 Album leaf; color on silk
 Mr. and Mrs. A. Dean Perry collection, Cleveland

Surprisingly, it is often possible to see Southern Sung paintings as embodiments of these fundamental cosmic principles. Upon even cursory examination these works prove to be balanced interweavings of solid and void, empty and full, still and moving, animate and inanimate, silence within sound. One last example appears to embody perfectly this interaction, an album leaf called *Birds in a Tree Above a Cataract* (fig. 40), painted by a twelfth-century academician named Li Ti. The theme was beloved of Southern Sung painters for reasons not altogether clear. Dozens of similar compositions still exist, although *Birds in a Tree* is possibly the finest of them all. The tense, powerful composition, measuring not quite ten inches high, is dominated by a twisted old cypress tree growing from a pile of boulders, its base surrounded by green bamboo. Below roars a swift mountain cataract crashing into waves through a rocky defile. These elements in their various ways suggest powerful forces —rocks, an ancient tree, rushing water—in an eternal struggle of cosmic energy. The pounding noise of the waves is almost audible.

Yet two birds sit quietly together on a dead branch outstretched over the water, beautiful symmetrical creatures poised in peaceful harmony with their raging environment. Expressively, they correspond to the wandering scholar of Ma Yüan's paintings (except that they have already attained what he still seeks), to the closed gates of Li An-chung's *Cottages* and the anonymous *Hermitage*, and to the parting friends in the Hsia Kuei-style fan. They are the "eye" of the world that the painter creates.

Writing of the creation of poetry, Su Shih (1036–1101) said:

> If you want poetry to be miraculous
> Nothing works better than being empty and tranquil.
> In tranquillity, one perceives everything in motion;
> In the state of emptiness, one takes in all the aspects.

In Li Ti's painting, the birds supply that point of stillness, quiet, and meditation through which all else takes on meaning.

4

Patriots and Dreamers

與女遊兮九河衝風起兮橫波乘水車兮荷蓋駕兩龍兮驂螭登崑
崙兮四望心飛揚兮浩蕩日將暮兮悵忘歸惟極浦兮寤懷魚鱗
屋兮龍堂紫貝闕兮朱宮靈何爲兮水中乘白黿兮逐文魚與女遊
兮河之渚流澌紛兮將來下兮交手兮東行送美人兮南浦波滔
兮來迎魚隣隣兮媵予

右河伯

Fig. 41. *The Nine Songs of Ch'ü Yüan*, last leaf dated 1305
Attributed to Chao Meng-fu, 1254–1322
"The Lord of the Yellow River"
Detail
Leaf from an album of eleven paintings; ink on paper
The Metropolitan Museum of Art

Figure Paintings of the Yüan Dynasty
(1279–1368)

It has become traditional in writing of the history of Chinese painting to make a sharp artistic demarcation around the beginning of the last quarter of the thirteenth century, coinciding with the destruction of the Sung government by the Mongols—the Sung capital, Hangchow, was seized in 1276, and the last claimant to the Sung throne died a suicide in 1279—and the establishment of a new foreign dynasty, the Yüan. It would indeed be surprising if so traumatic a national disaster, the first foreign occupation of all of China in the country's history, had not been accompanied by changes in art. To cite two obvious examples, the Southern Sung Imperial Painting Academy ceased immediately to exist, and the imperial court ceased to be the focus of artistic patronage and the center of artistic activity.

Perhaps most important in accounting for the changes in art in the late thirteenth century is the fact that from 1126—the year the Chin Tartars sacked the Northern Sung capital and seized all of north China—until the Mongol defeat of Southern Sung in 1279, China was a severed state with virtually total separation of the north and south. While the south saw the development of the academic styles we have considered, in the north under the Chin, Chinese scholars and artists followed different interests. On the one hand emulating the styles of the great Northern Sung masters of monumental landscape, and on the other continuing the innovations of such late Northern Sung literati as Su Shih, Wen T'ung, Mi Fu, and Li Kung-lin, the northern artists evolved styles and ideas about art that anticipate many of the developments subsequently achieved under the Yüan.

These two separate avenues were brought together only by the Mongol conquest. What distinguishes the art of painting in the early Yüan period, therefore, is its wholeness, its reunification of the north and the south. Until very recently, the entire artistic experience of north China under the Chin Tartars was scarcely known, and only now are we beginning to realize that there was far more continuity of development between Northern Sung and early Yüan, via the Chin, than had been suspected. It follows, too, that the imagined break between Sung and Yüan has been much exaggerated, although as in any period of new government, new sponsorship, and new kinds of social conditions, there was of course much change as well.

Many of the novel features of Yüan painting that distinguish it from that of the Sung grew in various ways from the dramatic reversal in the proportion of professional painters to amateur painters. Most of the Sung paintings we have surveyed were done by professional artists, most of the Yüan paintings by amateurs. The Yüan dynasty clearly represents the final triumph of the scholarly ideals first formulated by the late Northern Sung literati. But we must clarify what is meant by "amateur," since social circumstances were now much changed by the Mongol occupation of China.

In his glorification of the amateur ideal in painting, Su Shih envisioned a scholar trained in the classics and in history, poetry, and calligraphy, a government official by career, concerned on a day-to-day basis with the administration of his post and concerned intellectually with the welfare of the state and of the people. In his leisure the scholar-painter might write commentaries on the classics or on history, compose poetry in the company of friends,

edit old texts, compile records of events or of people—and from time to time in a moment of inspiration or self-amusement, he might paint a picture. He would naturally be able to do this, first because by lifelong practice he was a master of the calligrapher's brush, and second because as a scholar he would have made the study of ancient paintings his responsibility and would be able to comment knowledgeably on questions of style, provenance, and meaning. But he could not paint as true painters did, because he did not have the techniques or professional craft common only to master painters. Instead, he created "ink-plays," something any calligrapher could do.

With the victory of the Mongols, many scholars, either through personal choice or because traditional avenues were closed, found themselves cut off from official careers and chose instead to lead itinerant lives as fortune-tellers, geomancers, monks, schoolteachers, or farmers, muddling out a livelihood one way or another. For this new kind of "commoner," no longer able or willing to don the old garb of Confucian public official and thereby acquire his major identity, it became doubly important not only to preserve the Chinese past but to continue avidly the traditional cultural activities of the elite. Scholarship, poetry, calligraphy, and painting, in other words, now became the principal means of self-occupation and expression. "Ink-plays," against this radically changed background, were vested with a meaning and significance they had not had before.

The Nine Songs of Ch'ü Yüan

As in the Sung period, the most admirable achievements of figure and narrative painters during the Yüan dynasty were in the form of wall paintings for the great Taoist and Buddhist temples and for the new palaces built by the Mongols in present-day Peking. The examples that remain today—such as Yung-lo kung, a Taoist temple near Ta-t'ung, and the dismantled walls preserved in the Royal Ontario Museum in Toronto, the Metropolitan Museum, and elsewhere—represent a continuation of the highest level of professional workmanship in the ancient wall-painting format. By the Yüan period, however, the artists responsible for such work had come to be regarded as mere craftsmen, their lives and usually even their names not recorded, their attitudes toward art and the mechanics of their practice of it nowhere preserved. The unfortunate fate of the classical art of public figure painting was its decline in the eyes of connoisseurs to the level of decoration. Figure painting did not die, however, but took new form in the hands of scholar-painters, who sought now to regularize the manner of painting begun by the scholar-artists of the late Northern Sung period. By separating the subjects of painting into categories—figure and narrative; landscape; and tree, bamboo, and rock—we will examine the process by which the new mode, the art of the scholar-painter, was formalized and fashioned into a vehicle adequate for the expression of personality, character, thought, and emotion in the hands of the new scholarly amateur painter of the Yüan period.

The author of The Nine Songs, Ch'ü Yüan, was a third-century B.C. statesman and poet who drowned himself out of loyalty to his prince, who mistrusted him. His songs are shamanistic evocations of the spirit world, their titles suggesting something of their nature: "The Great One, Lord of the Eastern World," "The Lord Within the Clouds," "The Princess and the Lady of the Hsiang River," "The Greater Controller of Fate," and so forth. David Hawkes's explanation of the original use of the songs in shamanistic ritual stresses the side of them most esoteric and colorful and yet least important to later artists:

> Male or female shamans ... having first purified and perfumed themselves
> and dressed up in gorgeous costumes, sing and dance to the accompa-
> niment of music, drawing the gods down from heaven in a kind of divine
> courtship. The religion of which these songs are a liturgy is a frankly
> erotic one.

While the colorful drama and ritual embodied in the songs and their imagery survived as a literary treasure, the image of Ch'ü Yüan himself gradually grew in importance over the centuries until he stood for the concept of faithfulness and loyalty until death. Therefore, when the cycle was first portrayed by Li Kung-lin in the late eleventh century, his subject was not shamanistic ritual deities but the ideal of loyalty. Li's own paintings of the subject do not survive but something of their appearance can be seen, first by glancing back at his illustrations for *The Classic of Filial Piety* and then by looking at two of the many versions done after his work by Yüan painters, who made of his model a classic standard to be re-created again and again. It is this process of identifying a classic model, revising it, and re-creating it that stands at the heart of the scholar-artist reformation of the art of painting in the early Yüan period.

The earliest extant Yüan version of *The Nine Songs*, an album in the Metropolitan Museum, is attributed to Chao Meng-fu (1254–1322), a master repeatedly encountered in any examination of the origins of Yüan art. The last leaf bears an inscription by Chao dated 1305, and the work is the first in a sequence of paintings on the subject done in the fourteenth century. The style is the *pai-miao* plain line manner of Li Kung-lin; according to associated documents, the model was a version painted by Li Kung-lin. Chao is creatively imitating an earlier master, as he was to do with many other subjects and styles.

The eighth of the *Songs* (which, despite their title, number eleven in all) sings of the Lord of the Yellow River (fig. 41), a deity who controlled the forces of China's greatest river, and reads in part:

> I wander with you by the nine mouths of the river
> When the storm wind rises and lashes up the waves.
> I ride a water chariot with a canopy of lotus;
> Two dragons draw it, between two water serpents.

This consort of dragons and serpents, controller of floods, to whom in ancient China annual sacrifice of young brides was made, is represented by Chao Meng-fu as a handsome, finely bearded scholar seated on a tortoise, his robe gently swirling around him. There is no myth, no color, no drama, no otherworldly power; only the suave black and gray lines of a master brushman harmoniously weaving a rhythmic pattern.

Fig. 42. *The Nine Songs of Ch'ü Yüan*
 Attributed to Chang Tun-li, 13th century
 "The Princess and the Lady of the Hsiang River"
 Section of a handscroll; color on silk
 Museum of Fine Arts, Boston

The conscious aesthetic choice made by Chao Meng-fu in emulating Li Kung-lin's model is suggested by a comparison of Chao's work with another version of the subject in the Museum of Fine Arts, Boston. This thirteenth-century painting (fig. 42) attributed to the Southern Sung academician Chang Tun-li captures the lyrical and sweetly intense melancholy of some of the songs, particularly "The Princess of the Hsiang River" and "The Lady of the Hsiang River." These two songs tell the story of Emperor Yao's two daughters, who were believed to have drowned in the Hsiang River, thus becoming the guardian spirits of the river. Something of the mournful autumnal symbolism of the two women is suggested in the opening of the fourth song:

帝子降兮北渚目眇眇兮愁予嫋嫋兮秋風洞庭波兮木葉下登白薠兮騁望兮與佳期兮夕張鳥何萃兮蘋中罾何為兮木上沅有芷兮澧有蘭思公子兮未敢言荒忽兮遠望觀流水兮潺湲麋何食兮庭中蛟何為兮水裔朝馳余馬兮江皋夕濟兮西澨聞佳人兮召余兮將騰駕偕逝築室兮水中葺之兮荷蓋蓀壁兮紫壇匊芳椒兮成堂桂棟兮蘭橑辛夷楣兮藥房罔薜荔兮為帷擗蕙櫋兮既張白玉兮為鎮疏石蘭兮為芳芷葺兮荷屋繚之兮杜衡合百草兮實庭建芳馨兮廡門九嶷繽兮並迎靈之來兮如雲捐余袂兮江中遺余褋兮澧浦搴汀洲兮杜若將以遺兮遠者時不可兮驟得聊逍遙兮容與

右湘夫人

The emperor's child, descending the northern bank,
Turns on me her eyes that are dark with longing.
Gently the winds of autumn whisper;
On the waves of Tung-t'ing Lake the leaves are falling.

The autumn wind, the falling leaves, the waves, and the sad doomed women are all combined in the Southern Sung composition: trees, trailing vines, the water, and the delicate colors of the autumn landscape all echo the emotions and symbolic attributes of the female images.

Fig. 43.
The Nine Songs of Ch'ü Yüan
Attributed to Chao Meng-fu
"The Lady of the Hsiang River"
Detail
(see fig. 41)

Fig. 44. *The Nine Songs of Ch'ü Yüan*, dated 1360
Chang Wu, active ca. 1336–64
"The Lady of the Hsiang River and Female Attendant"
Section of a handscroll; ink on paper
The Cleveland Museum of Art

Fig. 45. *Liu Ch'en and Yüan Chao Entering the T'ien-t'ai Mountains*
Chao Ts'ang-yün, 14th century
"Entering the Mountains and Crossing the Stream"
Section of a handscroll; ink on paper
C. C. Wang family collection, New York

Chao Meng-fu, in his version of the subject (fig. 43), suggests only something of the waves, joining their delicate woven pattern to the curving lines of his goddess's dress, choosing as color only the blackness of her hair. All traditional painterly techniques have been rejected in favor of the pure brush line and black ink. If Chang Tun-li's composition is painterly and rich in feeling, Chao Meng-fu's is spartan and severe in its restraint.

Much less severity is seen in a version of the subject (fig. 44) painted in 1360 by Chang Wu (active ca. 1336–64). Chang achieves an extraordinary delicacy and subtlety of brush line and an interplay of ink tonalities that result in an effect of ethereality curiously comparable to Chang Tun-li's, although through entirely different means. Chang Wu's *Nine Songs*, the epitome of refinement and grace of line, is the creative end of the cycle of *pai-miao* figure painting that began with Li Kung-lin in the eleventh century. The style thereafter could be plain and simple, as with Chao Meng-fu, or delicate and elaborate, as with Chang Wu, but the basic elements of plain brush line and isolated figures were fixed and given, a classical model to be repeated and varied ad infinitum but never to be fundamentally changed.

Outside of the still vital sphere of Buddhist and Taoist figure painting, the old subject was approaching the end of its vitality. Such scholars as Chao Meng-fu had already realized that there were far greater spheres for expression in other subjects and that the rigorous forms of representation required in figure subjects were becoming the exclusive province of professional painting masters, who alone cultivated the necessary skills. Such themes as *The Nine Songs* functioned much as a revered literary text that could be written over and over in a refined, elegant classical hand as a kind of performance. The creative spark was gone, and at the elite scholar-artist level there were no new subjects or styles in figure paintings.

Liu Ch'en and Yüan Chao Entering the T'ien-t'ai Mountains

Fortunately, other types of painting continued to flourish, and at the popular level new kinds of narrative still appeared. One of the most interesting of such works is the scroll *Liu Ch'en and Yüan Chao Entering the T'ien-t'ai Mountains* (fig. 45). The artist signs himself "Moun-

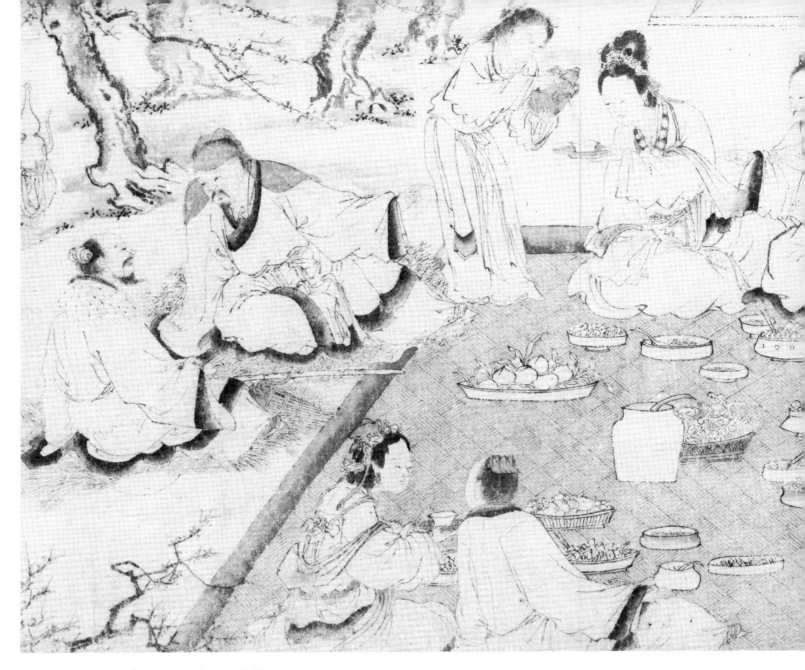

Fig. 46. *Liu Ch'en and Yüan Chao Entering the T'ien-t'ai Mountains*
"Feasting"

tain Man Ts'ang-yün." In the work's first colophon (see Appendix 1), by Hua Yu-wu, dated 1379, the painter is identified as Chao Ts'ang-yün, a fourteenth-century Taoist descended from the Sung imperial family and hence related to Chao Meng-fu. The scroll is one of the rare "solitary traces" (*ku-pen*) that provide the only extant information about their authors.

The painting illustrates an ancient Chinese tale, reminiscent of the Rip Van Winkle legend, that relates the adventures of the Han dynasty scholars Liu Ch'en and Yüan Chao. The two men travel into the sacred T'ien-t'ai mountains in search of herbal medicines, wander about until their food is gone, and then eat some peaches they discover growing wild. Two beautiful young women appear, welcome the scholars by name, and entertain them for several weeks in the company of other immortals (fig. 46) until the two men decide they must return home. They find that seven generations have passed during their brief absence and no one knows them. In 287, according to the story, after trying and failing to find their way back to the lost land of immortality, the two scholars disappear into the T'ien-t'ai mountains, never to be heard from again.

The narrative is developed in a variation of the familiar manner: most of the pictures are preceded by a section of text, but the third, fourth, and fifth episodes are joined pictorially, ending with the first appearance of the two young women. Using only black ink and shades of wash throughout, the painter achieves a rich visual effect with landscape settings, decorative patterns, subtle manipulation of black and gray accents, and picturesque

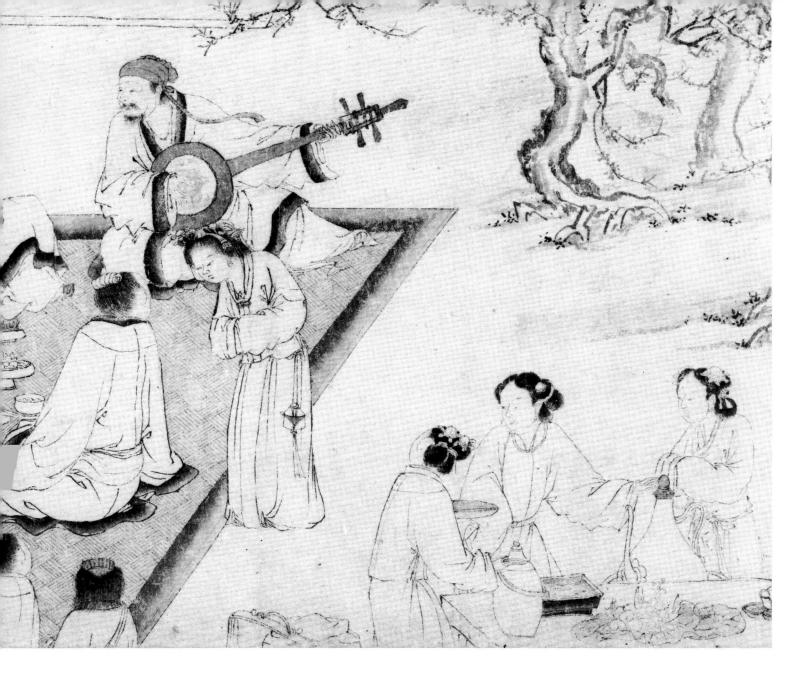

details of expression, gesture, and costume. Several details from the climactic banquet scene, in which the main characters are joined by an assortment of Taoist immortals, reveal the painter's sure feeling for lively characterization and effective human interaction.

The unknown Chao Ts'ang-yün obviously shares a great deal with his contemporary playwrights, the authors of the newly popular *tsa-chü*, or musical dramas, forerunners of the Peking Opera. The playwrights often recounted similar popular stories of the supernatural. Apparently, of the hundreds of paintings illustrating such tales that must have been done in the late Sung, Chin, and Yüan periods, this is the only one to have survived, a possibility that lends additional significance to its role as the only extant work of the artist.

From the style of the painting and the calligraphy and from the information given in the 1379 colophon, *Liu Ch'en and Yüan Chao Entering the T'ien-t'ai Mountains* may be tentatively dated from the early to the middle of the fourteenth century. The work suggests that the Li Kung-lin *pai-miao* style was current among the still little-known group of Taoist painters active in the Yüan period, since Chao Ts'ang-yün is clearly identified as a Taoist adept and his subject is a specifically Taoist one. Few other paintings of the time succeed so well in conveying the delightfully human qualities essential to narrative illustration.

5

Return to the Past

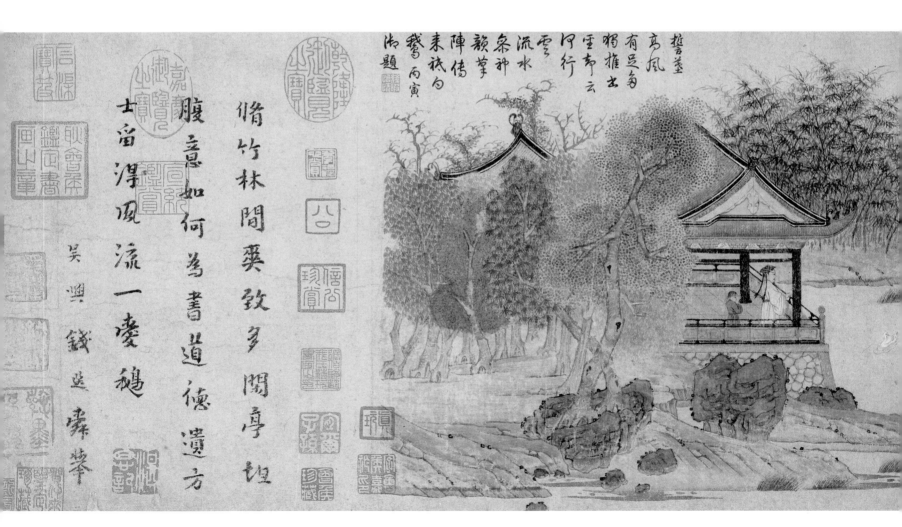

誓蓋
高風
有足多
媧推出
王希云
可行
流水
雪
条神
頴葦
陣偁
素被句
鵞而寅
御題

偕竹林間藥致多闍亭趨
腹意如何為書道德遺方
士當淳風流一麈穐
吳興錢選霥犖

Fig. 47. *Wang Hsi-chih Watching Geese*
Ch'ien Hsüan, ca. 1235–after 1300
Handscroll; ink, color, and gold on paper
The Metropolitan Museum of Art

Landscape Paintings of the Early Yüan Period

Wang Hsi-chih Watching Geese

Wang Hsi-chih (303?–361?), the "prince of calligraphers," greatest and most influential of all masters of the brush, was believed to have gained insight into the potential of the brush for graceful, energetic movement by studying such natural phenomena as clouds drifting and water flowing. He is depicted here watching the movements of geese from a pavilion by a river (fig. 47). As prototypical master of the essential art of Chinese scholars, Wang assumed the status of culture hero; he embodied the creative genius of the scholar class.

Stylistically, a greater contrast than that between this colorful composition and any of the monochromatic Sung paintings that have been considered would be difficult to imagine. Because of its utilization of mineral pigments in the blue green palette, the style falls into the old category called "blue and green landscape." The mode, at times enhanced by the addition of gold and silver, had achieved its initial popularity in the early T'ang period. Sung paintings in this style seem not to have been as sharply linear and schematic as T'ang

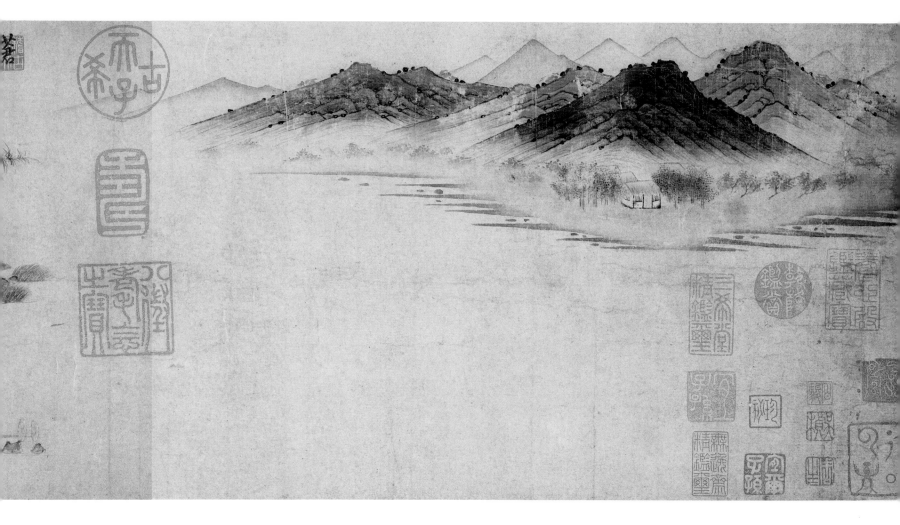

examples or the present work, but softer and more organically conceived, suggesting that Ch'ien Hsüan (ca. 1235–after 1300), the painter of *Wang Hsi-chih Watching Geese*, was deliberately returning to an archaic stage in the evolution of the style, perhaps considering it more in keeping with the historical period his painting illustrates. All of Ch'ien's figure paintings are concerned with Six Dynasties and T'ang subject matter, and his antique style is vaguely in harmony with that era.

However, the sensuous charm and beauty of Ch'ien Hsüan's color is not really very much like any earlier art. His bright color fields, his relatively insignificant use of ink in favor of direct painting in transparent colors, his vibrant, decorative texture motifs and crystalline forms constitute a new style, uniquely his own. The effect created by this emphasis on color and decoration is intensified by the artist's rejection of Sung illusionistic representation, space, and atmosphere. It was, perhaps, this two-dimensional quality that encouraged later collectors to fill the empty spaces with their seals—disfiguring intrusions that come close to destroying the painting's dreamlike quality.

To the left of the painting the artist added his poem:

> In that elegant bamboo grove is found much delight,
> Peaceful pavilion, bare stomach—one can imagine his thoughts.
> Intending to write the *Tao-te-ching* for a Taoist scholar,
> He left behind the romantic image of a man who loved geese.

Ch'ien Hsüan spent the last part of his life in much the same manner he imagines for his hero, with "bare stomach"—implying an untrammeled, artistic, and eccentric behavior—drinking, composing poems, painting, withdrawn from the world. Like many others of the time, he was a "leftover subject," loyal to the Sung dynasty he had served until its destruction by the Mongols, feeling morally bound—or possibly just personally inclined—to withdraw from society. He spent the last twenty years or so of his life in recollection and re-creation of the cultural past. From the present, he chose to paint only the flowers, birds, small animals, and insects around him that he must have loved dearly. They too are portrayed in a gentle, transparent, decorative manner that seems of another time, another place; scarcely real, they are curiously among the most affecting of such images in Chinese art and seem to hide a significance that we can only guess at.

It would be interesting if we could know the dates of Ch'ien Hsüan's works and thereby discern the effects of the Mongol invasion on his style and expression—if, indeed, there were any effects. It has only recently been ascertained that, because it bears a seal of Chia Ssu-tao (died 1275), Ch'ien Hsüan's celebrated *Dwelling in the Drifting Jade Mountains* in the Shanghai Museum was painted before the end of the Sung dynasty. A few paintings by masters active during the first half of his life, in the last fifty years of the Sung period, support the likelihood that some features of his art were already common to late Sung scholar painting. Thus, the style, until now associated only with the early Yüan period, had already substantially been formed in the Sung.

Illustrating this point is the long scroll of narcissus (fig. 48) by Chao Meng-chien (1199–1264), a member of the Sung imperial family, esteemed scholar, government official, and sometimes eccentric bon vivant. Chao created a distinctive style of flower painting loosely based upon Li Kung-lin's *pai-miao* style of figure painting, using primarily ink wash in silvery tones to create massed fields of narcissus in blossom. Like the orchid, the narcissus held symbolic meanings of loyalty and purity. Its common name, "the goddesses who rise above the waves," relates it to the ladies of the Hsiang River and hence to Ch'ü Yüan, author of *The Nine Songs* and the poem "On Encountering Sorrow" ("Li Sao"). Almost by their very depiction these flowers evoke a mood of rather mournful beauty because of these associations. Wen Fong's description of the Metropolitan's scroll, "a sea of narcissus . . . seemingly bathed in a soft, silvery moonlight, gently twisting and waving with the breeze," suggests the aes-

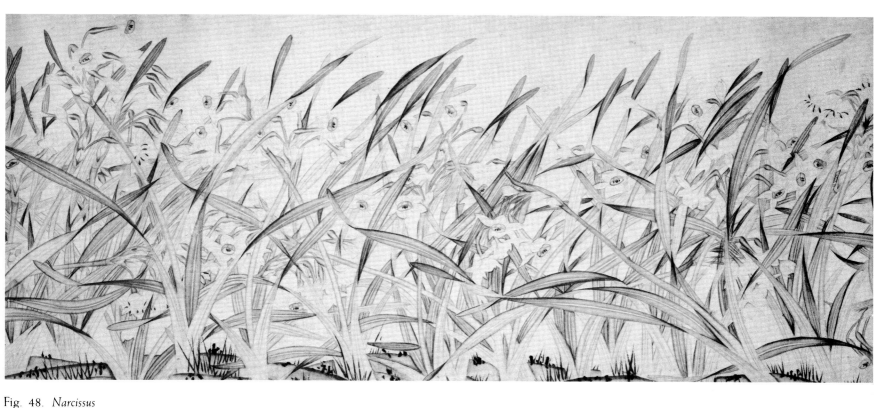

Fig. 48. *Narcissus*
Chao Meng-chien, 1199–1264
Detail
Handscroll; ink on paper
The Metropolitan Museum of Art

thetic effect of the picture. The intricate architecture of interwoven stalks, leaves, and blossoms is carefully maintained throughout the more than nineteen feet of the composition.

How Chao came to paint this flower a decade or so before the end of the Sung we do not know, but just a few years later, in a China occupied by the Mongols, it had come to be regarded as "the fragrance of a nation," in the words of the distinguished scholar and poet Chou Mi (1232–98), who in the 1280s or 1290s so described the narcissus in a colophon to the scroll (see Appendix 1).

By that time the Sung no longer existed, except as an ideal; Chao Meng-chien was dead; and the "water goddesses" had assumed an eloquent new significance that is beautifully and poignantly suggested in a colophon (see Appendix 1) by another "leftover subject" of the Sung, Ch'iu Yüan (born 1247):

> The ice is thin, the sand banks are dark,
> and the short grasses are dying;
> She who picks fragrant flowers is far away,
> on the other side of Lake Hsiang.
> But who has left these immortals' jade pendants
> in a moonlit night?
> They surpass even the "nine fields of orchids
> in an autumn breeze."
>
> The shiny bronze dish is upset,
> and the immortals' dew spilled;
> The bright jade tripod is smashed,
> like broken corals.
> I pity the poor narcissus
> for not being the orchid,
> Who had at least known the
> sober minister from Ch'u.

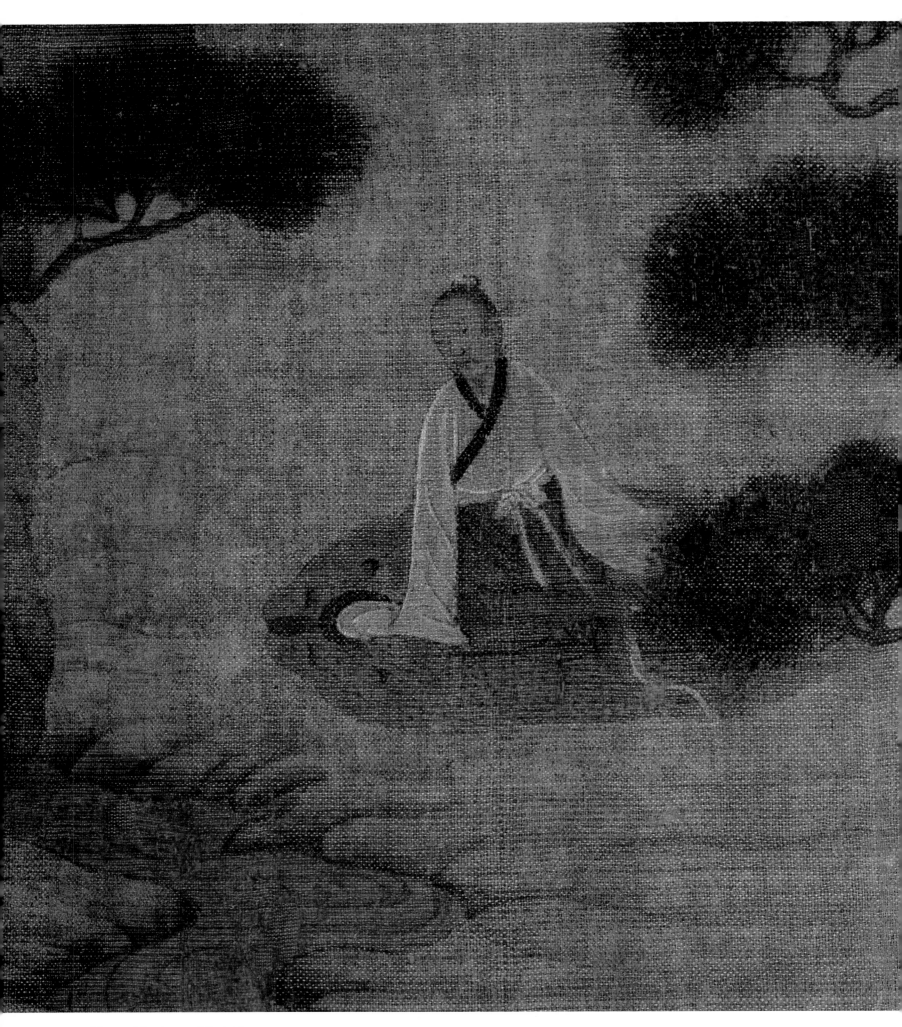

Fig. 49. *The Mind Landscape of Hsieh Yu-yü*
Detail (see fig. 50)

The flowers have been transformed into the lingering reflection of something once beautiful, now shattered and broken.

Returning to the question of style, it is apparent that Chao Meng-chien's silvery palette of ink tonalities, flat linear forms, and rejection of atmosphere, space, and naturalistic illusion all anticipate Ch'ien Hsüan's utilization of these same features; it is also apparent that vis-à-vis the Southern Sung academy both painters were making similar choices. Ch'ien Hsüan chose to disguise the style somewhat by his richly colorful approach, but in essentials his vision is comparable to that of Chao Meng-chien. When the few other scholarly paintings of the time are added to these two examples, it begins to appear possible that there was considerable unity of aesthetic and stylistic choice among southern literati painters of a period spanning most of the thirteenth century and bridging the Mongol conquest of China. But it was decidedly a provincial southern style, long cut off from all developments in the north. Even after the fall of the Sung, when travel once again became possible, Ch'ien Hsüan along with many other southern Chinese chose to remain in the area of his home in Wu-hsing and never saw the north.

Chao Meng-fu, who became the most celebrated of all early Yüan painters, was about twenty years younger than Ch'ien Hsüan and a fellow townsman and friend of the older master in Wu-hsing. Chao was related by common descent from the Sung imperial family to Chao Meng-chien, and thus by several avenues was heir to the highest level of the scholarly cultural tradition. Unlike such friends as Ch'ien Hsüan, in 1286 he chose to accept an offer—extended to a number of distinguished southern scholars by Kublai Khan himself—to serve the Yüan court. Chao went north to Ta-tu, the new Mongol capital of China at what is now Peking, to undertake an official career that would last sporadically until his death in 1322. This decision by a scion of the Sung imperial family—to collaborate with the Mongols—was held by some to be a betrayal of country, birth, and heritage, and it troubled Chao all his life. Many of his surviving paintings should probably be understood to reflect the conflict between his private attempts to uphold and strengthen his own heritage, while he struggled daily with administrative matters and the problems of state and of foreign domination.

His art is startlingly varied, and we will consider it in several contexts. We have in fact already seen it in Chao's version of Li Kung-lin's *Nine Songs* (see figs. 41, 43), which appears to be the earliest of several done in the Yüan period and which, typical of Chao's role in the various branches of painting, sparked a revival of that particular Sung literati style. In landscape painting, Chao Meng-fu begins with artistic interests that are comparable to those of Chao Meng-chien and Ch'ien Hsüan and that probably antedate his decision to serve Kublai.

The Mind Landscape of Hsieh Yu-yü is, like *Wang Hsi-chih Watching Geese*, an archaizing blue and green landscape. It represents the unconventional fourth-century scholar Hsieh K'un (or Hsieh Yu-yü, 280–322), seated among "the hills and valleys of his mind"—the environment he said was his natural place (fig. 49). Hsieh was one of the many eccentric individuals whose lives constitute the *New Account of Tales of the World* (*Shih-shuo hsin-yü*), a compendium of anecdotes concerning colorful Six Dynasties personalities. He and Wang Hsi-chih were contemporaries and reflect similar attitudes toward life and art. That both Ch'ien Hsüan and Chao Meng-fu chose to paint subjects illustrating the lives and philosophies of these men is significant, for there were many similarities between the two ages. The era of the Six Dynasties, also known as the Northern and Southern dynasties, was one of disunion and upheaval; north China was ruled by a succession of foreign conquerors and the south experienced turmoil and political uncertainty, warfare, bloodshed, and short-lived violent dynasties. Amid this instability flourished nonetheless a number of powerfully individualistic scholars, who formed such groups as the Seven Sages of the Bamboo Grove and the Eight Free Spirits, of whom Hsieh K'un was one. These eccentrics came to epitomize

the ideal of individual expressiveness and untrammeled behavior in Chinese society, and their appearance in later Chinese art and literature forms a leitmotiv against the dominant Confucian mode of behavior.

Hsieh's attitudes are expressed in two contemporary stories, the first of which reads:

> Hsieh K'un and the other companions of Wang Ch'eng emulated the "Seven Worthies [Sages] of the Bamboo Grove," and with their heads disheveled and hair falling loose, would sit around naked, their legs sprawled apart. They called themselves the "Eight Free Spirits." This was why the girl next door broke Hsieh's two front teeth. Contemporaries made up a ditty, which went,
>
> > "Dissolute without relief,
> > Hsieh K'un broke his two front teeth."

And the second:

> Hsieh K'un accompanied Wang Tun in his descent on the capital. Entering the court, he had an interview with the crown prince in the Eastern Palace, where they talked until nightfall. The crown prince casually asked K'un, "Those who discuss personalities compare you with Yü Liang. Which of you do you yourself consider to be superior?" K'un replied, "In the beauties of temple and hall, or the opulence of the hundred officials, I'm no match for Liang. But when it comes to letting the mind go free among hills and streams, I consider myself superior to him."

This ideal of freedom "among hills and streams" is clearly used by Chao Meng-fu in his painting, perhaps at a time when the goal was still a real possibility for him. While the painting is not dated, it bears a colophon by the artist's son Chao Yung (see Appendix 1), stating that it is an early work by his father, which suggests that the painting was done before Chao

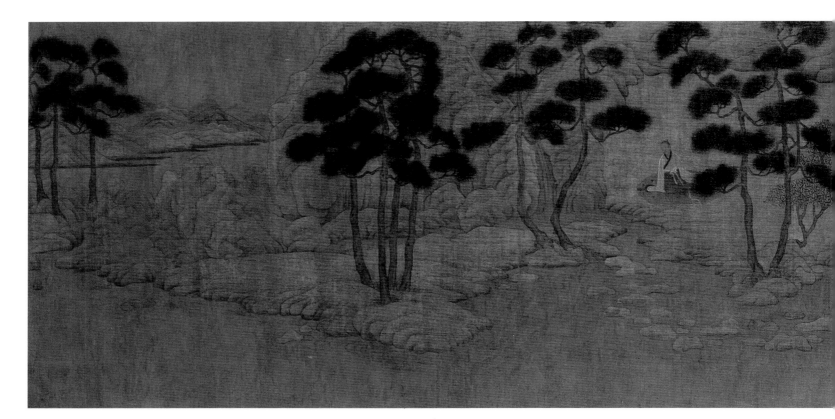

Fig. 50. *The Mind Landscape of Hsieh Yu-yü*
Chao Meng-fu, 1254–1322
Handscroll; ink and color on silk
The Art Museum, Princeton University

Meng-fu's decision of 1286 to forsake the freedom of the hills and streams for the responsibilities of office.

A comparison of Chao's painting with Ch'ien Hsüan's reveals that while both fit the category of blue and green landscape they are perhaps more different than similar. In place of the linear geometric repetition of angular rock forms, the color fields or bands, and the bold direct painting of patterns and motifs in color, Chao chose a softer, more rounded manner somewhat related to twelfth-century works in this style, using the strong shapes of the pines as a structural base (fig. 50). His restrained color and the trees are also reminiscent of the most famous of all Six Dynasties compositions, Ku K'ai-chih's *Nymph of the Lo River*. This composition, well known to Chao in at least two of its best versions, is clearly and deliberately recalled in *Mind Landscape*, which is after all a portrait not merely of a man of that time, but of a man whose first portrait, placed in a setting of the "hills and valleys of his mind," had been painted by Ku K'ai-chih himself.

The most consistently and broadly applied artistic standard in Chao Meng-fu's writing on art is the idea of *ku-i*, "the sense of antiquity":

> A sense of antiquity is essential in painting. If there is no sense of antiquity, then although a work is skillful, it is without value. Modern painters only know how to use the brush in a detailed manner and apply colors abundantly, and then think that they are good artists. They do not know that if a sense of antiquity is lacking, all types of faults appear throughout a work, and how can one look at it? What I paint seems to be abbreviated and rough, but connoisseurs realize that it is close to the ancients, and so consider it beautiful.

The ideas behind Chao's art seem similar to Ch'ien Hsüan's, but Chao's are fixed into an intellectual structure of consistency and focus while Ch'ien's, vaguely related to the sense of antiquity, are even more a personal invention. Since 1300, China and the West have

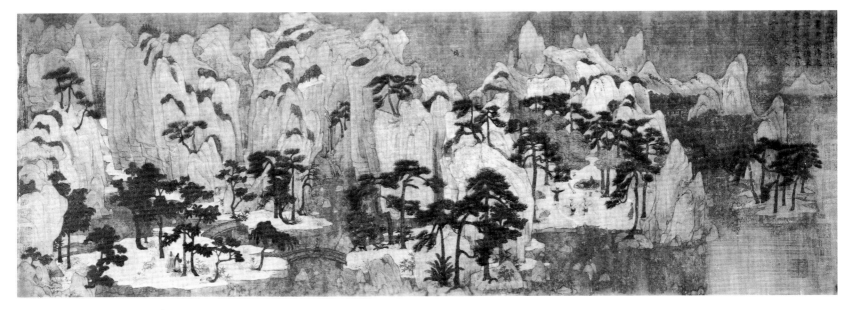

Fig. 51. *The Land of Immortals*
Ch'en Ju-yen, active ca. 1340–70
Handscroll; ink and color on silk
Mr. and Mrs. A. Dean Perry collection, Cleveland

been alike in their critical preference for art that belongs to an intellectual context, and Chao Meng-fu has been esteemed above Ch'ien Hsüan on this account.

Corollary to this distinction is another that we can discern in the art of the two men. Much of the meaning of Chao's work lies outside the painting; he wrote little of significance on his work except comments on style and the sense of antiquity, but his paintings are intellectual symbols that, for full understanding, require specific knowledge of past art and history and of his personal circumstances. The paintings by Ch'ien Hsüan are more nearly complete in themselves, and he usually added a descriptive poem to emphasize their self-sufficiency. The charm and artfulness of his pictures appeal immediately to the eye, while Chao's offer less on the surface and more beneath it. In its sympathetic interpretation of Chao's expression, the response of the painter Ni Tsan (1301–74) to Chao's *Mind Landscape* is typical of the reaction of his contemporaries and later scholar-artists to his intentions (see Appendix 1):

> This was Hsieh Yu-yü, the man who should have
> been depicted in the hills and precipices. But at
> the "Gull-wave Pavilion," as the moon was fading away,
> the windows that opened to the night were empty.

The "Gull-wave Pavilion" was Chao Meng-fu's study, so Ni Tsan, in sympathy with its overt subject, sees the painting as a reflection of Chao's desolation and loneliness as he made his fateful decision to collaborate.

A clear indication of Chao's influence on fourteenth-century art, paralleling his revival of Li Kung-lin's *pai-miao* figure style, is shown in a painting done about fifty or sixty years later than *Mind Landscape*. *The Land of Immortals* (fig. 51), by a scholar-painter named Ch'en Ju-yen (active ca. 1340–70), is a somewhat grander version of Chao's theme—hills and valleys are transposed into cliffs and ranges in Chao's soft blue green manner, and the half-dozen pines of the earlier work have been extended into dozens scattered across the deeply piled ranges. Ni Tsan inscribed this painting as he had Chao's *Mind Landscape*:

> The picture of *The Land of Immortals* was painted by Ch'en Wei-yün [Ju-yen]. Its refinement, mellowness, and purity have succeeded profoundly in capturing the brush ideas of Chao Meng-fu. Now the gentleman is no longer with us. One will never be able to acquire such a painting again.

Fig. 52. *The Land of Immortals*
Detail

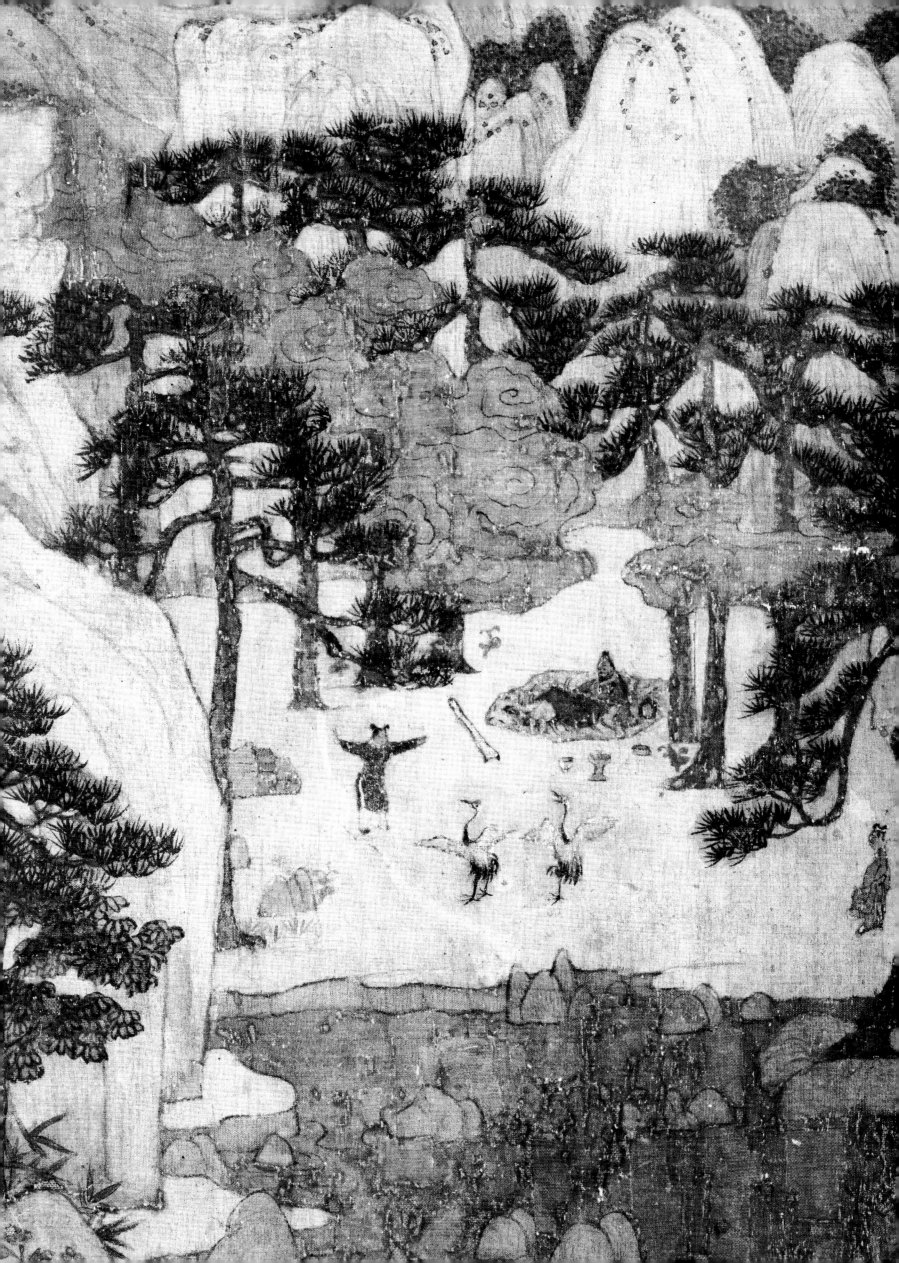

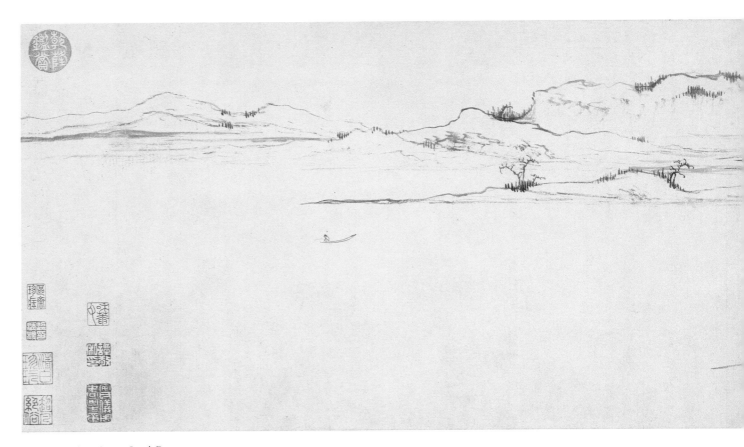

Fig. 53. *Twin Pines, Level Distance*
Chao Meng-fu, 1254–1322
Handscroll; ink on paper
The Metropolitan Museum of Art

We notice that Ni Tsan does not read the man into his art in quite the profound way he had done with Chao Meng-fu, although the "refinement, mellowness, and purity" he finds in the picture are a reflection of the painter as well as of the painting. But he does pointedly identify the clear stylistic relationship between Ch'en and Chao and thus indicates the extent to which Chao Meng-fu had already become an "old master" only one-half century after his death.

Ch'en's subject, an imaginary land of immortality, is well suited to the old-fashioned, otherworldly style, which had become like a medieval costume that could be donned at will to achieve instant antiquity. Whatever meaning the painting may have been intended to express was undoubtedly intimately associated with the city of Soochow, Ch'en's home, in the troubled years of the late Yüan period (a topic to which we will return). The subject itself may have been chosen simply as a desire to escape from an increasingly difficult situation to an antique dreamworld, charmingly suggested not only by the style but by such vignettes as the man shown flapping his arms like the cranes in front of him (fig. 52). Was he teaching them to fly? Or attempting flight himself?

Twin Pines, Level Distance

Much that the calligrapher-painter's brush would ever achieve is foreshadowed in Chao Meng-fu's *Twin Pines, Level Distance* (fig. 53), a masterpiece of the calligraphic reduction of form to its linear essence. Sherman E. Lee's apt characterization of the painting as "a skeleton or outline of the past" perfectly suggests not only its abbreviation of form but its relationship to past art. Its style is that of the Northern Sung masters Li Ch'eng and Kuo Hsi, and it is a virtuoso brush performance, as clean and clear a crystallization of brush and ink on paper as survives from the entire Yüan period. As Lee further describes it: "We are forced to see only the bones of brush and landscape. The latter is not the subject of the picture; the brush is. At the same time, there is some wonderfully observed structure transferred into terms of wash, the rocks being particularly notable."

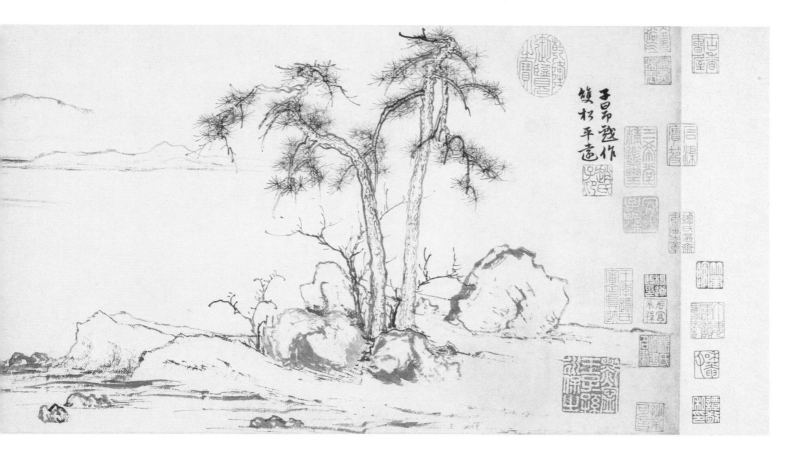

Even those of us who study the history of Chinese painting may tend to slight the boldly original character of *Twin Pines, Level Distance* by not placing it firmly within its true historical context. Since so much later painting evolves indirectly from it, we may sometimes find our vision clouded with the hundreds of later works in the tradition it sparked. But *Twin Pines* is profoundly different from almost everything of its time, except for a few northern paintings that have recently been found. In his inscription at the end of the scroll, Chao proudly boasts that "looking around at recent painters, I dare say my own work is a bit different." He was fully aware that he was breaking new ground, creating a new art that depended not upon an actual vision of landscape but upon the earlier styles of Li Ch'eng and Kuo Hsi and the new theory of the disciplined calligraphy of scholarly brush and ink. Classical models and calligraphy have replaced nature as the inspiration for art.

These are not necessarily unrelievedly good ideas, and happily not every later painter agreed with them. They proved, however, to be an effective means with which to create new traditions for new circumstances. Chao's was an avant-garde art in the guise of scholarship, and his position and influence were such that very few scholar-painters of note during the following three hundred years seriously questioned the tenets of his new faith. On these grounds, Chao Meng-fu might properly be termed the founder of modern Chinese literati painting.

Lest the graphic, abstract character of *Twin Pines* be exaggerated here, it should be noted that Chao Meng-fu's landscape has always projected rich symbolic meaning to its admirers, primarily through what was perceived to be the quality of the artist's mind. For example, the distinguished eighteenth-century connoisseur An Ch'i, who owned *Twin Pines* and recorded it in detail in his catalogue, noted that the figure of the lone fisherman adrift on the stream "suggests the flavor of tranquillity and profound distance"—and these are qualities of the mind.

Because of the overwhelmingly formalistic nature of Chao's accomplishments in the history of style, modern scholars have only recently begun to comment on the human presence in his art. Still, looking at this painting afresh in terms of its pictorial structure, we

僕自幼小學書之餘時々戲弄小筆然於山水獨不能工蓋自唐以來如王右丞大小李將軍鄭虔文洪之奇絕之跡不能一二見且至五代荊關董范輩出此與上世筆意遒絕代不相牟僕所作者雖未敢与古人比然此視近世畫手則自謂少異耳回野雲未定故士其未益愧

Fig. 54. *Twin Pines, Level Distance*
Detail

might well see the tiny fisherman as the expressive purpose and focus of the composition. Chao, as we have seen, rarely mentions such things; his comments nearly always have to do with style. But there are two circumstances that may require us to consider the humanistic expression of his painting more seriously than has been done thus far. First, by virtue of his position and heritage, Chao was not free to express himself openly, and, second, virtually without exception, contemporary and somewhat later Yüan writers of colophons to his paintings comment specifically on their human focus. Such colophons appear even when there are no human figures visible in his pictures, when the overt subjects are animals, as Chu-tsing Li has demonstrated. Typical of contemporary response is the poem immediately to the left of *Twin Pines* written by Yang Tsai, a younger friend of the painter (see Appendix 1):

> As the tiny boat tries to advance upriver,
> Mighty mountain trees are suddenly swept into tumult.
> Swiftly heavy wind and rain pour through the night,
> Clapping waves against the sky—making the oars
> hard to control!

This is a highly personal reading of Chao's painting, in which the fisherman is understood to be a symbol for the painter and his troubled life as he "tries to advance upriver" (fig. 54). Scarcely anything in Yang's poem is directly suggested in the painting: there is no wind, no rain, no sense of shrieking trees; no waves clap against the sky. But if indeed the

painter's friend was among that intimate audience which "understood the music"—knew the artist's mind and interpreted his meaning—then only at peril to an understanding of the purposes of Yüan literati painting can we ignore what he tells us. The passage of time may have caused Chao Meng-fu's art to seem to be one of formalistic purity, but in his own time it was read very differently.

Crows in Old Trees

During the several decades before and after 1300, when Chao Meng-fu was working out the structure of his new art, other painters were pursuing different goals. Ch'ien Hsüan typifies such men, but there were many others. One of the most interesting and least known was Lo Chih-ch'üan (died before 1330) of Lin-chiang, Kiangsi province, an almost exact contemporary of Chao Meng-fu. Their lives and art seem to have passed one another unknown, however, and could scarcely have been more different.

Lo Chih-ch'üan's existence had so completely faded from knowledge by as early as 1350 that his name is recorded in no traditional history of Chinese painting. Everything we know of him today is owed to Shūjiro Shimada's discovery in 1938 in Kyoto of a painting attributed to someone else, but bearing the seal of Lo Chih-ch'üan, and to Shimada's subsequent research into Yüan writings uncovering additional information on Lo's life and art. Since that time, two other paintings have been added to the one discovered by Shimada, and a distinguished artist has been resurrected along with his oeuvre.

As Chao Meng-fu rose through public office and artistic accomplishment to the most exalted position in the cultural life of the early Yüan period, Lo Chih-ch'üan chose to sink into anonymity. He became a hermit, unknown even to most of the art-conscious elite, and was saved from total obscurity only because a number of the most distinguished poets and scholars of the period—most of them from his home province of Kiangsi—sought him out and cherished his art and personal character.

Perhaps the admirer whose life is most revealing of the artist's own was Chao Wen (1238–1315), a Sung official who served with the heroic Sung prime minister Wen T'ien-hsiang (1236–83) in the defense of Fukien province against the Mongols until the minister's defeat and capture. Chao then returned to his home in Wu-hsing and subsequently performed provincial academic duties until his death in 1315. His poetry is likened to that of another famed exile, Yü Hsin (513–81), whose elegiac "Lament for the South" came to stand for the poignant memories of those forced to serve a foreign dynasty. Of Yü Hsin, the T'ang poet Tu Fu wrote: "He spent all his days in desolation. Yet in his last years his verse moved the River Pass." Clearly, Lo Chih-ch'üan represents the same mentality, that of men like Chao Wen and Yü Hsin, exiles living under alien rule.

Toward the end of his life, Chao Wen visited Lo Chih-ch'üan in Lin-chiang and in a long and revealing poem recorded the event:

> As I look around at the things of heaven and earth,
> It seems to me that every one of them is a painting
> and a poem.
> In Yü-ch'uan are the two Lo's
> Who in their paintings attain the heroic wonders of
> heaven and earth.
> The elder Lo's fame as a poet reverberates through
> the lakes and seas,
> The younger Lo's creativity is like a hurricane.
> His discontent is transformed into brush and ink:
> When he wields the brush, he overcomes even the
> creative force of nature,

When he splashes the ink, it is saturated with the
　　primeval breath.
Ah, that these old eyes were able to see it just once;
I rub the painting with my hand, but my heart still
　　disbelieves its reality!
I ask you, sir, since antiquity what painters
　　have there been?
Who do you follow in this painting now?
"I regard my eyes as my hands," you say,
"The myriad things of heaven and earth are all
　　my teachers.
If I am able to attain their meaning and their
　　natural principles,
And in their depiction to obtain their appearances,
　　particularly their 'skin,'
Then, when the painting is finished, I'm really not
　　conscious of resemblance or the lack of it—
All men have eyes, so who can deceive them?
It is as in Ch'an Buddhism there is the need for
　　dhuta [disciplined cleansing of the mind
　　to achieve nirvana];
Reverent love for the Buddha should not be considered
　　a sin!
As in writing poetry, one tries to bring out the 'eyes'
　　that were not there before,
And with a single sweep of the brush, wash away Hsü
　　Hsi and Kuo Hsi!"

The quotation of Lo Chih-ch'üan's views offers a remarkably full explanation of his atti-
tude toward the art of painting. It indicates that he approached painting much as did Hsü
Hsi and Kuo Hsi, the Northern Sung masters he praises backhandedly, and that to him
the meaning of art was akin to that of religion. The Chinese characters used to transliter-
ate the Sanskrit word *dhuta* give an even stronger impression of religiosity than the transla-
tion (in brackets above) reveals, because they imply a stripping down to spiritual essence,
a cleansing of all extraneous elements so as to free the inherent Buddha-nature to unencum-
bered flight. It is also noteworthy that Lo Chih-ch'üan stresses the importance of surface
appearances, the "skin" of things, because this requirement puts him in a totally different
artistic camp from Chao Meng-fu or Ch'ien Hsüan: he is still essentially approaching the
natural world directly with his eyes as well as his mind. He seeks the eyes through which
to see the natural world in a way it has not been seen before, indicating his clear pursuit of
fresh and individual vision, and he is as conscious as Chao Meng-fu of the need for each
artist to sweep away the great masters of the past in order to be himself.

　　All of Lo Chih-ch'üan's views are focused in his surviving masterpiece, *Crows in Old
Trees* (fig. 55). It is a painting that adds little or nothing of intellectual significance to the
development of Chinese art, but our vision of fourteenth-century artists would be impover-
ished by its absence. The old theme, birds circling the barren branches of winter trees, is
painted with freshness and sensitivity, with an affecting feeling for space, atmosphere, mood,
and the actual appearance of a snow-covered landscape.

　　The old title label, still attached to the scroll, attributes the picture to Li Ch'eng,
the first and greatest master intimately associated with the wintry forest theme. As with
the painting discovered by Shimada, however, the seals of Lo Chih-ch'üan along the left

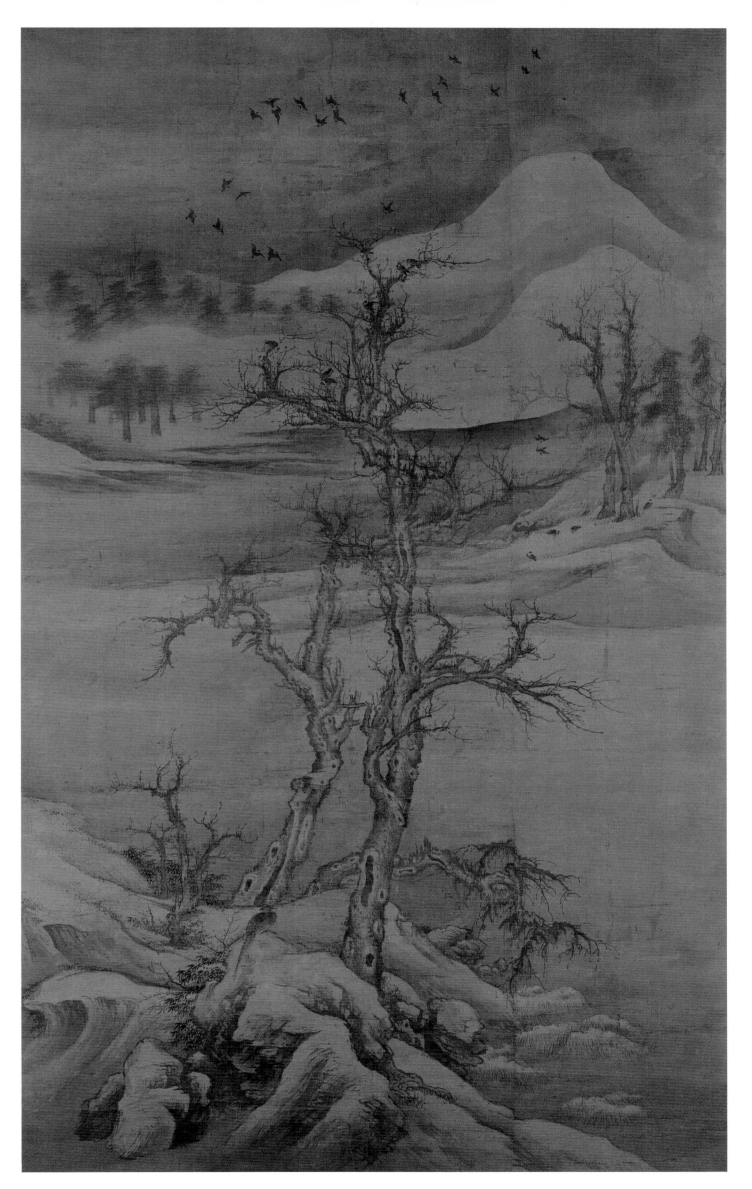

Fig. 55. *Crows in Old Trees*
 Lo Chih-ch'üan, died before 1330
 Hanging scroll; ink and color on silk
 The Metropolitan Museum of Art

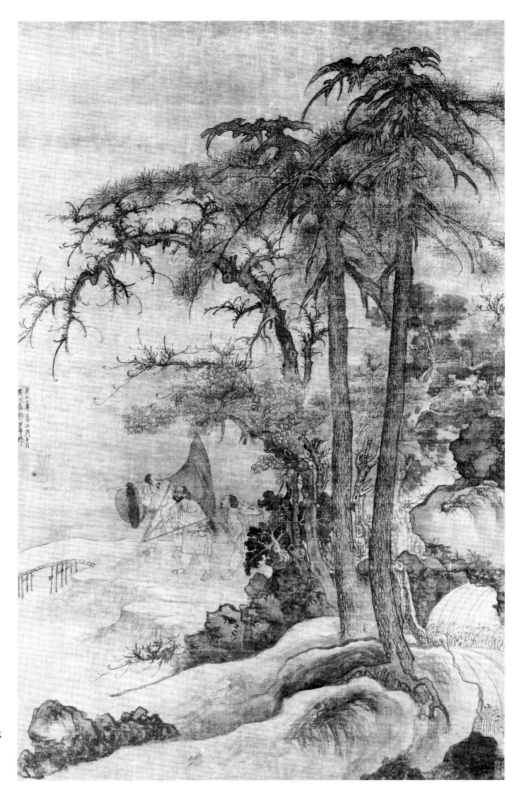

Fig. 56. *Returning Fishermen*, dated 1342
T'ang Ti, ca. 1296–1367
Hanging scroll; ink and color on silk
The Metropolitan Museum of Art

border identify the true author. Aside from the theme itself, it is difficult to point to any direct analogies with works associated with Li Ch'eng or his Sung followers, and one feels that Lo Chih-ch'üan shared with his distant "masters," Li Ch'eng and Kuo Hsi, primarily a common appreciation of and sensitivity to the winter landscape. The stylistic and motivic devices used to evoke the earlier styles by such contemporaries of Lo Chih-ch'üan as Chao Meng-fu and his followers are mostly avoided in *Crows in Old Trees*, as we can see by comparing it with T'ang Ti's *Returning Fishermen* of 1342 (fig. 56). The latter is an unabashed imitation of the Li/Kuo idiom, with dramatic "crab-claw branches," whiplash curlicues defining branch ends, "devil-face rocks," loose ovals to suggest pine bark, billowing cloudlike rock

Fig. 57. *Crows in Old Trees*
Detail (see fig. 55)

and earth formations, and so forth. Each of these motifs or techniques becomes a kind of subtheme in the hands of T'ang Ti, who was taught by Chao Meng-fu, and when we return from this perspective to *Crows in Old Trees*, we find scarcely any such obviousness or formulas. And instead of the stock figure group used by T'ang Ti (who places exactly the same trio of figures in another work, dated 1338, in the National Palace Museum, Taipei), Lo Chih-ch'üan enlivens his world with colorful pheasants nestled beneath the trees and chattering birds settling into the branches (fig. 57). Lo was an observer and a composer who found the eye, as he said, through which the world is seen anew, and although history has forgotten him until now, he, more than T'ang Ti, deserves the title of artist.

6

The Iconography of Virtue

Fig. 58. *Leafless Tree, Bamboo, and Rock*, dated 1321
Chao Meng-fu, 1254–1322
Hanging scroll; ink on silk
C. C. Wang family collection, New York

Trees, Bamboo, and Rocks of the Yüan Dynasty
(1279–1368)

Chao Meng-fu was an artist of extraordinarily broad range, in both subject matter and style. We have seen him as a figure painter in the Li Kung-lin tradition, as a painter of archaistic blue and green landscape, and as the inventor of the spare, calligraphic landscape style of *Twin Pines, Level Distance*. In each category, he established a mode that was followed and re-created again and again during the course of the fourteenth century. These accomplishments, however, barely begin to suggest the extent of his mastery. He was regarded as a great painter of horses in the tradition of Li Kung-lin of the Sung and that of the classical T'ang masters. He was the greatest and most influential calligrapher of southern China. He mastered not only the landscape painting styles of the northerners Li Ch'eng and Kuo Hsi, but also those of the southerners Tung Yüan and Chü-jan; and in the painting of such specialized scholarly subjects as old tree, bamboo, and rock, his style and vision are the source of the tradition that dominates the later centuries of Chinese painting.

This compositional combination of three symbols beloved of the scholar—tree, bamboo, and rock—is in many respects the most eloquent and typical expression of Yüan painting. Like so much else that the Yüan scholars revived, the subject was first associated intimately with Wen T'ung and Su Shih in the late eleventh century, and through its identification with the loving and deeply understanding friendship of the two Sung cousins had already come to possess an unusually personal meaning. Su Shih interpreted Wen T'ung's paintings of the subject as indirect reflections of his personality and character, thus beginning the long tradition in which an artist is seen in his work. Fourteen years after Wen's death, Su wrote this poem on one of his paintings of old tree, bamboo, and rock:

> Bamboos are chilled but preeminent,
> Trees are lean but enduring,
> And rocks, ill-featured but distinctive:
> These are "the three beneficial friends."
> Their warmth makes us befriend them;
> Their independence forbids their being constrained.
> I am thinking of this man—
> Alas, can I ever meet him again?

The virtues of the objects thus became the virtues of the man who portrayed them.

Chao Meng-fu, a distinguished calligrapher, advocated the use of calligraphic techniques in paintings, especially in the genre of tree, bamboo, and rock. Rocks, he wrote, should be painted in the *fei-pai* technique of rough streaked brushwork, trees in the "seal" style of round full brushstrokes, and bamboo in the *pa-fen* tradition of elegant precisely tapered strokes. Such ideas had a vague history going back to the T'ang dynasty and had received a distinguished endorsement from, again, Su Shih, who wrote:

> Why should a high-minded man study painting?
> The use of the brush comes naturally to him.

Su was of course referring to the high-minded man's lifelong practice of calligraphy and advocating that such men as he did not need to study the techniques of painting as they had been practiced by professional artists up until that time. As scholar-calligraphers they already possessed full familiarity with related techniques of the calligrapher's brush. Chao Meng-fu was expanding upon that basic view and giving it a more precise formulation.

Two paintings of tree, bamboo, and rock attributed to Su Shih (Shanghai Museum; Peking Palace Museum) suggest that his own amateur efforts in the genre, relaxed and very freely painted, were an important precedent for the paintings we will examine below. If indeed the two works accurately reflect Su's art, then we are bound to conclude that Chao Meng-fu's work in this mode directly follows Su's example and that Su Shih and his cousin Wen T'ung were the inventors of the style, not Chao, who now revived it as he had so many other styles.

Leafless Tree, Bamboo, and Rock

It is perhaps surprising that such consideration of Chao's sources and models does nothing to lessen the impact of his *Leafless Tree, Bamboo, and Rock* of 1321 (fig. 58), painted a year before the artist's death and the latest dated painting in his oeuvre. The painting anticipates the art of the next century in much the same way Tung Yüan's *Riverbank* prefigures the landscape art of Northern Sung. Like the early Northern Sung works, *Leafless Tree* is also a large picture, approximately sixty-three inches high, formed of two lengths of silk of unequal width. This similarity with monumental landscape lends an unexpectedly grand and cosmic feeling to the genre of tree, bamboo, and rock, as if to suggest that the hitherto intimate and minor subject matter were being elevated to a position of importance comparable to the formerly unrivaled stature of landscape. Beside the powerful vision of Northern Sung landscape, the subject seems mundane, a little vignette of nature that one might stumble across during a walk in the woods. But we may be sure that the painting is not closely related to anything Chao Meng-fu saw in nature. This is art reflected in the tranquillity of the studio—a graphic exercise like calligraphy, an act of composing like the writing of a poem. We note the meaning of Chao's dictum concerning calligraphy: the contours of the rocks are done with a broad stiff dry brush in the *fei-pai* manner, the bamboo leaves in the finely turned precise strokes of the *pa-fen*, and the trunk and branches of the tree in the broad wet round lines of the ancient seal script. The forms are those of nature, but they have been intellectualized into a mode and structure of compositional technique that can be viewed as the painterly equivalent of a written character: the basic form is given just as in a calligraphic script, and each Yüan artist will henceforth write the image in his individual manner, while always remaining true to the given form.

A similar composition—*Lofty Virtue Reaching the Sky* (fig. 59), dated 1338, by Wu Chen (1280–1354), called the Plum Blossom Taoist and subsequently one of the Four Great Masters of Yüan painting—is seen at once to be the same form and, just as quickly, to be the expression of a totally different personality. Wu Chen is less interested in careful equivalents of calligraphic strokes, using instead a consistently broad wet brushstroke. His tree and bamboo seem soaked in mist or rain, weighted down with moisture, and his rock looms up in front like a mountain. This suggestion of atmosphere, unusual after Chao Meng-fu, is but one of several indications of Wu Chen's aloof individuality. Looking back at Chao's painting of the same subject, one senses the restraint and tightness of the earlier man's personality, his unwillingness or inability to let loose. His forms seem held back and closed up in comparison with the sprawling openness and atmospheric richness of Wu Chen's. In the following passage, translated by James Cahill, Wu reveals aspects of his character that are reflected in the relaxed, easy, bold forms seen in his painting:

Fig. 59. *Lofty Virtue Reaching the Sky*, dated 1338
Wu Chen, 1280–1354
Hanging scroll; ink on silk
C. C. Wang family collection, New York

蕭蕭風雨麥秋寒把筆臨摹強自寬尚
賴吾君相慰藉松肪筍脯勸加餐四
月十七日風雨中　茂異携酒殽相餉
於晚節軒中固為寅翁石喬柯并題
寫入畫圖稔更濱趙俞
柯生書陰于戈阻絕歸未得
清閟閤前雲蒲林筠石喬
色媚媚著可餐　哀華
酒邊寬獨憐晚節軒前許翠
新試羅裳怯薄寒容裏全賴
想像題詩感慨多陸平
墨寫喬柯當年人物今何在
晚節軒前風雨過與餘吟
雲林道士倪元鎮老去
材名育薿人見畫題詩
雲石信恍惚菩月嫫精
神知白道人造

絕句雲林子攢

I would like to have composed another "Homecoming" ode [like T'ao Ch'ien's], but am ashamed to have no such lovely verse as "The three paths are almost obliterated." I would like to have wandered around the Yangtze and Hsiang rivers, but unfortunately hadn't the proper bearing to go about in a coat and hat of green leaves. I might have studied agriculture, but hadn't the strength needed for plowing; I might have taken up vegetable gardening, but taxes are oppressive and the foreigners [the Mongols] would only have confiscated my land. Advancing [into public life], I could not have fulfilled any useful function; retiring, I could not have concealed myself happily in idleness. So I have lived by the Changes [the *I Ching*], practicing frugality, and done what I pleased. Through a harmonious life I have drifted into old age. What more could I have wanted?

Bearing out the concept of the revelation of personality through brush and ink, another tree, bamboo, and rock composition, this one by Ni Tsan, reveals a man of apparently severe restrictions of self with nothing of the dignified assurance of Chao Meng-fu and not an inkling of the breadth and openness of Wu Chen. In *Bamboo, Rock, and Tall Tree* (fig. 60), the spareness of Ni's pale dry brush is relieved only slightly by the spiky bamboo leaves and the ink dots carefully placed in the crooks of branches and twigs, and his cramped tight forms make Chao Meng-fu's seem positively bold and vigorous by comparison. Ni Tsan's obsessiveness with cleanliness, chasteness, and restraint in all things is part of his legend, but his paintings confirm the truth of the legend with devastating certainty. When we read these paintings as we are intended to read them—as images of the minds of their makers—they are startling revelations of inner reality.

Beyond their widely divergent expressions of individuality within the confines of a common compositional mode, these three paintings differ fundamentally in terms of expressive purposes if judged by each painter's inscription, and as a group they reveal much of the varied uses of art among fourteenth-century scholars. Chao Meng-fu's one-line notation in the upper-left corner of his picture simply records the date of the painting and his name. As noted, Chu-tsing Li has demonstrated that underlying much of Chao's art is a depth of symbolic meaning scarcely glimpsed on the surface, and we have seen something of this in his landscape paintings; in *Leafless Tree* we can safely assume only the traditional symbolic meanings of the forms, and even of that Chao says nothing. The painting seems overridingly concerned with form, style, and structure; to make that observation is not to rule out the possibility that Chao may also have had other intentions at which we can only guess.

Wu Chen, with the same exuberance he demonstrates in the painting, inscribed in a bold, running cursive hand in the upper-left corner a poem that reveals other interests. In it, he speaks of the lofty virtue of his bamboo touching the clouds, of the phoenix branches of his old tree, and the jadelike sound of their rustling. Almost as a Southern Sung academician would, he matches word and image to create a unified statement of the qualities and emotional meanings of his subject, confirming the evidence of his wet atmospheric style that he is the most Sung-like of the major Yüan masters.

In *Bamboo, Rock, and Tall Tree*, Ni Tsan's dry scumbled brushwork is accompanied in the upper-right corner by a poem and a personal comment written in his characteristic precise delicate hand. He tells us that on a windswept, rainy spring day in the fourth lunar month of a year not specified, feeling lonely and depressed, he was visited by a friend (probably Yüan Hua, born 1316, whose poem, which follows Ni's, is in the top center of the painting) who brought along some wine and delicacies to cheer up the painter. In appreciation, Ni did the painting for his friend, then inscribed on it this poem:

Fig. 60. *Bamboo, Rock, and Tall Tree*
Ni Tsan, 1301–74
Hanging scroll; ink on paper
The Cleveland Museum of Art

Mournful wind and rain, cold April,
Grasping the brush, I try to cheer myself up by
 making copies.
Fortunately, my friend, I can still depend upon
 you to look after me—
Pine-sap wine and dried meat with bamboo shoots
 force me to be hungry!

These rather melancholy lines, together with the painting, seem to be an attempt to convey
a state of mind or a mood: "Mournful wind and rain, cold April." The barren forms are in
harmony with the mood, as, indeed, they always are. If in fact Ni Tsan was concerned in

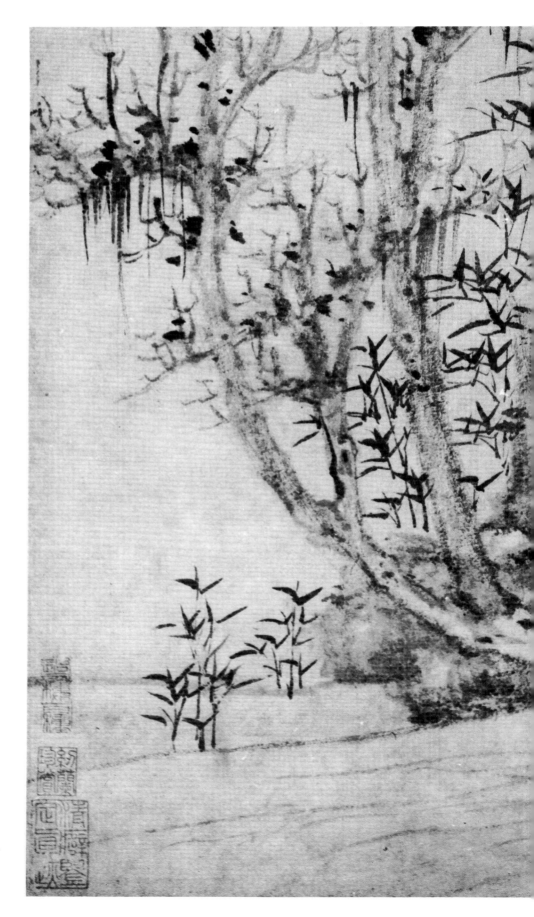

Fig. 61. *Bamboo, Rock, and Tall Tree*
Detail

his art with the crystallization of a mood, then the mood is nearly always the same; he was rarely capable of humor or exuberance. But he found a style precisely suited to his needs, a style pared of all extraneous elements, until further restraint was impossible—the bones of form in pale ink that he "cherished like gold."

On one level the three masters are in complete harmony: each in his way loves the sensual, tactile interplay of brush and ink with natural forms. This is made especially clear by Ni Tsan, whose art at first glance appears least interested in natural description. Ni boasted that "a *total* lack of resemblance [as I have managed to attain] is hard to achieve!" His painting, he said, was "an overflow of his madness." Yet, looking at a detail of his painting (fig. 61), one notices the almost sculptural sense of mass nurtured by his scumbling brush from the base of the tree, the subtle variations of light and shade, the knotholes, and beside them the

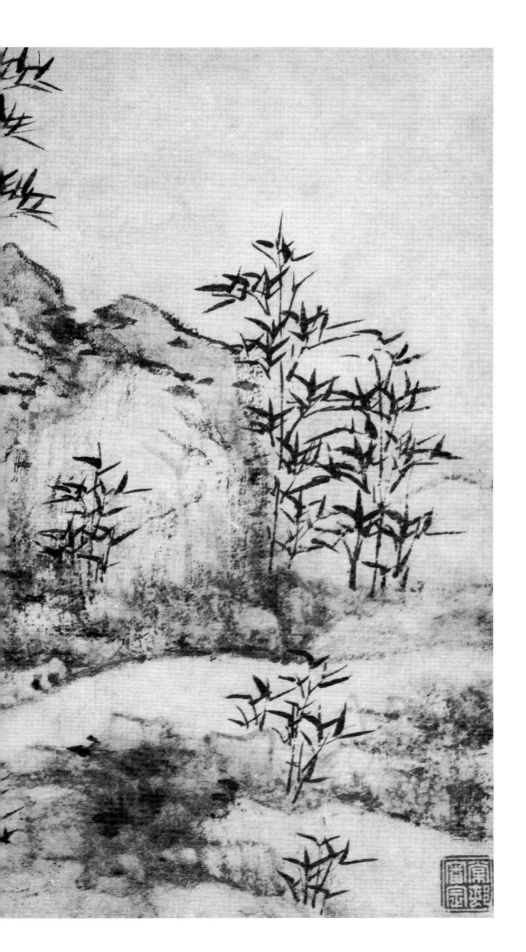

weathered moss-grown rock accented by tense sharp bamboo leaves. Using less ink and less tonal and textual contrast did not prevent Ni Tsan from approaching natural forms like a sculptor in ink. He simply posed himself the difficult task of attempting to do more with less.

Bamboo After Wen T'ung

As the art of painting became more and more restricted in its means and its goals, scholar-painters began to limit their subject matter as well. Most of the single subjects—bamboo, plum blossoms, narcissus, pines, old trees, orchids—began to evolve as separate genres during the Sung dynasty. In the thirteenth century, Ch'an painters intensified this tendency, as did such late Southern Sung scholar-painters as Chao Meng-chien and such Chin artists as Wang T'ing-yun. Before 1300, however, the achievements of these specialists were relatively minor, and beside the versatile great masters they occupied a peripheral position in the world of art. Tree, bamboo, and rock is a genre typical of this development: only in the Yüan period could a succession of great artists (as Chao Meng-fu, Wu Chen, and Ni Tsan) occupy themselves with and extend the realm of art in this subject alone, even though each also painted other subjects. There are two important issues involved in this change: the techniques of painting were being reduced to those directly or indirectly related to calligraphy, and the significance of the subjects themselves was both intensifying and broadening, allowing them to become fully viable vehicles for the expression of self.

To describe these aspects of Yüan painting, James Cahill has suggested the analogy of chamber music. He is writing specifically of the subject of wintry forests, but what he says is immediately applicable to all the subjects of scholar-artists:

> The motif became a favorite of Yüan artists, for whom the severity of mood and the astringent monochrome linearity that this encouraged had a special attraction. It was also an ideal vehicle for exercises in the lucid arrangement of objects in space; like chamber music for the composer, it was a form that, by imposing strict limitations on materials and means and subduing colorism and variety, opened possibilities of creating orderly structures within which each line could be clearly perceived.

In tracing the evolution of Yüan painting we see not only a marked tendency to restrict the subjects chosen to paint, but also a deliberate effort to classify all the great traditions of the past, even in such broad classifications as landscape, into three or four readily identifiable styles. Thus, with few additions, Yüan artists speak of the Li/Kuo style, the Tung/Chü style, the Mi style, and the archaic blue and green style, and with these four clearly defined categories the broad stylistic possibilities are exhausted. This restriction was acceptable only because, at the same time, the individually expressive possibilities of brush and ink were being redefined along the lines of calligraphy; each painter, therefore, could achieve his own unique "handwriting," his own graphic identity. The range of possible forms thus lessened as the individual painter's desire to utilize a few given forms for his own purposes increased.

The first and ultimately most influential bamboo painter was Wen T'ung of the mid-eleventh century, Su Shih's cousin and a central figure in the emergence of a literati aesthetic and theory of art in the Northern Sung period. A good indication of his influence is a copy of one of his paintings by the distinguished Yüan bamboo master K'o Chiu-ssu (1290–1343). According to K'o's inscription, the original painting bore Wen T'ung's signature and the date 1069; K'o's copy—*Bamboo After Wen T'ung* (fig. 62)—was made in 1343, the year of his death. It thus represents one of the most accomplished bamboo painters of

Fig. 62. *Bamboo After Wen T'ung*, dated 1343
K'o Chiu-ssu, 1290–1343
Hanging scroll; ink on silk
C. C. Wang family collection, New York

Fig. 63. *Bamboo and Rocks*, dated 1318
Li K'an, 1245–1320
Pair of hanging scrolls; ink and
color on silk
The Metropolitan Museum of Art

his era joining himself in form and spirit, at the end of a lifetime of study, to the progenitor of the genre three hundred years earlier—a type of relationship that is central to an understanding of the nature of literati painting in the fourteenth century.

K'o Chiu-ssu's bamboo demonstrates why the genre was so popular among scholars: the brushwork required for both leaves and stalks is literally identical to that required for the strokes of calligraphy, as can be seen by comparing the individual strokes in K'o's inscription with the leaves and spidery branch network of his painting. Only the main stalks, broad strokes of dilute ink, demand a technique not intrinsic to calligraphy. With bamboo,

in other words, Su Shih's boast is fulfilled: the scholar need not study painting since the use of the brush comes naturally to him. Free to indulge his systematically acquired abilities as a brushman, the scholar-painter begins building a structure of black lines, another process like calligraphy in that it requires the putting together of linear elements much like the lines of an individual character: there are openings and closings, upward and downward thrusts, curves, and interrelated spaces. Once the basic leaf-shape stroke has been mastered, it is almost impossible not to create the semblance of real bamboo; little had to be learned, and even the formal models were given by historical precedent, as K'o's copy of Wen T'ung indicates. K'o was no amateur, of course, and he introduces far more variation of ink tonality and texture than a genuine amateur would. Plain black ink is simplest, but in part the beauty of ink-bamboo is that anyone trained in calligraphy could do it and could fully appreciate the attempts of others. It became a kind of scholarly language only incidentally related to painting.

Through long literary and philosophical tradition, the bamboo had symbolically acquired many of the attributes of the Confucian gentleman: uprightness, pliancy, plainness, tenacity, and longevity, to name a few. This symbolism, summed up in the common reference to the plant—"this gentleman"—contributed significantly to bamboo's appropriateness as a subject for scholar-painters.

Except for Wu Chen and perhaps Chao Meng-fu, the most important painter of the fourteenth century who specialized in bamboo was Chao's contemporary and friend Li K'an (1245–1320). No later painter approached him in versatility or mastery of the craft of painting, and his *Treatise on Bamboo* is the major work on the subject. Li K'an's approach was by no means that of the scholarly amateurs, but of an artist and botanist combined —searching, examining, questioning, dissecting, and rearranging for ultimate effect. His stylistic expression ranged from the most carefully academic and colorful manner to free, sketchy ink painting; major examples of each are in American collections. Li's *Bamboo and Rocks* of 1318 (fig. 63) is a late work and among the most realistic and precisely rendered Chinese paintings of bamboo in existence. Bamboo here is not ink but green and brown leaves growing in thick masses, intricately and painstakingly worked out in all details. The bamboo is shown in various phases of growth, from shoots just appearing aboveground to plants of leafy fullness (fig. 64), in a variety of heights and densities, clustered around a garden rock. The painter's interest in realistic description obviously ends at the earthen bank below, which is done in the decorative, stylized manner of Hui-tsung's academy.

Li's treatise is an important confirmation of his belief in the kind of craftsmanship found in his painting. He makes quite clear that in his opinion already by about 1300 too many "painters" expected to bypass the slow, laborious process of training and study and proceed directly to a free and easy use of the brush. Commenting on a passage by Su Shih on this point, Li elaborates carefully and persuasively his view of craft versus amateur enthusiasm:

> People only know that painting bamboo does not consist of doing it joint by joint or piling on leaf after leaf. If they do not have "perfected bamboo" in their minds obtained through contemplation, where will it come from? They aim too high and leap over the steps in between, releasing momentary feelings and smearing and daubing about. Then they think that by obtaining release from step-by-step craftsmanship they have attained [art] through naturalness.
>
> This being so, [a painter] ought to put himself within the bounds of technical proficiency, and when, through practising unflaggingly, concentration has been accumulated and effort has been long-lasting and he is convinced that there is really "perfected bamboo" in his mind,

Overleaf:
Fig. 64. *Bamboo and Rocks*
Detail

only then may he take up the brush and dash ahead to capture what he has seen. Otherwise, he will grasp the brush and look around in vain, for what has he seen that he can capture? If he is able to hold by rules and regulations, he will be without flaws and blemishes; and there is no cause for worry about achieving. Even if he errs by adhering to them, after a while he can still reach beyond rules and regulations. But if a man indulges in unbridled freedom from the beginning, I fear that he will not be able to accept rules and regulations later and will not achieve anything. So a student must arrive through method; then he will attain his goal.

In both his art and his theory Li K'an argued against the amateur ideal in favor of the mastery of traditional craft. This controversy dominated the world of painting in the early fourteenth century and Li K'an was fighting a losing battle. He was a northerner in an age dominated by southern culture and an advocate of professional craft in an age beguiled by amateur, calligraphic freedom and "naturalness"; by the time his life ended, the southern scholar-amateurs had all but won their victory.

Fragrant Snow at Broken Bridge

Few bamboo painters of the period rival the stature of Li K'an, but no painter of plum blossoms surpassed Wang Mien (1287–1366), the son of a poor farmer, a self-trained scholar, artist, and swordsman, and a noted eccentric. The histories of these two genres are quite similar, as is the range of symbolic virtues they embody, but the artistic problems posed by plum blossoms are far different from those common to bamboo. The amateur rarely tried to pass himself off as a painter of plum blossoms because, as natural forms of considerable complexity, they were simply too difficult to represent convincingly, nor do they allow any technique common to the calligrapher.

Consider Wang Mien's *Fragrant Snow at Broken Bridge* (fig. 65) in the Metropolitan Museum. Its two major components, branches and blossoms, require boldly structural, vigorously tactile brushwork, on the one hand, and minutely detailed fine brushwork, on the other—neither type very closely related to calligraphy. Furthermore, to highlight the effect of blossoms drifting down in a breeze, the painter applied a pale ink wash across the silk surface, smoothly covering everything except the individual petals adrift in the air. He tried to suggest the gnarled character of the bark of the aged tree with a vigorous, dark dry-brush technique, and he was concerned throughout with the complex interweaving of forms —crisscrossing, overlapping, passing behind or in front of one another—tracing them with both logic and naturalness. Even so, as in the finest ink-bamboo, his plum tree forms an endlessly rewarding construction of lines and shapes on a two-dimensional surface.

Confirming this graphic character, as Wu Chen and Ni Tsan did with their tree, bamboo, and rock compositions, the painter added a poem in his bold, rather old-fashioned style, within a frame of branches and petals:

> One single tree of cold prunus, with branches of
> white jade;
> Stirred by the warm breeze, its snowy petals are
> scattered in the air.
> In his heart, "the Recluse of the Lonely Hill"
> Is still faithful to himself,
> But someone has just passed by the Broken Bridge,
> Carrying with them the music of reed pipes and songs.

一樹寒梅白玉條臨風

酌乱雲飄。孤山不在生

好夜離數墨額画梢標

元章

Fig. 65. *Fragrant Snow at Broken Bridge*
 Wang Mien, 1287–1366
 Hanging scroll; ink on silk
 The Metropolitan Museum of Art

The Broken Bridge (so called because in winter, when partially covered with snow, it appears to be broken) connects the shore of West Lake in Hangchow with Lonely Hill (Kushan), where Lin Pu (967–1028) lived. A hermit, poet, and calligrapher in the early years of the Sung dynasty, Lin Pu loved the plum blossom as though it were his wife, as he said, and wrote of its beauty in poems that were ever after quoted admiringly. His name became synonymous with the virtues of the tree and its flower: hardiness, beauty flourishing in isolation (that is, outside society), strength, and tenacity. Wang Mien is thus recalling, in the forms of his tree and blossoms, the image of Lin Pu, "the Recluse of the Lonely Hill," and, as he graphically re-creates that image, he makes it his own. The sound of pipes and song in his poem symbolically carries the virtue of the past into the present. The branch he paints appears almost torn from its trunk but still showers the earth with its blossoms.

When the sixteenth-century scholar-poet Ku Ta-tien looked at the painting two hundred years later, it was Wang Mien he saw:

> The plum blossoms painted by the Stone-Cooking Mountain Peasant, Wang Mien, are in no way less marvelous than those of Yang Pu-chih [the first great Sung painter of plum blossoms]. His brushwork is aged and free, at the same time forceful, extraordinarily imaginative, and stubborn, singularly peerless in his time. From the painting, it is possible to imagine his noble conduct and crazy manner, wearing a tall brimmed hat and high wooden clogs, swinging a wooden sword. Unfortunately, since he was not prolific, very little of his work has survived.

Wang Mien's vigorous individuality injected strength and freshness into the tradition of the arts, much as steely-eyed northerners such as Li K'an did in their way. Only two years after Wang Mien's death, another peasant, Chu Yüan-chang, drove the Mongols from China and became the first emperor of the Ming dynasty.

7

The Earth Transformed

Landscape Paintings of the Late Yüan Period

Nearly all the paintings included under this heading reflect the rarified and cultivated atmosphere of the city of Soochow during the chaotic quarter-century that culminated in the expulsion of the Mongols from China and the establishment in 1368 of a new Chinese dynasty, the Ming. During this period of flood, famine, rebellion, and destruction, Soochow was among the least disturbed of the major centers. Twice, however, its placidity was disrupted, although only briefly: in 1356 when the rebel leader Chang Shih-ch'eng captured the city and made it his headquarters, and again in 1367 when he was defeated by Chu Yüan-chang. Already a famed cultural, artistic, and economic center and many say the most beautiful garden city in China, Soochow, with its immediate adjacent neighbors Sung-chiang, Hangchow, and Wu-hsing, attracted during this period thousands of disillusioned scholars, poets, and artists of the more troubled areas. It was an age in which, as Frederick W. Mote has described it, the elite scholar-official class had a choice only between serving a corrupt barbarian court or joining the peasant rebels who fought for control of China. In the face of impossible courses of action, most scholars chose to withdraw and to preserve themselves and their values until a better time. Their mood of resignation is indicated by these lines from Kao Ch'i (1336–74), the leading Soochow poet:

> Clouds come and clouds go, but the mountains
> remain the same; the tide falls and the tide rises,
> but the river flows on unheeding. . . .
> The immemorial nature of river and mountains
> will never be exhausted, while men come and men
> return, their heads inevitably growing white.

In their years of waiting they devoted themselves to scholarship, poetry, and painting, cultivating the sensitive awareness of the eternal and enduring that lends intensity to nearly everything they wrote or painted. Nature once again became both inescapable environment and constant companion:

> Sometimes I climb a hill and gaze out where the
> Yangtze's waters race past for a hundred miles,
> to pour into the sea. The tumbling and tossing of
> its waves, the dark mysteries of its mists and haze,
> the flowering and dying of plants and trees, the
> soaring and drifting of birds and fishes, in fact
> all sorts of things that can move the mind and entice
> the eye have been here set forth in poetry. For it is
> in this way that I have been able to dispel disquieting
> sadness by forgetting both myself and the world,
> granting to matters of gain and loss no more than a laugh.

Soochow landscape painting of the late Yüan period is, as we might expect, rather limited in its stylistic range and inward in its expression, since its audience was a small and

Fig. 66. *Streams and Mountains,* dated 1372
Hsü Pen, 1335–78
Hanging scroll; ink on paper
Mr. and Mrs. A. Dean Perry collection, Cleveland

familiar one. They are paintings we "read" for what they tell us of the mentalities, experiences, and lives of their makers. Three typical Soochow painters—Hsü Pen (1335–78), Chao Yüan (active ca. 1350–75), and Lu Kuang (active ca. 1360)—are represented by works formerly in the C. C. Wang collection. All are done with dry brushwork and a sharply limited range of ink tonality and texture. Their motifs—mountains and trees—are based upon conventions popularized earlier by Chao Meng-fu, Huang Kung-wang (1269–1354), and Wang Meng (ca. 1301–ca.1385). One generally finds the same distant waterfalls, the same round rocks and moss dots, the same foliage conventions, the same pines and secluded dwellings. At the heart of each is a friendship, a meeting, or a parting. Hsü Pen's *Streams and Mountains* (fig. 66), painted for "the elder Chi-fu," commemorates a trip Hsü made with a group of scholars to the mountains near Wu-hsing and bears poetic inscriptions by some of them. Chao's painting, *Farewell by a Stream on a Clear Day* (fig. 67), is a gift for a friend who is leaving on the river. Lu's *Spring Dawn at the Cinnabar Terrace* (fig. 68) was done for a certain Liu Kuang-wen, called Po-yu, "distant descendant of the old immortals" of the Cinnabar Terrace, and is concerned with immortality, springtime, celestial music, and the company of scholars. These paintings all represent scholarly dreamworlds, distant, pale reflections of life—rarified, lofty, unreal. Ch'en Ju-yen's *Land of Immortals* (see fig. 51) is the most overt expression of the dream; he too was a resident of Soochow in these years and an intimate friend of Hsü Pen and Chao Yüan.

Of the three scrolls, only Hsü Pen's is dated, and the year, 1372, falls four years into the new Ming dynasty. It was during this period that Chu Yüan-chang took revenge on the hated city of Soochow, which for so long had resisted his rule. In 1374 the brilliant poet Kao Ch'i, who inscribed Hsü's painting, was executed. Chao Yüan was executed sometime in the 1370s, as was Ch'en Ju-yen; and Hsü Pen starved himself to death in 1378 while awaiting execution. Of Lu Kuang's fate we are ignorant.

None of this turmoil can be sensed in these paintings. They offer no hint of the state of the world; almost everything they express is written on them, not painted. Nothing of the fear, uncertainty, or anguish of the scholars of Soochow can be directly seen. It is this absence of violence that, finally, lends them a quality beyond the beautiful. Knowing what we do of the painters and the poets who wrote on the paintings, of their lives in the lovely, doomed city of Soochow, and of their tragic deaths, we can look at their paintings as images of the artists themselves. Their art represents a kind of paradise lost, and their dream is recognizable as a dream.

The Su-an Retreat

Among all the landscape painters living in southeast China in the late Yüan period, three stand out as true artists in the sense that they were creators of individual worlds, of aesthetic systems that did not otherwise exist. Wang Meng, Ni Tsan, and Fang Ts'ung-i (ca. 1301–after 1378) approached creation from different viewpoints and pursued widely different goals, but each had a vision that he nurtured into reality in his art and each valued creative individuality above tradition. Their paintings are the measure of artistic greatness in late Yüan art in southeast China.

Wang Meng, a grandson of Chao Meng-fu, was born in Wu-hsing in the first decade of the fourteenth century and died in prison about 1385, another victim of Chu Yüanchang's purge of southern scholars. With his distinguished lineage (his father, Wang Kuo-ch'i, was also an accomplished poet and scholar), it is perhaps not surprising that Wang Meng was technically the most accomplished of all the major Yüan painters. As a master of the craft of painting, he did not seem to approach the art through calligraphy, as did most other scholar-painters. Even in his most sketchy ink drawings, his lines and forms possess an energy and a pulsing flow that could only have come from an interior vision—not simply from

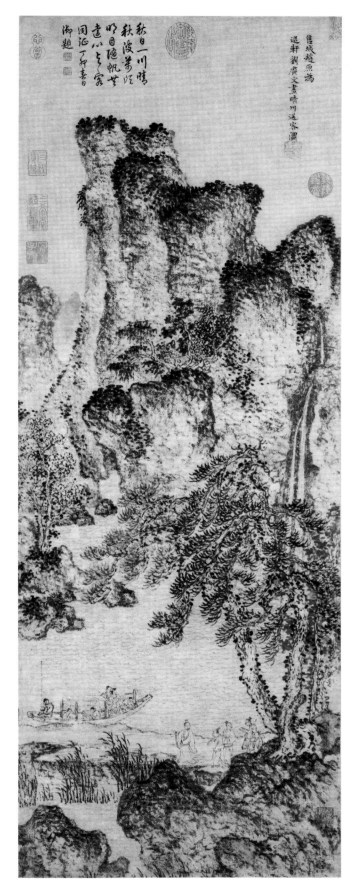

Fig. 67. *Farewell by a Stream on a Clear Day*
Chao Yüan, active ca. 1350–75
Hanging scroll; ink on paper
The Metropolitan Museum of Art

Fig. 68. *Spring Dawn at the Cinnabar Terrace*
Lu Kuang, active ca. 1360
Hanging scroll; ink on paper
The Metropolitan Museum of Art

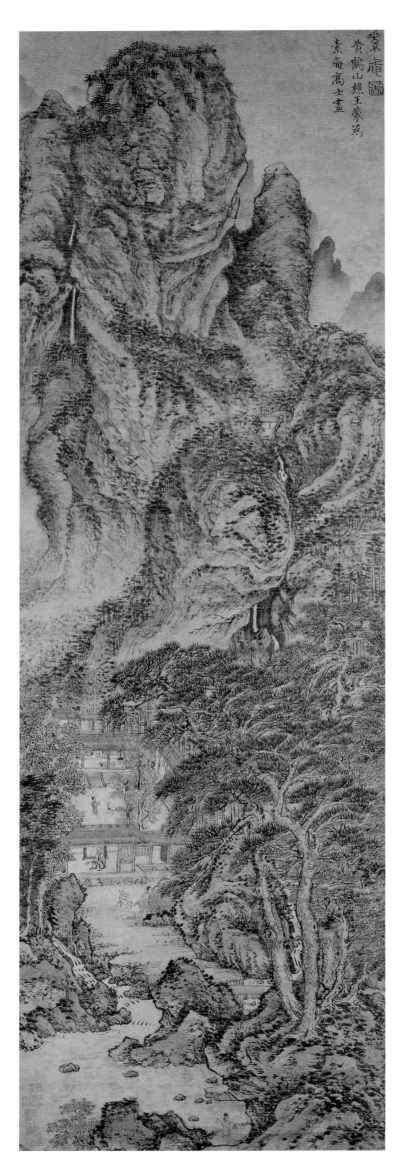

Fig. 70. *The Su-an Retreat*
Detail

Fig. 69. *The Su-an Retreat*
Wang Meng, ca. 1301–ca. 1385
Hanging scroll; ink and color on silk
C. C. Wang family collection, New York

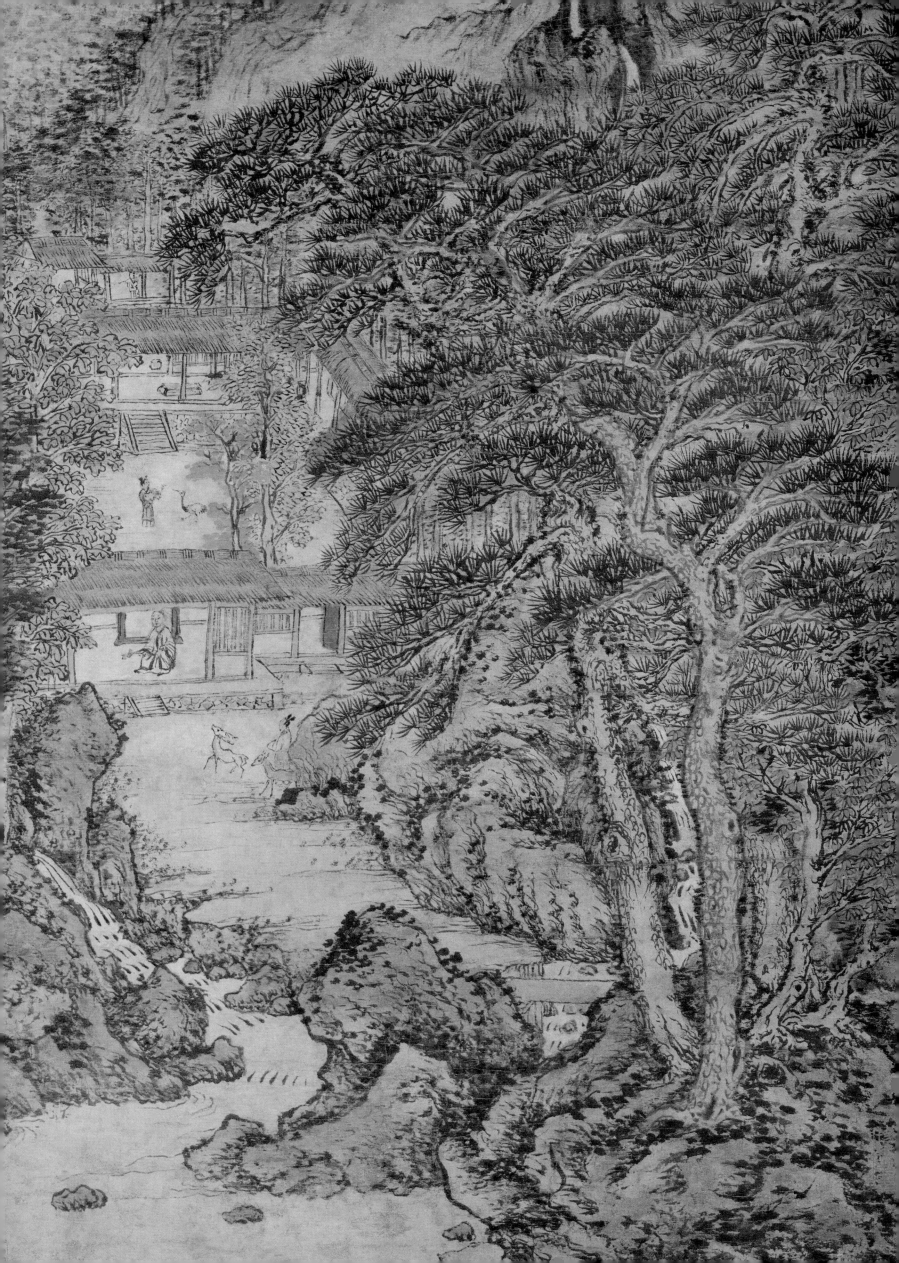

the gradual addition of one line after another. Wang Meng was a painter's painter, and in the minds of his peers his art was the standard of painterly excellence against which the work of others could be measured.

The Su-an Retreat (fig. 69) was probably painted about 1360 for an unidentified hermit named Su-an. Although he lived on Yellow Crane Mountain near Hangchow, Wang Meng was frequently in Soochow during this period, and the influence of his style on such Soochow masters as Hsü Pen and Chao Yüan can easily be seen. Wang was the first painter to succeed in conveying the idea of an interior life in rocks and mountains and to bring out the "dragon veins," as popular tradition describes the embodiment of living spirit in natural forms. In The Su-an Retreat, his mountains writhe with a sense of organic movement; the foreground rocks, the trunks and spreading branches of the pines, the rocky mountains beyond—all pulse in a continuous surge of restless energy. Yet almost as if contesting this

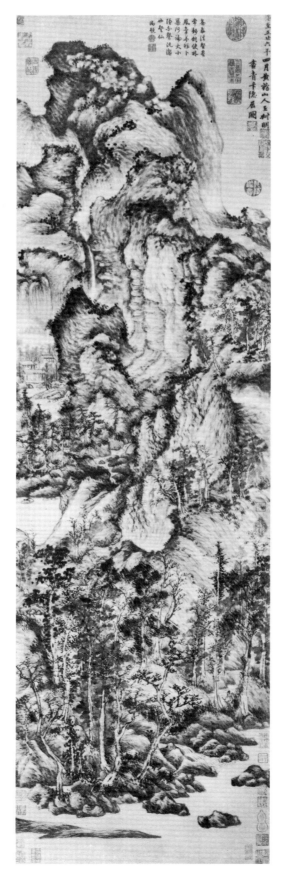

Fig. 71. Dwelling in the Ch'ing-pien Mountains,
 dated 1366
 Wang Meng, ca. 1301–ca. 1385
 Hanging scroll; ink on paper
 Shanghai Museum

indication of incorporeality, all forms are modeled with thick textures and tonalities, like richly painted sculpture. Even the stream in the lower left seems to be a solid substance. Over these tactile organic forms, in a shifting screen of density of weight and tone, is a shower of ink dots, and into this mix is washed a bold palette ranging from red orange to blue green. Softening the dense mass of Wang's form, texture, color, and movement is an interior network of water, mist, and air that provides the yin counterpart of the yang forces: two waterfalls plunge from the distant mountain, dissolving into the light-filled pocket of Su-an's retreat at the lower left. There the retired scholar sits quietly on the veranda as a boy brings refreshments and a friend approaches from the forest in the company of two gamboling deer (fig. 70).

The varied elements of the painting are almost too complex to describe and yet Wang Meng achieves an impressive coherence and unity of composition that is perhaps revealed

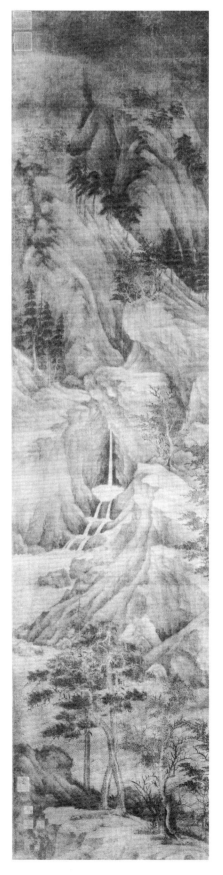

Fig. 72. *The Riverbank*
Detail (see fig. 1)

most fully when compared with Hsü Pen's *Streams and Mountains*. In the attempted complexity of its form and movement, the latter is certainly in part dependent upon Wang Meng. Measured against Wang Meng's painting, however, Hsü Pen's work consists of fragmentary, individual units of form that fail to achieve the dynamic unified vision of *The Su-an Retreat*. The paintings of Hsü Pen and Chao Yüan are in fact miniature reflections of the work of Wang Meng, lacking his immense vitality and painterly richness.

The most extreme expression of Wang Meng's idea of living mountains is his beautiful painting of 1366, now in the Shanghai Museum, called *Dwelling in the Ch'ing-pien Mountains* (fig. 71). Well known to C. C. Wang since his days in Shanghai, although never in his collection, this work appears to be related to *The Riverbank*, attributed to Tung Yüan, and demonstrates some of the ways in which a great Yüan painter utilized Sung art to achieve the new vision of his own age and invention. We remarked of the massive *Riverbank* that it is formed of two scrolls now joined at the center, and that in the fourteenth century it may have been differently mounted, perhaps as two scrolls forming a set or as two framed panels of a fixed structure such as a screen or a wall. One reason for this assumption is the presence on both pieces of silk of the seals of the Yüan bamboo painter and connoisseur K'o Chiu-ssu. Later collectors liberally placed their seals all over their prized paintings, but fourteenth-century private collectors evidently did not; one or two seals placed together was their common practice. The presence of two of K'o's seals in the lower-left corner and another in the lower right therefore suggests that when he owned *The Riverbank* it was two panels, not one. A second reason for this hypothesis is the formal relationship between the left half (fig. 72) of *The Riverbank* and Wang Meng's *Dwelling in the Ch'ing-pien Mountains*.

In his pioneering study of Wang Meng published in 1939, Max Loehr offered what is still perhaps the most perfect description of the formal and expressive effect of *Dwelling in the Ch'ing-pien Mountains*:

> The picture seems not so much to describe a passage of mountain scenery as to express a terrible occurrence, an eruptive vision. Now we have before us nothing less than an illustration of the life of the earth.

The eruption follows a billowing arc from lower left across to the right, and then angles back toward the upper-left corner in a final series of pulsing movements. An eerie light seems to play across or through the mountains, and a disturbingly surrealistic landscape is suggested by the emphasis on adjoining concave and convex surfaces. All of these features are at least faintly present in *The Riverbank*, even in some portions the strange lighting, which appears to come from within the rocks. Most important are the similarities of structural configuration, which are too unusual to be accidentally similar.

Wang Meng, of course, borrows only a few ideas that allow him to elaborate his own vision, and he transforms the neat unobtrusive techniques of Tung's *Riverbank* into a mesmerizing array of brush textures, movements, tonalities, using such altogether unprecedented devices as the dry smoky clouds of blurring shadow that here and there obliterate forms. What may be common to the two pictures is historically interesting, but their differences are what make each a masterpiece of its time. On the basis of three works by Wang —*Spring Plowing at the Mouth of a Valley* (National Palace Museum, Taipei), which the scholar Chang Kuang-pin dates to about 1364, *Retreat in Summer Mountains* (Peking Palace Museum), dated 1365, and *Dwelling in the Ch'ing-pien Mountains*, dated 1366—we may be certain that in the mid-1360s, the artist was fascinated by *The Riverbank*. He presumably observed something new in the work, elements in that painting different from those usually seen in Tung's oeuvre, among them the monumental composition, the powerfully tactile mountain forms, the strange light, and the thrusting, heaving movement. From these qualities, Wang Meng created the most startling expression of his own interior image of the earth alive.

Two Trees on the South Bank

Nothing could be further from the warm, sensuous, energetic art of Wang Meng than the icy restraint of Ni Tsan; Ni's is the counterpole to Wang's in defining the creative vision of late Yüan painting in the southeast. "Ni of the Cloudy Forest," as he often called himself, pursued an expressive world of utter simplicity and restraint. Wang Meng tried to rival and re-create in his own terms the complexity and vitality of trees and mountains, whereas Ni Tsan created an alternative world using the forms of nature, but not imitating nature, except in his attempt to crystallize the single, still, fragile perception of his mind's eye. The stillness of Ni Tsan and the exuberance of Wang Meng are the yin and the yang of late Yüan art. The two men knew and admired each other, as they did most of the other painters and scholars of the Lake T'ai area. It was a small and close-knit world, and within that world these two seem to have been the guiding lights. Like the others, Ni and Wang were in turn deeply indebted to the innovations of Chao Meng-fu and Huang Kung-wang, but their art is original and inventive far beyond the common debt they owed to their predecessors. If we think of Wang's art as the epitome of movement and energy and Ni's as the embodiment of stillness and silence, then the two artists will be seen to have realized the almost inevitable potential for elaboration of these primal forces that landscape painting had embodied since its inception.

Although a native of Wu-hsi on the banks of Lake T'ai, Ni Tsan, like Wang Meng, was a central figure in the late Yüan group of painters associated with Soochow. Ni's inscription of 1372 on his friend Ch'en Ju-yen's *Land of Immortals* mourns the passing of an intimate associate, the first of the Soochow friends to die at the hands of Chu Yüan-chang. In 1373 he cooperated with another friend, Chao Yüan, in painting one of the famed sights of Soochow, the Lion-Grove Garden. Ni's *Garden of Green Waters*, discussed below, was painted for and dedicated to the master of that Soochow garden, Ch'en Ju-chih, another leading Soochow scholar and the brother of Ch'en Ju-yen. Ni was in the city frequently during the years of his voluntary exile, as he roamed the lakes and rivers in a boat for nearly twenty years to avoid the troubles, until his return to Wu-hsi in 1374, the year of his death. He became the cultural exemplar of the mode of lofty, chaste simplicity and restraint in both art and life, and his subsequent influence over the art and taste of Chiangnan cannot be overstated.

C. C. Wang has probably admired Ni Tsan more than he has any other Chinese painter, and his collection of Ni Tsan paintings is the largest in the world outside of China. The six works by Ni chosen for illustration in this volume will allow us to trace his development over a period of nearly twenty years. We have already seen his *Bamboo, Rock, and Tall Tree*, probably painted about 1365, although Wang, whose articles on the painter are the most comprehensive studies yet undertaken, dates it a few years later.

A work of 1353, *Two Trees on the South Bank* (fig. 73), illustrates the delicacy and charm of Ni's earlier work. This is actually a tree, bamboo, and rock composition too, a subject specially favored by Ni Tsan, no doubt because it was an established form, allowing him to "play" it over and over with slight variations and minor changes. *Two Trees*, the earliest of his seven or eight extant examples of this type of composition, is the most precise, delicate, and restrained of the sequence. His poem in the upper-right corner ends with the lines, "I still recall the two trees on the south bank/ In the clearing rain green bamboo stretched up toward the stars." By now it may not be necessary to point out that there is no hint in the painting itself of night or of rain (except in the convention used for the bamboo), nor of the river or the white birds mentioned elsewhere in the poem. This is just a little chamber music, in James Cahill's analogy—an exercise in nostalgic recollection in a familiar form. Simple lucid structure, clear open lines, and an intense interior mood are some of the goals Ni Tsan pursued in his painting, and in the tree, bamboo, and rock compositions they are achieved with particular impact.

余既為谷遠茂十寫此并賦絕句
甫里宅邊曾繫舟滄江白鳥思
悠悠憶得岸南雙樹子雨餘青
竹上牽牛俔瓚至正十三年二月
晦日

Fig. 73. *Two Trees on the South Bank*, dated 1353
Ni Tsan, 1301–74
Hanging scroll; ink on paper
The Art Museum, Princeton University

Ni's *Bamboo, Rock, and Tall Tree* (see fig. 60) of perhaps a decade later is a more accomplished performance. With even less ink and a somewhat narrower tonal range, he is able to give more substance to the tree, a sharper, more vivid crispness to the bamboo, and a hoarier, more weather-beaten look to the rock. The composition is unusually full for Ni Tsan, as if he had gradually expanded its possibilities until the limits of the form had been reached.

Lastly, an undated work in the genre, *The Garden of Green Waters* (fig. 74), reveals the painter in his most dashing and untrammeled mood, "splashing ink in the clearing rain," as he writes in his inscription. The given form has not only been mastered, it has been all but forgotten. There is little of the concern Ni shows elsewhere for structure, tactile mass, or texture (always, of course, within the deliberately limited range he explores). The moss and foliage dots on the trees drift about like smoke; the nearer of the two trees is rather meaninglessly broken off; the rock is not integrated spatially, just stuck in at the side; and even the familiar spiky calligraphy has become loose, open, and all but disordered.

If the painting is considered in isolation, with no knowledge of Ni's other works, the viewer may feel it offers little attraction as a picture. In context, however, we may admire this evidence of the painter's success in rising above the limitations of a fixed mode, of his disinterest in conventional representational requirements, and of the freedom he ultimately found in "splashing ink." Success or failure in any objective sense is irrelevant to the painter at this point; the act of creation is all that matters.

River Pavilion and Distant Mountains

In landscape painting, no traditional mode had the particular fixed boundaries that Ni Tsan wished to exploit, so he borrowed certain features from his contemporaries and adapted them to his own needs. When fully developed by about 1363, a "Ni Tsan composition" consisted of some foreground earthen banks, rocks, and trees, usually with an empty hut or pavilion somewhere among them, a few distant hills, and a stretch of empty water—lake or river. Wu Chen, as early as 1341, had created similar river landscapes, and possibly Ni Tsan borrowed the basic structure and compositional idea from him. As suggested by our brief survey of his tree, bamboo, and rock paintings, Ni showed no interest in inventing new forms, but rather was attempting to achieve expressive freedom within narrow boundaries. Wu Chen's river landscapes generally focused upon himself, introduced in the form of a hermit-fisherman on the river and described in his autobiographical poems calling attention to his presence. The absence of human figures, often emphasized by an empty hut in the foreground, is a distinctive feature of Ni Tsan's landscapes. To a question about the lack of figures in his painting, he is said to have replied, "I don't know that there is anyone around in the world," an attitude of solitude of mind that his paintings nearly always suggest. In his poem inscribed on *The Garden of Green Waters*, clearly referring to himself, he wrote: "Who else is there like this visitor in the Garden of Green Waters/In the setting sun, alone in the empty garden, chanting his poems?"

River Pavilion and Distant Mountains of 1368 (fig. 75) not only combines all of the familiar elements, but, in the artist's poem, supplies the ever-present mood: "I can't wake up from this spring melancholy—as if I were drunk/Waves and wild winds beat against my window." Melancholy seems to have been Ni Tsan's constant state, and the stylistic means he cultivated suit the expression of this mood so perfectly that one supposes he cultivated them for just that reason. The dry lines, like charcoal; the "wash," actually done by just rubbing the paper with a dried-out brush; the sharply cut rock and mountain forms; the quiet interplay of gray and white spaces and shapes; the absence of anything remotely rich or moist—all contribute to the graphic crystallization of a mood and a personality (fig. 76). As one becomes attuned to the strict limitations Ni imposed upon himself, just as one must

Fig. 74. *The Garden of Green Waters*
Ni Tsan, 1301–74
Hanging scroll; ink on paper
C. C. Wang family collection, New York

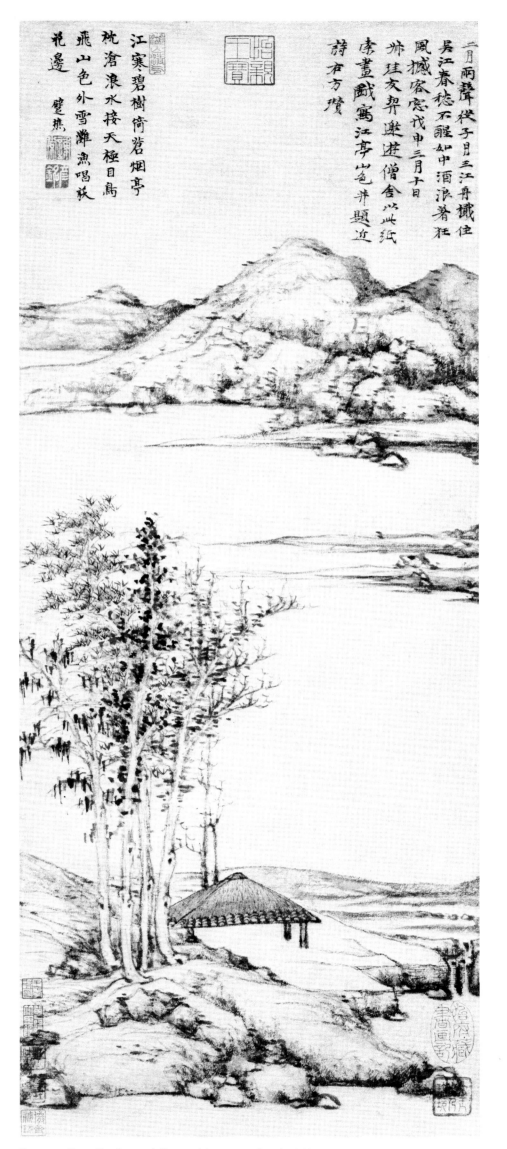

二月兩聲從子且三江舟識住

昌江春黍不醒如中酒浪著狂

風撼客窓戊申三月十日

師珪友契遽進僧舍以此紙

索畫戲寫江亭山色并題近

詩其方瀆

江寒碧樹猗菭煙亭

枕滄浪水接天極目烏

飛山色外雪灘漁唱荻

花邊 壁熊

Fig. 75. *River Pavilion and Distant Mountains*, dated 1368
Ni Tsan, 1301–74
Hanging scroll; ink on paper
C. C. Wang family collection, New York

Fig. 76.
River Pavilion and Distant Mountains
Detail

adjust focus and make mental reduction into the world of Sung landscape, one may even come to see a certain veiled sensuousness in the occasional dot or line in pure black ink, emphasized by the icy sharpness of his rocks and his precise, logical structure. Ni Tsan was obsessed with cleanliness, as we have noted, and the cleanliness of his art is manufactured from these elements.

Ni Tsan loved these familiar forms and dimensions, loved to shorten a bit here, lengthen there, extend the mountains up or across, juggle things about, while holding always to his basic idea. Everything he felt necessary to his vision is there—nothing more, nothing less. A painting done four years later and given by the painter precisely the same title, *River Pavilion and Distant Mountains* (National Palace Museum, Taipei), is simply a variation on the theme of the 1368 version, the kind of variation he must have done a hundred times. Nearly all of his landscapes might just as well be titled *River Pavilion and Distant Mountains*.

Ni Tsan more than any painter before him deals with his physical materials—brush, ink, paper—frankly and without illusion. Consider, for example, the river that falls in a series of shallows across the rocks into a pool in the lower-right corner of the 1368 painting. We can read the natural configuration, but we also become aware of another dimension. There are only two conditions here: one is the untouched paper; the other is the ink that changes that paper. The ink builds its gray structures, but what passes through and surrounds the ink is still paper, paper flowing into paper through an architecture of ink.

After Ni Tsan, few scholar-painters pretended any longer to be representing mist or atmosphere or space, thereby denying the physical presence of their materials; they were instead conscious of the hard two-dimensional surface, which they worked upon and transfigured into graphic abstraction. Li Kung-lin and Mi Fu may first have conceived that idea along with Su Shih; Chao Meng-fu undoubtedly advanced it and lent it an intellectual structure. But Ni Tsan hammered the nails into the coffin of naturalistic illusion.

Ni Tsan's masterpiece in the United States is *Woods and Valleys of Mount Yü* (fig. 77), painted in January 1372, less than three years before his death. It is as close to an expansive, monumental, and even perhaps optimistic state as he ever pushed his vision. The foreground trees are spread out and breathing, not pressed together and cramped. The mountains in the distance give the impression of actually extending beyond the frame. Twenty-six years earlier he had painted another landscape that does not include an empty hut or pavilion, the famous *Six Gentlemen* in the Shanghai Museum. In *Woods and Valleys*, the six are now five; the cramped, tight brushwork is now in a state of easy mastery; the miniature vision is now monumental—but superficially nothing much has changed. As we study the sequence of his landscape paintings, we come to realize how perfectly Ni Tsan defined the artistic world he envisioned and gradually nursed into existence. Once he had set its boundaries, they stood permanently, and he found all he wished to find within them.

Is it possible to discern changes in meaning within such narrow boundaries? We know, for example, that Ni returned from his long journey in 1374, and died in the home of his son-in-law later that year. We can guess that the decision to return to Wu-hsi grew from changes in himself and his attitude toward his circumstances. He wanted to die at home, we might assume. He wished to be home, certainly. When this desire began is not known. It is tempting to think that we can sense changes in his art that may reflect the set of his mind. In fact, recalling the characteristics we have observed during a period of twenty years, it might be suggested that we have already begun to define the changing contours of a mentality and personality. From delicate and small-scale compositions in the 1350s and earlier, Ni moved toward larger images that about 1360 settled into a pattern. Within that pattern we saw the artist enlarge his strength of brushwork and his confidence and by about 1368 reach maturity. In that same year the rule of the Mongols was finally ended and the new Ming dynasty was established by the Chinese peasant Chu Yüan-chang.

Woods and Valleys of Mount Yü and several other pictures of 1372 reveal Ni Tsan at

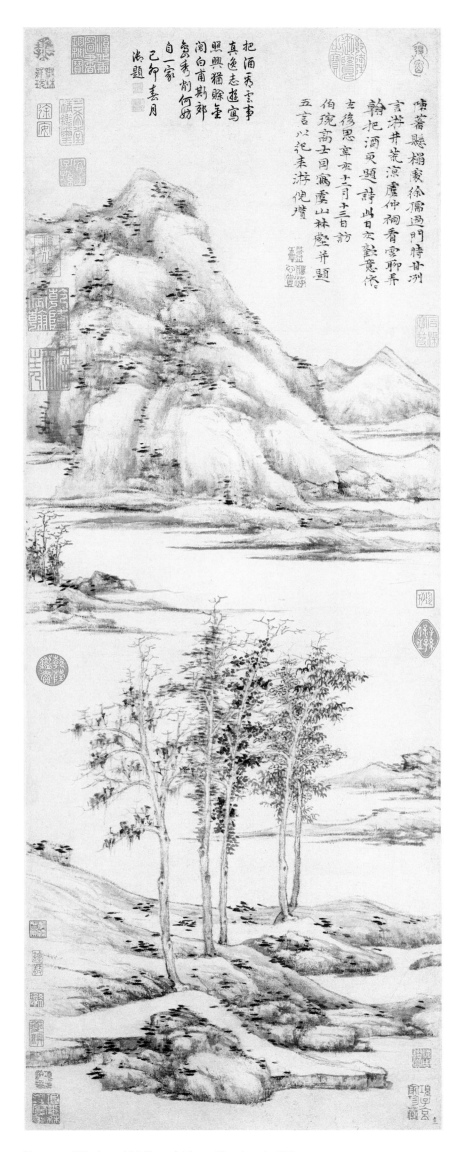

把酒两忘言
言游井荒凉
照兴犹账至
阁白甫期郊
自立一家
己卯春月
渶题

陈蕃悬榻爰徐孺过门時甘洌
言游井荒凉庐仲祠香雲聊弄
翰把酒更题诗此日灰馜意依
去後思章在十二月十三日訪
伯琬高士目寓霞山林壑并题
五言以记未游倪瓚

Fig. 77. *Woods and Valleys of Mount Yü*, dated 1372
Ni Tsan, 1301–74
Hanging scroll; ink on paper
The Metropolitan Museum of Art

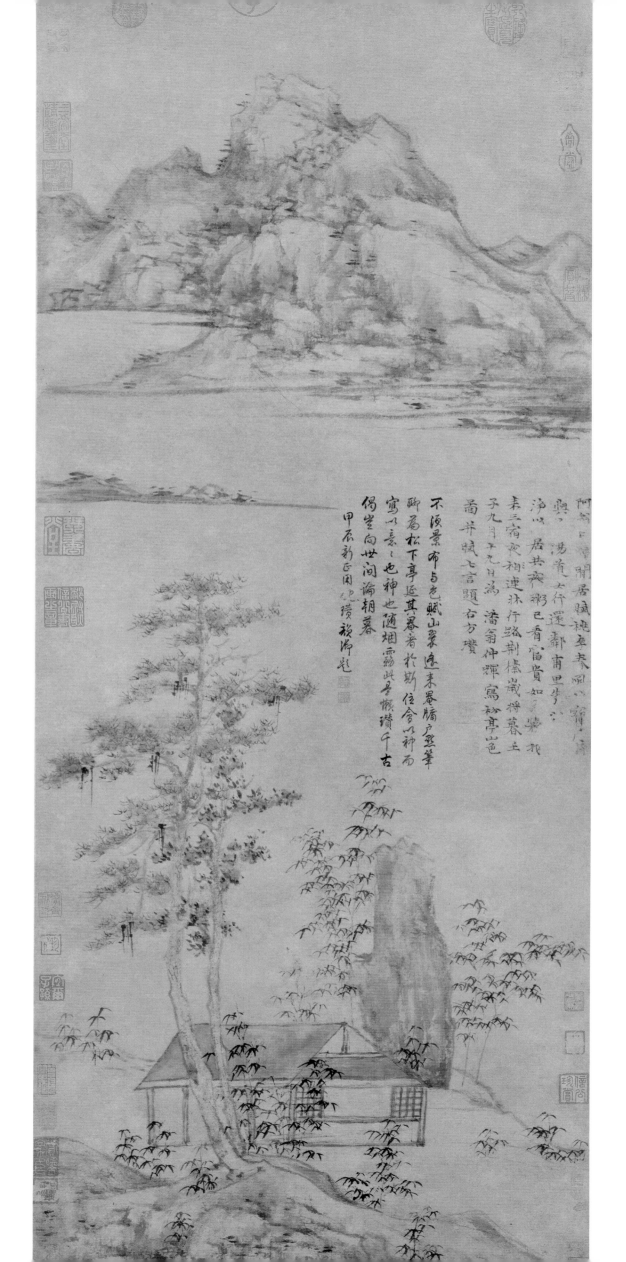

his most expansive, painting large high mountains and spacious foreground settings for flourishing trees. On this evidence, we might safely assume a very different Ni Tsan from the timid, tentative scholar of earlier years. We might also sense a quiet celebration of the land and the nation, something not even hinted at in his art prior to 1368, when the Ming was established. That 1372 was indeed a significant and new phase of the artist's life and mood is confirmed by a rediscovered work of great importance within his oeuvre and in the formation of his legend.

Pine Pavilion, Mountain Scenery (fig. 78) was painted in October 1372 (the ninth month of the jen-tzu year) and is the latest dated landscape by the artist that is known today. Less imposing than Woods and Valleys of Mount Yü, it is a more relaxed and comfortable work that suggests an easy frame of mind and a total absence of striving. The usual elements are present, but so also is the curious cottage that he painted elsewhere during this time—a building that looks almost like a home rather than the empty pavilion of earlier days. Perhaps it is merely coincidence that, only a year or so before he at last returned to Wu-hsi, Ni for the first time painted houses to be lived in. If so, we can be quite certain on the evidence of this long-lost work and the few other small-scale pictures he painted before his death that the artist had attained a state of mind close to contentment.

Later connoisseurs often wrote that during the Ming period the taste of gentry families in southern China was judged by whether or not they owned a painting by Ni Tsan. Pine Pavilion, Mountain Scenery also establishes the authority for that view. In his colophon mounted above the painting the great Ming master Shen Chou (1427–1509) wrote: "The people of Chiangtung [i.e., south-central China] judge purity or vulgarity on the basis of ownership of Master Yün-lin's ink plays" (see Appendix 1). By the fifteenth century, therefore, some of the social, aesthetic, and moral meanings of purity had come to be defined by the landscape painting of the Master of the Cloud Forest. We may assume that the Ch'ien-lung emperor, whose inscription disfigures the center of Pine Pavilion, would not have met this standard—if only on the grounds of good taste.

Ni Tsan is not an artist altogether easy to admire. If there are painters who expand and painters who restrict the limits of art, I suppose he would have to be included among the latter. The astringent remoteness of the world created by his dry brushwork and smoky ink dots lies almost wholly within a sphere of spareness and restraint; rarely does his mind sparkle with wit or laughter. We wonder in fact whether he saw the same world we see, and we know instantly that he did not. He perceived within the experience of his life something no one else could, and he found stark bones of ink with which to convey this perception to all who wished to see it. James Cahill has referred us to the comment about Ni Tsan's art by the Ch'ing scholar and connoisseur Juan Yüan (1764–1859):

> In landscapes painted by other men, which make use of real, existing scenery, one can roam over their terrain and enjoy it. With Ni Tsan, one is given a withered tree or two, a squat building, "remnants of mountains and residual waters," drawn onto a sheet of paper—decidedly the ultimate in loneliness and remoteness, the most dilute and withdrawn. If one were to enter bodily into this world, he would find it without flavor and would be emptied of all thought.

To empty the mind of all thought, like the perfect, unblemished mirror of the mind in Ch'an Buddhism; to be without flavor, like brook water or the sky—these are achievements no painter had ever attained. Some critics of the Ming period classified Ni Tsan as an "untrammeled" master, meaning that his art could not really be compared or discussed with that of other artists, that he was unique, with a language and a vision uniquely his own, untranslatable into traditional values and standards. That is probably a fairer, truer assessment of the character of his art than the subsequent verdict classifying him simply as one of the

Fig. 78. Pine Pavilion, Mountain Scenery, dated 1372
Ni Tsan, 1301–74
Hanging scroll; ink on paper
C. C. Wang family collection, New York

Fig. 79. *The Romantic Spirit of the Eastern Chin,* dated 1360
 Fang Ts'ung-i, ca. 1301–after 1378
 Handscroll; ink and color on paper
 C. C. Wang family collection, New York

Four Great Masters of Yüan painting. His art is also the only tangible embodiment of his life and thought that exists today, and we may be excused for peering within it to find memory of the man present in the marks of his brush.

The Romantic Spirit of the Eastern Chin

> Fang-hu's brush pursues the state of immortality. Accordingly, it gives shape to the shapeless, and returns that which has shape to shapelessness. That this can be done in painting must indeed be the ultimate achievement of art. If Fang-hu were not himself an immortal, could he have done this?

This remarkable critical observation by the Yüan writer Li Ts'un (1281–1354) suggests that the Taoist painter Fang Ts'ung-i (Fang-hu) realized the ultimate potential of representational art: he dissolved form and gave suggestion to the unseeable, the "wind and flow" of primal existence. Something like this had already been attained by the painter Mu-ch'i, a mid-thirteenth-century Ch'an monk, although no one spoke of it at the time, and now this mysterious sense of a vision of immortality is attributed to Fang Ts'ung-i. The means were quite different, but it is noteworthy that it was first a Ch'an monk and later a Taoist priest who seem to have been preoccupied with these indefinable forces of life. Both men sought immortality in their lives through identification with spirituality—that of the Buddha or of the Tao—but it is by no means safe to assume that religiosity in life equals religiosity in art. Still, even considering the difficulties of isolating or suggesting the elements of spirituality in landscape painting, modern art historians have been curiously reluctant to discuss the subject at all.

Complicating the matter in the Yüan period is the intimate relationship at that time among the "three doctrines"—Confucianism, Taoism, and Buddhism. As a form of both cultural protection and religious revival, schools teaching the three doctrines sprang up all over China during the century of Mongol occupation. Some historians tend to view this

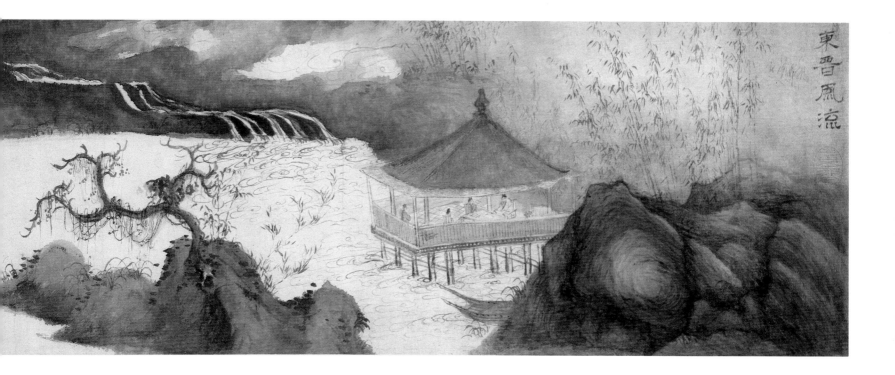

phenomenon as an extension of the Sung neo-Confucian amalgam of Confucianism and the cosmology of Taoism and Buddhism, that is, as a philosophical rather than religious movement. But the evidence of true religious conviction in the fourteenth century, extending to all levels of the population, is persuasive.

Of the artists we have considered, Wu Chen in particular appears to have lived a humbly religious life of hermitage. He named his son Fo-nu, or Servant of Buddha, and occasionally signed his paintings "Plum Blossom Sramanera [disciple]," more often "Plum Blossom Taoist." Nearly all of the paintings surviving from his maturity were done for persons associated with Buddhist or Taoist temples. Ni Tsan and Huang Kung-wang both were serious followers of the Taoist religion, and Huang is said to have established a School of Three Doctrines in Soochow. Lo Chih-ch'üan may have been a Buddhist.

Fang Ts'ung-i was a man of somewhat different and very evident religious conviction, however. He was a Taoist priest and teacher by profession, from the 1350s a revered master at the Shang-ch'ing-kung monastery at Mount Lung-hu, or Dragon Tiger Mountain, in Kiangsi province. The Taoist church sporadically gained much influence at the Mongol court, and Fang visited Peking sometime in the 1330s or 1340s. He claimed only to be visiting the sacred mountains of the north, however, not seeking office like so many of his compatriots; in any case, he did not remain long in the capital. The remainder of his life, until at least the age of ninety, was spent in the monasteries of Mount Lung-hu and Chin-men. He was known and admired by many of the leading scholars of the time and had achieved remarkable fame as a painter by mid-century, as proven by Li Ts'un's comment written not later than 1354. Copies of Fang's works made as early as 1348 survive, but the earliest of his extant original works is *Boating at Mount Wu-i* of 1359, now in the Peking Palace Museum.

The following year, 1360, after "much fear and trembling" at the responsibility given him, as he notes in his inscription (see Appendix 1), Fang Ts'ung-i painted an illustration for a copy of the *Preface to the Gathering at Orchid Pavilion* by the master calligrapher Wang Hsi-chih. The gathering at the Orchid Pavilion, a celebrated cultural event that took place near Nanking in 353, was commemorated in the *Preface*, the most hallowed and esteemed

Overleaf:
Fig. 80. *The Romantic Spirit of the Easter Chin*
Detail

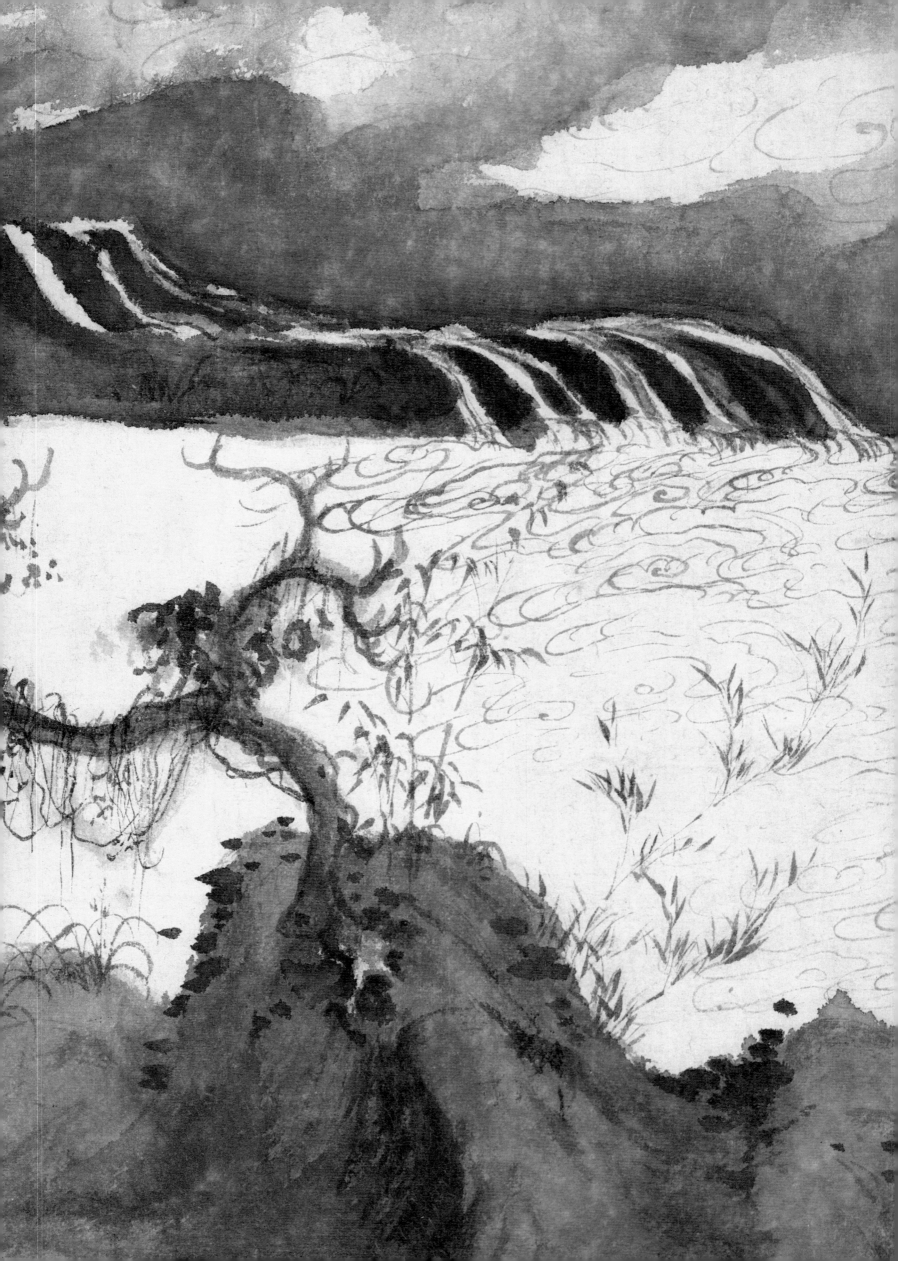

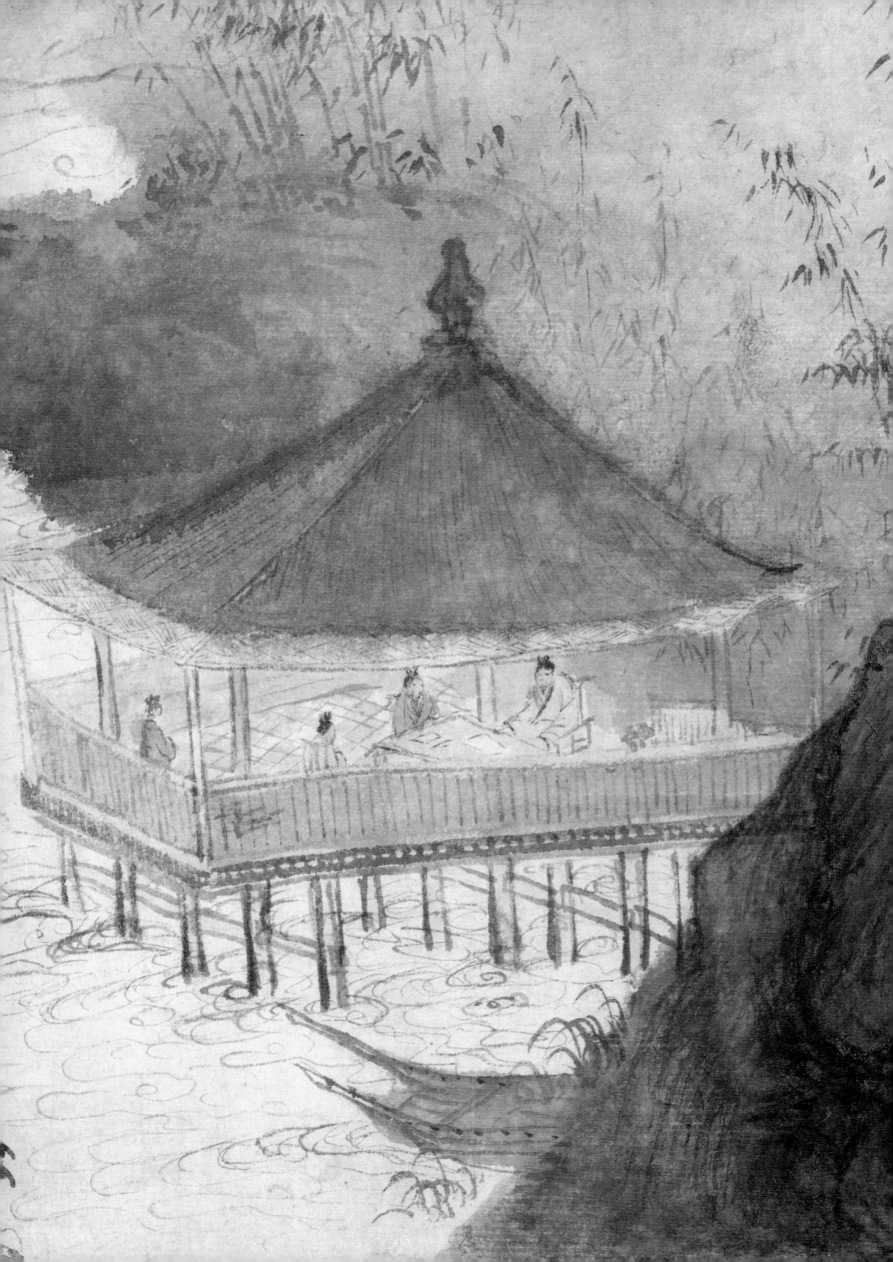

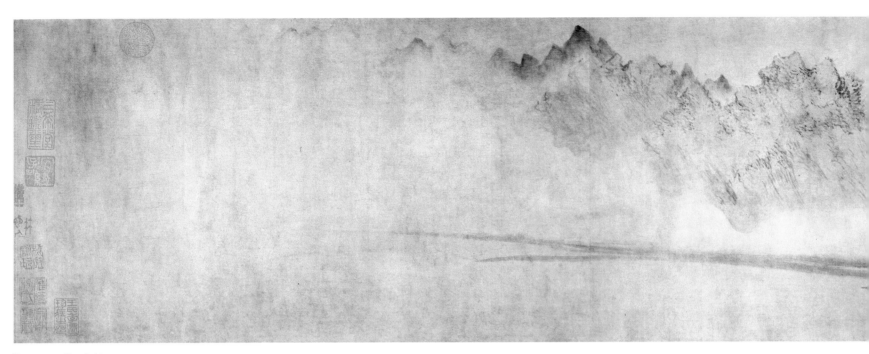

Fig. 81. *Cloud Mountains,* ca. 1365
Fang Ts'ung-i, ca. 1301–after 1378
Handscroll; ink and color on paper
The Metropolitan Museum of Art

masterpiece in the history of calligraphy. The copy of the *Preface* illustrated by Fang was attributed to Chao Meng-fu (see Appendix 1), himself the most influential follower of Wang Hsi-chih in the Yüan period. Fang's painting, which he titled *The Romantic Spirit of the Eastern Chin* (fig. 79)— the Eastern Chin was the historical period in which the Orchid Pavilion gathering took place —is a truly untrammeled work, so unusual in its own historical context that many art historians find it impossible to believe. Throughout its history it has caused wonderment on the part of art historians and connoisseurs, and there is no reason to expect different reactions today. The seventeenth-century connoisseur Wu Sheng called the painting "the most surpassing of all of Fang-hu's works"; Ku Fu, in the same period, said it "throws off all the common practices of painters"; and Wu Ch'i-chen, about 1677, wrote: "Its lofty simplicity and easy freedom penetrate deep into the realm of metamorphosis. It has a kind of immortal spirit that touches one like ice. This is not something that ordinary mortals can attain, but is a work of the highest order of the untrammeled class."

The subject is basically the same as Ch'ien Hsüan's *Wang Hsi-chih Watching Geese* (see fig. 47) of sixty or seventy years earlier; comparison of these two approaches to the same subject suggests something of the real diversity of Yüan art. Fang's wet, life-filled shimmering vision is the antithesis of Ch'ien's dry, still, archaic dreamworld, but both successfully capture the ineffable spirit of the hallowed cultural ideal they celebrate.

Fang's techniques are unusual, as if invented for this specific occasion rather than drawn from the common repertoire of his time. Slight color is washed into ink and ink wash; pockets of light and mist-filled space are all but absorbed into the swirling moist atmosphere; and, as it is followed from right to left, the entire composition gives the appearance of gradually dissolving from dense dark mass into transparent emptiness. The calligrapher Wang Hsi-chih, about to begin writing, seems to be quietly absorbing the natural forces around him, preparing to seize and pass them through his brush into the calligraphic masterpiece that shook the world of art.

This kind of almost tangible sense of on-going process intertwining the natural world, man, and artistic creation (fig. 80) might be thought of as the unspoken, underlying meaning of all Yüan scholar-painting, but few succeeded better than Fang Ts'ung-i in giving it vivid, direct visual expression. In *The Romantic Spirit of the Eastern Chin* Fang seems to suggest

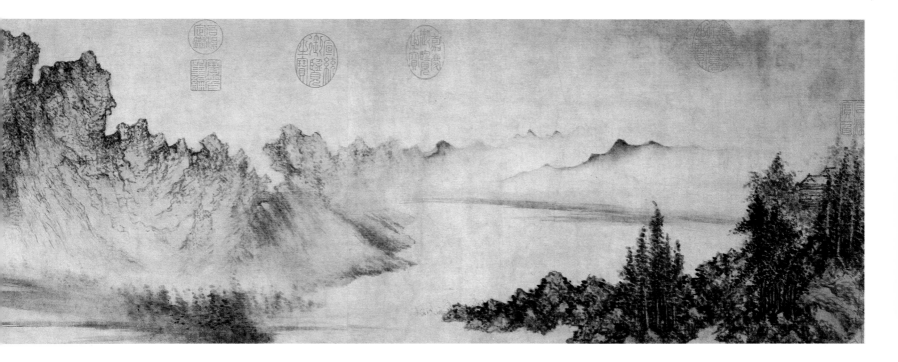

the existence of a cosmic breath, translatable into painting only through an impression of light, color, moisture, space, and atmosphere. There is the idea of the dissolution of concrete things into spirit or ether—the *ch'i* of Chinese cosmic theory—and of ether into things, in an endless cycle of being and nonbeing.

In his *Cloud Mountains* of about 1365 (fig. 81), Fang Ts'ung-i evokes this process first to create then to dissolve an entire massive mountain range into a state of primal light and color (for colophons to this painting see Appendix 1). This magnificent, exuberant celebration of the creative process and of the final oneness of all things exactly corresponds to the phrases of Li Ts'un's wondering encomium:

> [His brush] gives shape to the shapeless, and
> returns that which has shape to shapelessness.

Among the three great visionary artists of late Yüan painting in southeast China, Fang Ts'ung-i's legacy is the least transferable. Wang Meng gave to later masters the concept of richly painterly form—energized, dense, and tactile—which became the structural foundation of much later art. Ni Tsan crystallized a bleak, barren state of mind and minimalist technique, which became a counter ideal. Fang Ts'ung-i, however, pursued some private inner voice, which spoke to him of eternity, oneness, and the spirit. Perhaps Tao-chi (born 1642) among all later painters most nearly shared Fang's ideals. Fang's achievement, which enters the realm of spirit, fittingly suggests the gradual internalization of expression that led from the fourteenth century to the Ming mystic Shen Chou and beyond to the free spirit of seventeenth-century Chinese art, Tao-chi—and allows me to finish this appreciation without implying that there has been an end.

Notes

Appendix 1
Selected Signatures, Inscriptions, and Colophons

Appendix 2
Comments by C. C. Wang

Index

Notes

Page 23
"the myriad phenomena": Kuo Jo-hsü, *T'u-hua chien-wen chih* (ca. 1075); Mao Chin, ed., chüan 1, p. 12b. Cited in Shūjiro Shimada (translated by James Cahill), "Concerning the I-p'in Style of Painting—III," *Oriental Art*, n.s. 10, no. 1 (Spring 1964): 23.

Page 29
"The nation is destroyed": from *Ch'un-wang* ["Spring Meditations"], in *A Concordance to the Poems of Tu Fu* [in Chinese], 3 vols., Harvard-Yenching Sinological Index Series, Suppl. (Peking, 1940), vol. 2, p. 296; reprinted (Taipei, 1966).

Page 29
"My friend bade farewell": *The Works of Li Po, the Chinese Poet*, translated by Shigeyoshi Obata (New York: E. P. Dutton and Company, 1922), p. 68.

Page 29
"I can never see my old friend again": *Poems of Wang Wei*, translated by G. W. Robinson (Harmondsworth: Penguin Books, 1973), p. 45.

Page 29
"Nature is vast": *Chung yung* ["Doctrine of the Mean"], par. 26; translation from Sherman E. Lee, *Chinese Landscape Painting*, 2nd ed., rev. (Cleveland: The Cleveland Museum of Art, 1962), p. 4.

Page 30
"Landscapes are big things": Kuo Hsi, *Lin-ch'üan kao-chih* (ca. 1100); reprinted in Yü An-lan, ed., *Hua-lun ts'ung-k'an* (Peking, 1962), p. 17.

Page 30
"The wise find pleasure": *Confucian Analects* VI, 21.

Page 34
Over a decade ago: Richard M. Barnhart, *Marriage of the Lord of the River: A Lost Landscape by Tung Yüan*. Artibus Asiae Supplementum 27 (Ascona: Artibus Asiae, 1970), pp. 32–33.

Page 34
The most plausible solution: Max Loehr, *Chinese Landscape Woodcuts: From an Imperial Commentary to the Tenth-Century Printed Edition of the Buddhist Canon* (Cambridge, Mass.: Harvard University Press, Belknap Press, 1968), pp. 52–53.

Page 37
Recorded in the list of paintings in Chao Yü-ch'in's collection: *Chao Lan-p'o so-ts'ang shu-hua mu-lu*, in Chou Mi, *Yün-yen kuo-yen lu* (ca. 1300); reprinted in *I-shu ts'ung-pien* (Taipei, 1968–71), vol. 17, no. 150.

Page 38
an exceedingly rare seal reading *Shang-shu-sheng yin*: Wai-kam Ho, in *Eight Dynasties of Chinese Painting: The Collections of the Nelson Gallery–Atkins Museum, Kansas City, and The Cleveland Museum of Art* (Cleveland: The Cleveland Museum of Art, 1980), pp. 16–18.

Page 42
In his study: see Wen Fong, *Sung and Yuan Paintings* (New York: The Metropolitan Museum of Art, 1973), pp. 24–25. For a more extensive discussion see idem, *Summer Mountains: The Timeless Landscape* (New York: The Metropolitan Museum of Art, 1975).

Page 43
"Ch'ü Ting was a native": *Hsüan-ho hua-p'u* (preface 1120); reprinted (Peking, 1964), chüan 11, p. 194.

Page 44
"The Master said": adapted from *The Sacred Books of China: The Texts of Confucianism*, translated by James Legge, 3 vols. (Oxford: Clarendon Press, 1879–85), vol. 1, pp. 487–88.

Page 45
"In illustrating the eighteenth chapter": Su Shih, "Colophon to Li Kung-lin's *Hsiao ching t'u*," in *P'ei-wen-chai shu-hua p'u* (1708); reprinted (Shanghai, 1883), chüan 83, p. 1a.

Page 46
"inexhaustible flavor of nature," "ink-plays," etc.: for these and other terms and concepts of the Northern Sung literati, see Susan Bush, *The Chinese Literati on Painting: Su Shih (1037–1101) to Tung Ch'i-ch'ang (1555–1636)* (Cambridge, Mass.: Harvard University Press, 1971), pp. 67–74.

Page 46
"hills and valleys within the breast": Bush, *The Chinese Literati*, pp. 45–47, 53.

Page 52
A painting . . . from a recently rediscovered twelfth-century temple: *Wen-wu* 2 (1979): 1–10, pl. 2.

Page 53
The discovery in 1972: *Wen-wu* 8 (1972): 39–51.

Page 55
"The great masters of previous generations": Liu K'o-chuang, *Hou-ts'un chi* (13th century), in *P'ei-wen-chai shu-hua p'u*, chüan 83, p. 2a.

Page 55
"As they serve their fathers": adapted from Legge, *The Sacred Books of China*, vol. 1, pp. 470–71.

Page 57
"He was able to distinguish": *Hsüan-ho hua-p'u*, chüan 7, pp. 130–31.

Page 66
Wen Fong discusses these issues: see Fong, *Sung and Yuan Paintings*, pp. 29–36.

Page 67
Since the Metropolitan's scroll has been fully published: *Eighteen Songs of a Nomad Flute: The Story of Lady Wen-chi*, edited and translated by Robert A. Rorex and Wen Fong (New York: The Metropolitan Museum of Art, 1974).

Page 67
"In the vast barbarian sky": adapted from *Eighteen Songs of a Nomad Flute*, Song 4.

Page 71
"In the days of the Third": *The Book of Songs*, translated by Arthur Waley (New York: Grove Press, 1960), pp. 164–67.

Page 72
"Oh, kite-owl, kite-owl": *The Book of Songs*, p. 235.

Page 75
"Broken were our axes": *The Book of Songs*, p. 236.

Page 75
"The movements of the figures": Fong, *Sung and Yuan Paintings*, p. 50.

Page 80
"Master Kuo . . . wrote that there are three ways": Han Cho, *Shan-shui ch'un-ch'uan chi* ["A Pure and Complete Collection of Landscape"] (1121); reprinted in *Hua-lun ts'ung-k'an*, p. 36.

Page 82
"Long and serene my solitary day": translation by Gerald Bullett, in Cyril Birch and Donald Keene, eds., *Anthology of Chinese Literature: From Early Times to the Fourteenth Century* (New York: Grove Press, 1965), p. 387.

Page 82
"Here in the country": *The Poetry of T'ao Ch'ien*, translated by James Robert Hightower (Oxford: Clarendon Press, 1970), p. 51.

Page 85
"Where dogs seem to bark": *Li Po and Tu Fu*, edited and translated by Arthur Cooper (Harmondsworth: Penguin Books, 1973), p. 105.

Page 85
"In delicate gradations of ink tone": James Cahill, *Chinese Painting* (Geneva: Skira, 1960), p. 82.

Page 86
"In light shadows": Chang Tzu, *Mei-p'in* (ca. 1185), reprinted in *I-shu ts'ung-pien*, vol. 30, pp. 5b–6a.

Page 86
"I stand by the stream": *Heaven My Blanket, Earth My Pillow: Poems by Yang Wan-li*, translated by Jonathan Chaves (New York: Weatherhill, 1975), p. 67.

Page 90
"I see you off by the southern shore": adapted from *Poems of Wang Wei*, p. 114.

Page 90
"Far mountains sharp": *Poems of Wang Wei*, p. 54.

Page 91
"The morning rain of Wei City": *Wang Yu-cheng chi-chu* (1736); reprinted in *Ssu-pu pei-yao*, chüan 4, p. 5a.

Page 93
"the principle of yin and yang asymmetrical balance": Fong, *Sung and Yuan Paintings*, p. 68.

Page 94
"If you want poetry to be miraculous": quoted in Wai-lim Yip, "Yen Yü and the Poetic Theories of the Sung Dynasty," *Tamkang Review* 1, no. 2 (October 1970): 186.

Page 98
"Male or female shamans": *Ch'u Tz'u: The Songs of the South*, edited and translated by David Hawkes (Oxford: Clarendon Press, 1959), p. 35.

Page 99
"I wander with you": *Ch'u Tz'u: The Songs of the South*, p. 42.

Page 101
"The emperor's child": adapted from *Ch'u Tz'u: The Songs of the South*, p. 38.

Page 110
"a sea of narcissus": Fong, *Sung and Yuan Paintings*, p. 68.

Page 111
"The ice is thin": adapted from Fong, *Sung and Yuan Paintings*, p. 71.

Page 114
"Hsieh K'un and the other companions" and "Hsieh K'un accompanied Wang Tun": Liu I-ch'ing, *A New Account of Tales of the World*, translated by Richard B. Mather (Minneapolis: University of Minnesota Press, 1976), p. 254.

Page 115
"A sense of antiquity": quoted in Bush, *The Chinese Literati*, pp. 121–22.

Page 116
"This was Hsieh Yu-yü": translation by Wai-Kam Ho, in Sherman E. Lee and Wai-kam Ho, *Chinese Art Under the Mongols: The Yüan Dynasty, 1279–1368* (Cleveland: The Cleveland Museum of Art, 1968), p. 91.

Page 116
"The picture of *The Land of Immortals*": translation by Wai-kam Ho, in Lee and Ho, *Chinese Art Under the Mongols*, cat. no. 264.

Page 118
"a skeleton or outline of the past" and "We are forced to see": Lee, *Chinese Landscape Painting*, p. 40.

Page 119
"suggests the flavor of tranquillity": An Ch'i, Mo-yüan hui kuan (1742); reprinted in I-shu ts'ung-pien, vol. 17, chüan 3, p. 146.

Page 120
Such colophons appear even when there are no human figures visible: see Chu-tsing Li, "The Freer Sheep and Goat and Chao Meng-fu's Horse Painting," Artibus Asiae 30 (1968): 279–326.

Page 121
Shimada's discovery in 1938: see Shūjiro Shimada [in Japanese], "Concerning Lo Chih-ch'üan's Snowy Riverbank," Houn 22 (1938): 41–52.

Page 121
"He spent all his days in desolation": A Concordance of the Poems of Tu Fu, vol. 2, p. 472.

Page 121
"As I look around at the things": Chao Wen, Ch'ing-shan chi (ca. 1300); reprinted in Ssu-k'u ch'uan-shu, chüan 7, pp. 22b–23a. See also Shimada, "Concerning Lo Chih-ch'üan's Snowy Riverbank," p. 50.

Page 129
"Bamboos are chilled": quoted in Bush, The Chinese Literati, p. 101.

Page 129
"Why should a high-minded man": quoted in Bush, The Chinese Literati, p. 36.

Page 133
"I would like to have composed": quoted in James Cahill, Hills Beyond a River: Chinese Painting of the Yüan Dynasty, 1279–1368 (New York: Weatherhill, 1976), p. 69.

Page 133
As noted . . . underlying much of Chao's art is a depth of symbolic meaning: see Chu-tsing Li, "The Freer Sheep and Goat."

Page 135
"a total lack of resemblance": quoted in Cahill, Chinese Painting, p. 113.

Page 135
"an overflow of his madness": quoted in Bush, Chinese Literati, p. 134.

Page 136
"The motif became a favorite": Cahill, Hills Beyond a River, p. 68.

Page 139
"People only know that painting bamboo": quoted in Bush, The Chinese Literati, p. 140.

Page 142
"One single tree of cold prunus": translation by Wai-kam Ho, in Lee and Ho, Chinese Art Under the Mongols, cat. no. 250.

Page 144
"The plum blossoms painted by the Stone-Cooking Mountain Peasant": adapted from translation by Wai-kam Ho, in Lee and Ho, Chinese Art Under the Mongols, cat. no. 250.

Page 147
"Clouds come and clouds go": quoted in Frederick W. Mote, The Poet Kao Ch'i, 1336–1374 (Princeton: Princeton University Press, 1962), p. 180.

Page 147
"Sometimes I climb a hill": quoted in Mote, The Poet Kao Ch'i, p. 128.

Page 154
"The picture seems not so much to describe": see Max Loehr, "Studie über Wang Mong (die Datierten Werke)," Sinica 14, nos. 5–6 (1939): 27–90; translation from Cahill, Hills Beyond a River, p. 124.

Page 154
which the scholar Chang Kuang-pin dates: see Four Great Masters of the Yüan (Taipei: National Palace Museum, 1975), no. 405.

Page 155
although Wang, whose articles on the painter are the most comprehensive: see Wang Chi-ch'ien [both articles in Chinese with English summary], "The Life and Writings of Ni Yün-lin [Ni Tsan]," National Palace Museum Quarterly [Ku kung chi k'an] 1, no. 2 (October 1966): 17, 29–42; and "The Paintings of Ni Yün-lin [Ni Tsan]," National Palace Museum Quarterly [Ku kung chi k'an] 1, no. 3 (January 1967): 19, 15–46.

Page 157
"I don't know that there is anyone around in the world": quoted in Cahill, Hills Beyond a River, p. 118.

Page 165
"In landscapes painted by other men": quoted in Cahill, Hills Beyond a River, p. 119.

Page 166
"Fang-hu's brush pursues the state of immortality": Li Ts'un, Su-an chi (ca. 1350), in P'ei-wen-chai shu-hua p'u, chüan 54, p. 11a.

Page 170
"the most surpassing of all of Fang-hu's works": Wu Sheng, Ta-kuan lu (1713); reprinted (Taipei, 1970), chüan 19, p. 1.

Page 170
"throws off all the common practices of painters": Ku Fu, P'ing-sheng chuang-kuan (preface dated 1692); reprinted (Shanghai, 1962), chüan 9, p. 99.

Page 170
"Its lofty simplicity and easy freedom": Wu Ch'i-chen, Shu-hua-chi (ca. 1677); reprinted (Shanghai, 1962), chüan 3, pp. 265–66.

Appendix 1
Selected Signatures, Inscriptions, and Colophons

The signatures, inscriptions, and colophons reproduced below, many for the first time, are of primary importance for the attribution and documentation of certain of the paintings discussed in the text.

The Riverbank (fig. 1)
Attributed to Tung Yüan, died 962

Signature of Tung Yüan: "Painted by
　　Assistant Administrator of the Rear Park,
　　Servant Tung Yüan" ("Hou yüan
　　fu-shih ch'en Tung Yüan hua")

Cloudy Mountains (fig. 11)
Mi Yu-jen, 1074–1153

Colophon, dated 1200, by Wang Chieh

Colophon, dated 1290, by Hsien-yü Shu (1257–1302)

Colophon by Kuo T'ien-hsi (active ca. 1280–1302)

Colophon, dated 1437, by Fang Mien

Procession of Taoist Immortals to Pay Homage to the
 King of Heaven (fig. 13)
Attributed to Wu Tsung-yüan, died 1050

右吳道子畫五帝朝元圖參政羅公所藏
也後以歸余不改裝褾猶爲物之質者爲
乾道八年六月望岐陽張子珌書

Colophon, dated 1172, by Chang Tzu-shao (?)

余嘗見山谷跋武虞部
五如來像云虞部筆力遒古可追
吳生便覺石恪筆相去遠甚不之可觀此圖是虞
此宣和譜中所載朝元仙仗是也与余兩所見五如來像用
筆又同故不敢以爲吳筆然數百年間寶繪也虞部
名宗元字總之大德甲辰八月望日吳興趙孟頫跋

Colophon, dated 1304, by Chao Meng-fu (1254–1322)

Duke Wen of Chin Recovering His State (fig. 16)
Attributed to Li T'ang, active early 12th century

Spurious colophon signed Ch'iao K'uei-ch'eng
 (ca. 1250–1300)

Spurious colophon, dated 1334, signed Shih Yen

Colophon, dated 1470, by Wu K'uan (1435–1504)

Colophon by Chou T'ien-ch'iu (1514–95)

Hermitage by a Pine-Covered Bluff (fig. 30)
Unknown artist, mid-12th century

Signature: the first of two characters appears to read
 Tz'u (Yen Tz'u-p'ing?, active ca. 1160–80)

Liu Ch'en and Yüan Chao Entering the T'ien-t'ai Mountains
 (fig. 45)
Chao Ts'ang-yün, 14th century

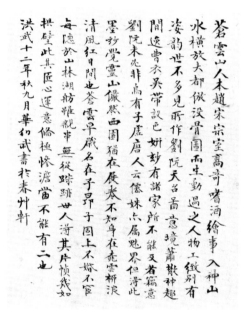

Colophon, dated 1379, by Hua Yu-wu (1307–after
 1379)

Colophon, dated 1386, by Yao Kuang-hsiao (1335–1419)

Narcissus (fig. 48)
Chao Meng-chien, 1199–1264

Colophon by Chou Mi (1232–98)

Colophon by Ch'iu Yüan (born 1247)

The Mind Landscape of Hsieh Yu-yü (fig. 50)
Chao Meng-fu, 1254–1322

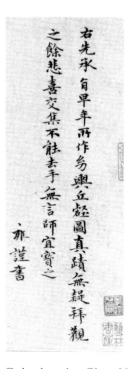

Colophon by Chao Yung (ca. 1289–ca. 1362)

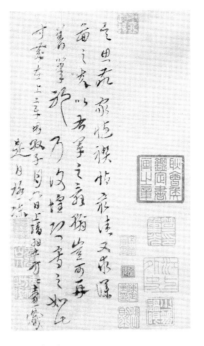

The Romantic Spirit of the Eastern Chin, dated 1360 (fig. 79)
Fang Ts'ung-i, ca. 1301–after 1378

Detail of inscription by Fang Ts'ung-i

Colophon by Ni Tsan (1301–74)

Twin Pines, Level Distance (fig. 53)
Chao Meng-fu, 1254–1322

Colophon by Yang Tsai (1271–1323)

Pine Pavilion, Mountain Scenery, dated 1372 (fig. 78)
Ni Tsan, 1301–74

Colophon by Shen Chou (1427–1509)

Transcription, attributed to Chao Meng-fu (1254–1322),
of The Preface to the Gathering at Orchid Pavilion by Wang
Hsi-chih (303?–361?)

壬寅正月僕同虁翁鄭□先生劉得閒閣長史奉
左轄王公之命拜觀龍虎山中壺公尊師因示此弓
巳十年前筆也鄭先生玄卷首石間蘇堂絕逼坡
仙蓋真知畫之言曰識玩味歲月為時十八日也盧貞

Colophon, dated 1362, by Lu Chen

Cloud Mountains, ca. 1365 (fig. 81)
Fang Ts'ung-i, ca. 1301–after 1378

雲山圖一幅上清高士方丈壺兩
作也好事者藏之以為珍玩觀其
筆法精到意態悠遠与米南宮高
房山同一軏度非後来浅之為學
者之比然而情嵐疊峰掩映之為煙
雲縹緲之際山坡一帶長若隱
築巖巘靠幽邃闃然無人蓋仙家
之勝境塵埃之絕觀也芋家宥方
壺手蹟一披其布置遠近大小雄
不散差肩於斯而精神跳染之妙
弦不方以優芳論鳴呼水墨之妙如
方壺者不復多見矣其流落人間距
今餘七十載不能不使人重其景仰之
思因為五言律一以紀其事云
不見瀛洲客無聲意趣多斷雲
野墅遠樹帶山坡木客深潛跡樵
人已罷歌披畫想高致清興欲如
何
正統十二年歲在丁卯夏後四月十
有三日
工部右侍郎蕪翰林院侍講學士
蕪
經遂官淮南高穀識

Colophon, dated 1447, by Kao Ku

上清高士方丈何年畫此
雲山圖奇構豈為俗情牽
異境自与塵寰阻風遙
迤接蓬島弱水東連大霞
表瑤草香生向日遲儲龍
實熟青春好臺殿巍峩
氣丹光仿佛潤中見鵉誥
紫翠刃白雲薈蔚文氣
依俙樹裹聞廣咸安期在
何蒙對此令人益傾篸乘風
便欲向大還不與濁世蘇
沉痾
永嘉周凱

Colophon by Chou K'ai (15th century)

Appendix 2
Comments by C. C. Wang

The Riverbank
Attributed to Tung Yüan

Barnhart: "While there is no way to confirm or to deny the authenticity of the signature, *The Riverbank* gives every indication of being a tenth-century painting, and its importance to the history of Chinese landscape painting can scarcely be overstated."

Wang: As Mr. Barnhart has also noted, *The Riverbank* bears the seals of various well-known Sung and Yüan connoisseurs. All these seals are genuine, evidence that the painting has been treasured by great collectors.

When we examine this large scroll, we see that the brushstroke technique for painting the weathered trees at the bottom center of the picture is exactly the same as that in the following two works: Tung Yüan's *Wintry Groves and Layered Banks* (Kurokawa Institute for Studies of Ancient Cultures, Hyogo, Japan) and *Along the River During Winter's First Snow* (fig. 4) by Chao Kan (active ca. 970), a student at the Southern T'ang academy. Two paintings by Wang Meng also display the same brushstroke technique: *Spring Plowing at the Mouth of a Valley* (National Palace Museum, Taipei) and *Dwelling in the Ch'ing-pien Mountains* (fig. 71), the artist's most celebrated landscape painting. Since the Yüan dynasty, it has generally been believed that this masterpiece was painted after Tung. It is now clear, based on *The Riverbank*, that in *Dwelling in the Ch'ing-pien Mountains* Wang was indeed imitating Tung.

In *The Riverbank*, Tung's brushstrokes are forceful yet smooth, his landscape elements are arranged naturally, in accordance with the principles of geomancy, and his figures and huts are delineated with exquisite simplicity—qualities only a great artist could achieve. The ink of the signature has penetrated the silk and the ink tone is harmonious with that of the painting. In my opinion, there can be no doubt that Tung himself painted and signed this work.

Summer Mountains
Attributed to Ch'ü Ting

Barnhart: "Since the style of *Summer Mountains* is precisely equivalent to Ch'ü Ting's active period and stylistic lineage and since in [Hui-tsung's] collection there were three works by him of the same subject, the scroll is now attributed to Ch'ü Ting."

Wang: On the painting *Summer Mountains* (fig. 7), the title by which this scroll is now known, is an inscription that I believe to be by Liang Ch'ing-piao stating that Yen Wen-kuei was its painter. Surely, Liang, a noted seventeenth-century collector, would not have made such a claim without good reason.

Although Yen's name does not appear in the collection catalogue of the Northern Sung emperor Hui-tsung, *Summer Mountains* bears two of the emperor's seals. The presence of such seals is not unusual, many paintings in Hui-tsung's collection but not listed in the catalogue bear them. As Mr. Barnhart has stated, Ch'ü Ting is recorded in the catalogue as the painter of three works, all titled *Summer Scene*. There is no work titled *Summer Mountains* listed under that artist's name.

Procession of Taoist Immortals to Pay Homage to the King of Heaven
Attributed to Wu Tsung-yüan

Barnhart: "Even if we choose to ignore all documentation prior to the Ch'ing period . . . we would still probably come to the conclusion that the work preserves the style of the Northern Sung period and of such a master as Wu Tsung-yüan."

Wang: In his colophon, Chao Meng-fu attributed *Procession* (fig. 13) to Wu Tsung-yüan, correcting the error made by earlier collectors, who thought the painting was the work of Wu Tao-tzu. One of the most eminent

connoisseurs in Chinese art history and a painter himself, Chao must have been very familiar with the styles of figure painters. In my view, his attribution is beyond question.

Eighteen Songs of a Nomad Flute
Unknown artist

Barnhart: "The work...served as the model for the Metropolitan's fourteenth-century copy."

Wang: In my opinion, the version of the *Eighteen Songs* (figs. 22, 23) in the Metropolitan was painted by a Southern Sung (1127–1279) court painter working in the iron-wire drawing technique, an unmodulated line that is precise and controlled, especially when compared with that of the scroll in the Museum of Fine Arts, Boston (fig. 24). The technique in the Metropolitan's painting can be compared with that of a Sung painting titled *Return from a Spring Outing* (Peking Palace Museum). No fourteenth-century painter, no matter how accomplished, could have mastered the technique displayed in the Metropolitan's handscroll.

Cottages in a Misty Grove
Li An-Chung

Barnhart: "...*Cottages in a Misty Grove* (fig. 29), is dated 1117. Its painter, Li An-chung... was a minor academician in Hui-tsung's academy...."

Wang: As Mr. Barnhart also notes, Li An-chung was a better painter of birds and flowers than of landscape. *Cottages in a Misty Grove* should be compared with *River Village in Autumn Dawn*, a handscroll by Chao Ta-nien in the Metropolitan Museum. It is my belief that *Cottages* was painted by an unknown artist following Chao's style.

Index

Page numbers of illustrations are in **boldface**.
Alphabetization ignores diacritical marks.